LOST CITIES OF PARAGUAY

LOST CITIES OF PARAGUAY

ART AND ARCHITECTURE OF THE JESUIT REDUCTIONS 1607-1767

BY **C. J. McNASPY, S.J.**

PHOTOGRAPHS BY **J. M. BLANCH, S.J.**

A Campion Book

LOYOLA UNIVERSITY PRESS
CHICAGO 60657

Ad majorem Dei gloriam

All rights reserved under International and
Pan-American Copyright Conventions. Printed and
bound in the United States of America.

Design by Mary Golon

All the photographs in this book were taken by José
Maria Blanch except those on pages 82, 101, 110 (2), 113
right, 116 right, and 118 right which were taken by C. J.
McNaspy. The aerial photo on page 74 was taken by
Anna-Maria Lopez.

Library of Congress Cataloging in Publication Data

McNaspy, C. J. (Clement J.)
 Lost Cities of Paraguay.

 1. Art, Jesuit — Paraguay. 2. Art, Colonial —
Paraguay. 3. Art, Baroque — Paraguay.
 4. Jesuits — Paraguay — Missions. 5. Guarani
Indians. I. Blanch, José María. II. Title.
 N6703.M36 709′.892 82-6524
ISBN 0-8294-0396-5 AACR2

For Ernest J. Burrus
Mentor and Guide

**Monogram of the Society of Jesus
Detail, statue of Saint Ignatius
San Ignacio Guazú**

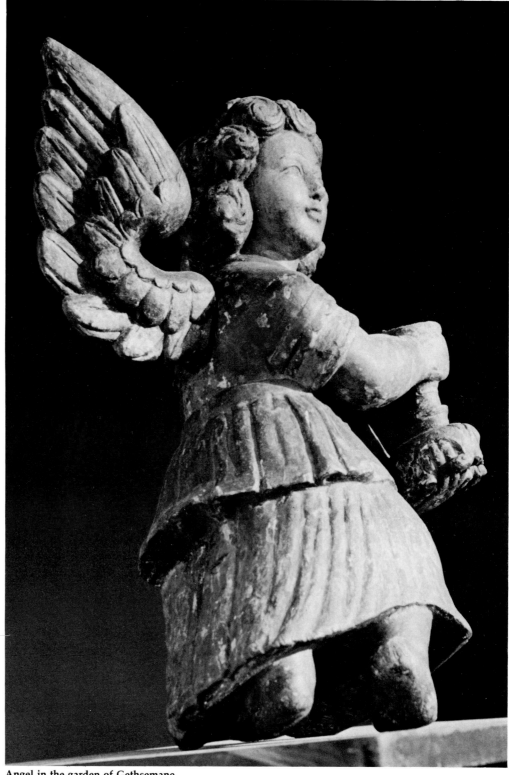

Angel in the garden of Gethsemane
San Ignacio Guazú

CONTENTS

Note on the word "Reductions"

Since many readers may be unfamiliar with the term "Reductions" as used in this volume and in other literature on the subject, a brief description may be in order. "Reduction" is a transliteration of the Spanish word *reducción,* and it may perhaps best be translated as "community." The Spanish *reducir,* in the usage of the period, meant to gather into mission settlements. The Reductions marked a serious attempt by the Jesuits to save the Guaraní Indians from enslavement by Portuguese *bandeirantes* as well as by Spanish colonists.

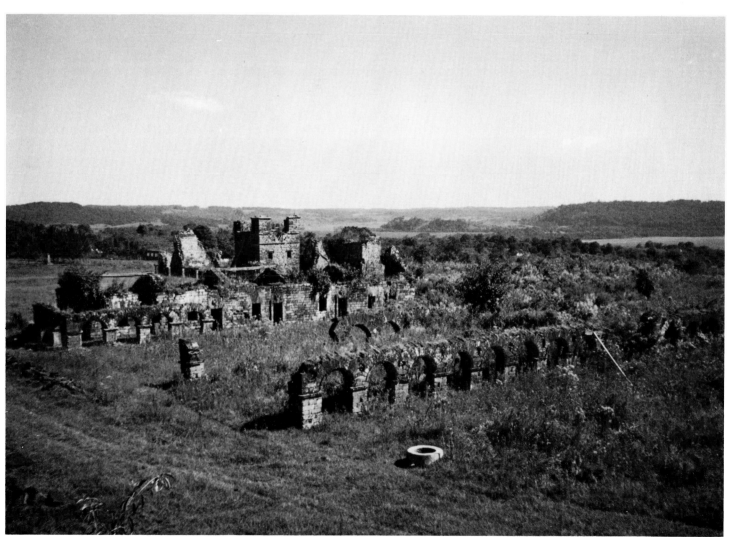

Ruins of Trinidad

FOREWORD

"The establishment in Paraguay by the Spanish Jesuits appears alone, in some way, the triumph of humanity. It seems to expiate the cruelties of the first conquerors. The Quakers in North America and the Jesuits in South America gave a new spectacle to the world."
—Voltaire

No matter how remarkable they were in the social history of the western world, no matter how unique in the story of civilization, the Jesuit Reductions of Paraguay were begun and carried on as a missionary enterprise of the Society of Jesus.

The Jesuit Order, founded as a missionary and teaching order by Ignatius Loyola, was approved by Pope Paul III in Rome in 1540. Ignatius early sent his men to the farthest reaches of the known world to preach the Gospel of Jesus Christ for "the greater glory of God and the good of souls." In 1540 Ignatius sent Francis Xavier to evangelize the people of India and the Far East. In 1549 he sent Manuel de Nóbrega with six Jesuit companions to Brazil. These men, working out from São Paulo, sought out and evangelized the native Indians who lived in the jungles.

In 1607 the Superior General of the Society of Jesus formed a new province of the Order to be known as the Province of Paraguay. The principal subjects of this missionary effort were the Guaraní Indians, nomadic tribes who lived in an area south and east of Asunción in Paraguay. These were primitive people, cannibals in fact, who lived together in small groups with allegiance to a cacique or chieftain. Yet for all their primitive characteristics, the Guaraní Indians had a remarkable receptivity to Christianity.

The work of the missioners among the Indians in South America was greatly hampered by the European colonists. Slave hunters, called Paulistas because they set out from São Paulo, regularly captured thousands of Indians and sold them into slavery. In one year alone, these raiders are reported to have killed or captured some thirty thousand Indians. They totally destroyed the first two Reductions of the Paraguay Province. Other colonists trapped or cajoled the natives into *servicio personal,* a kind of day labor which was so often abused that the Indians lost most of their liberty and were in fact treated like slaves. Besides these flagrant abuses, the bad example of the colonists in general made belief in Christianity all but impossible for the Indians.

For these reasons, together with the difficulty of keeping up with nomadic people, the Jesuits decided to separate their Indians from the Europeans and establish the mission settlements or Reductions in otherwise uninhabited areas.

While the word "Reductions" is unhappy, it is the standard term used in dictionaries in most languages. *Pueblo,* town, or some variant of mission would be more descriptive of the settlements, but the word "Reduction" has become the basic reference to these Jesuit settlements in South America.

One of the pioneer missioners, Father Ruiz de Montoya, spoke of the Reductions as "gatherings of Indians and Indian villages into larger towns and into political and humane societies." He also offered a more dynamic description: "These Indians scattered amid forests were gathered by our efforts into large towns and transformed from rustics into city-dwelling Christians by the constant preaching of the Gospel." In no sense of the word were the Indians "reduced"; rather the contrary.

Angel
São Miguel

Ten years after the founding of the Paraguay province, the number of Jesuit priests and brothers assigned to it had grown from seven to 113. The Indian settlements eventually numbered more than thirty cities and came to be known as the Guaraní Republic.

The Reductions formed a sort of semi-autonomous unit within the Spanish empire. Each mission normally included from two thousand to four thousand Indians directed by two or three Jesuits. A superior living in Candelaria, roughly in the center of the mission area, was in general charge of the Jesuits and he appointed the priests and brothers to each mission. He, in turn, was under a provincial superior and the provincial answered to the general of the Society of Jesus in Rome. While the Jesuits did not permit Europeans to live in the Reductions for the reasons given above, visiting merchants were occasionally allowed in and governors and bishops made frequent visits. The internal government of each mission town was provided by the chiefs or caciques, the elected *cabildo,* and the chief magistrate who was appointed by the governor on the pastor's recommendation.

In these remarkably organized settlements, the Jesuits provided for all the spiritual and material needs of the Indians, training them to practice not only the Christian faith, but numerous trades and crafts as well. And because of their exceptional native talents, the Guaranís were soon able to practice most of the trades and crafts known at the time. Some became tailors, carpenters, joiners, builders; others became stone cutters, blacksmiths, tile makers; still others became painters, sculptors, printers, organ builders, copyists, and calligraphers.

As the Reductions developed, each had an elementary school with Indian teachers educated by the Jesuits. In some of the Reductions, printing presses were set up and books were published. As early as 1705, the Indians had built their own presses and even made the type as well.

The skill of the Indians is especially evident in the beautiful stone work seen in the ruins of the churches. And the churches themselves were the scenes of liturgies, complete with polyphonic music, that were equal to those performed in the cathedrals of Europe.

The Reductions of Paraguay have been called a model theocratic commonwealth. The Jesuits who directed these cities were an international team of men from Western Europe, Paraguay, and Peru, who volunteered to serve on these missions. In 1772 the Guaraní Reductions numbered over eighty thousand Indians in over thirty towns or cities.

The great tragedy of the Jesuit Reductions of Paraguay came about in 1767 when the Jesuit priests and brothers were expelled from Spain and all of its colonies. By order of the king the men were rounded up and deported to Europe. The populations of the Reductions declined and, in succeeding years, time and military actions took their toll on the buildings.

What remain today are noble ruins, some sculpture, and the memory of one of the brightest chapters in human history.

The photographs of José Maria Blanch and the text of Father C. J. McNaspy, S.J., tell the story of the Jesuit Reductions of Paraguay.

George A. Lane, S.J.
Editor

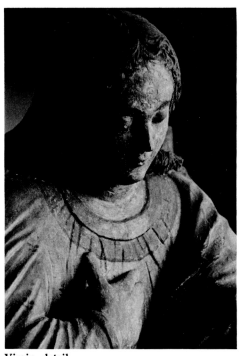

**Virgin, detail
Santa María**

PREFACE

Some of us who saw Kenneth Clark's graceful and persuasive television series "Civilisation" must have wondered, Why no mention of Spain? Perhaps Lord Clark himself wondered too. As if in reply to this very question, Clark explains in the Foreword to the book which largely reprints the TV scripts: "If I had been talking about the history of art, it would not have been possible to leave out Spain; but when one asks what Spain has done to enlarge the human mind and pull mankind a few steps up the hill, the answer is less clear. *Don Quixote*, the Great Saints, the Jesuits in South America? Otherwise she has simply remained Spain." This is surely as genteel and cautious a put-down as ever was penned.

My aim in this book is not to remind Kenneth Clark, a revered former teacher, of Vittoria's pioneer work in international law; nor of Suarez' teaching on kingly power deriving from the people; nor of the humane *Leyes de las Indias,* so different from the traditional English contempt for "savages"; nor, for that matter, of the monumental achievements of Franciscans, Dominicans, Augustinians, and others in Latin America even before the Jesuits arrived there.

My aim is rather to focus on a somewhat neglected chapter of civilisation and art which was hinted at by Lord Clark when he singled out for praise "the Jesuits in South America." For all I know, Clark may have been referring to the defense of American Indians by Peter Claver, Luis de Valdivia, and other Spanish Jesuit missioners. It seems more likely, however, given his expertise in art and a British enthusiasm for what R. B. Cunninghame Graham calls *A Vanished Arcadia* and G. K. Chesterton calls "Paradise in Paraguay," that he is suggesting rather the institutions popularly known as the Paraguay Reductions.

A century and a half before Lord Clark's "Civilisation," another Englishman, Robert Southey, found much to say in praise of the Reductions. He was poet laureate as well as an historian, and he composed an elaborate epic poem of some 2,198 lines in Spencerian stanzas on a single episode that he had discovered. He titled the poem, "A Tale of Paraguay." In his *History of Brazil* Southey waxes eloquent about the Reductions: "The Jesuits opposed the Indian slave trade with the zeal of men who knew that they were doing their duty; never had men a better cause, and never did men engage in any cause with more heroic ardour." Hardly British understatement as we know it today.

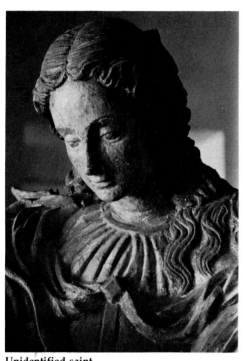

Unidentified saint
Santa María

Southey continues: "Europe had no cause to rejoice in the establishment of the Jesuits; but in Brazil and Paraguay their superstitions may be forgiven them, for the noble efforts which they made in behalf of the oppressed Indians, and for the good which they effected . . . They formed a Utopia of their own . . . But erroneous as they were, the sanctity of the end proposed, and the heroism and perseverance with which it was pursued, deserve the highest admiration . . . It was their fate to be attacked with equal inveteracy by the unbelieving scoffers and philosophists on one side, and by the all-believing bigots and blockheads of their own idolatrous Church on the other." This, of course, is hard to beat for pre-ecumenical overstatement and spleen.

Eminent among Southey's "unbelieving scoffers and philosophists" was certainly Voltaire, who in his *Candide* pokes a great deal of fun at the Jesuit missioners. Everyone is familiar, if not with the original *Candide,* at least with Leonard Bernstein's delightful musical comedy based upon it. Less read, however, is the more mature Voltaire's disavowal of *Candide* and his changed evaluation of the Reductions. This appears in Chapter 154 of his massive *Essai sur les moeurs et l'esprit des nations:* "The establishment in Paraguay by the Spanish Jesuits appears alone, in some way, the triumph of humanity. It seems to expiate the cruelties of the first conquerors. The Quakers in North America and the Jesuits in South America gave a new spectacle to the world." Generous, indeed; but did Voltaire know about the Franciscans, or Bartolomé de las Casas, or so many other non-Jesuits?

Southey's "all-believing bigots and blockheads," however, as well as his "unbelieving scoffers" eventually had their way. As historian Richard Alan White puts it: "They spread rumors of hidden gold mines and of a Jesuit conspiracy to create an independent state in the wilds of South America." These rumors spread to Europe and were eagerly grasped by certain absolutist political figures: Pombal in Portugal, Aranda in Spain, de Choiseul in France, Tanucci in Naples, and others. The rumors contributed at least in part to the suppression of the Society of Jesus in Portugal in 1759, in France in 1762, throughout the Spanish empire in 1767-68, and eventually, under pressure from the same Bourbon courts, throughout the rest of the Catholic world in 1773.

While many issues were involved in the European context, far too complex to be touched upon here, White again puts it as well as anyone as far as the Paraguay Reductions were concerned, when he says that the rumors of hidden gold and an independent state "contributed only the pretext for expulsion; it is the larger historical context of 18th century absolutism which provided the rationale."

In any event, this small book is simply meant to be a survey of the art of the Reductions as manifested in what remains of their architecture and some surviving pieces of sculpture. Only sparse relics of their painting and other visual arts survive, unfortunately, and most of the music has vanished. For a broader view of the Reductions and their social, political, and economic structures, the reader is referred to the bibliography at the end of this book and especially to Philip Caraman's book *The Lost Paradise*. I shall only touch upon these subjects in a very introductory way in order to situate the art works in some sort of context.

Anyone beyond the age of sixty-five finds it hard to resist reminiscing. This is not a book for specialists; and without pretending to be a specialist myself, I take some comfort in the old French adage, "In the kingdom of the blind the one-eyed are kings." Unlike many of my readers, I have personally seen, at least with one eye, so to speak, the art works presented here. Furthermore, I have read most of the significant literature written by specialists, largely in Spanish and Portuguese, but also in French, German, English, and Latin. As a result, I can employ the scholarship of the experts for the advantage of those readers who may never be able to visit the ruins or museums of the Reductions personally, as well as for others who may.

When I first visited the area of the Reductions in July of 1976, I expected to find little more than I had seen in books. Thanks to the prodding of my Paraguayan friend and colleague, Casimiro Irala, I overcame my skepticism enough to make a tour of the Reductions. At the time I was lecturing in several museums and universities in Brazil. It occurred to me that I would never be so close to Paraguay again; it seemed now or never. Little did I anticipate.

My friend Casimiro sketched out on the back of an envelope an impromptu map of the principal ruins and assured me that a week or so of exploration would be revealing. I agreed to go.

After the overpowering experience of seeing the Iguazú Falls, surely one of the supreme natural wonders of the world, I crossed by ferry into the Misiones Province of Argentina and took a rickety bus to the area where the Reductions had been. I narrowly escaped death that wet wintry day; for the bus I had just missed was to collide with a truck, killing or maiming all occupants of both vehicles.

My first stop was the former Reduction of San Ignacio Miní where the local parish priest, José Marx, S.V.D., welcomed me warmly and started me on my visit to the shattered world of the Reductions. He drove me by jeep to several fairly inaccessible ruins hidden in the jungle. San Ignacio was so exciting that it made the whole effort already seem worthwhile.

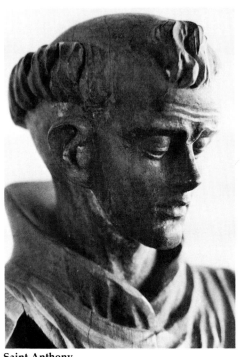

Saint Anthony
São Miguel

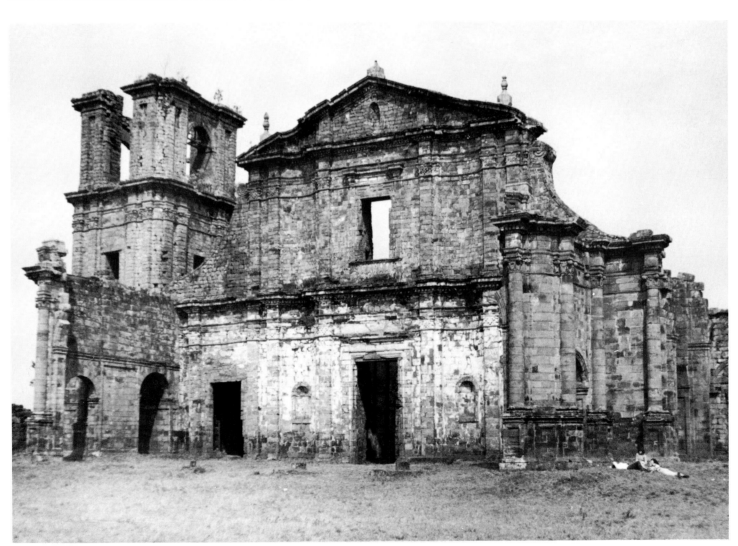

Facade of church
São Miguel

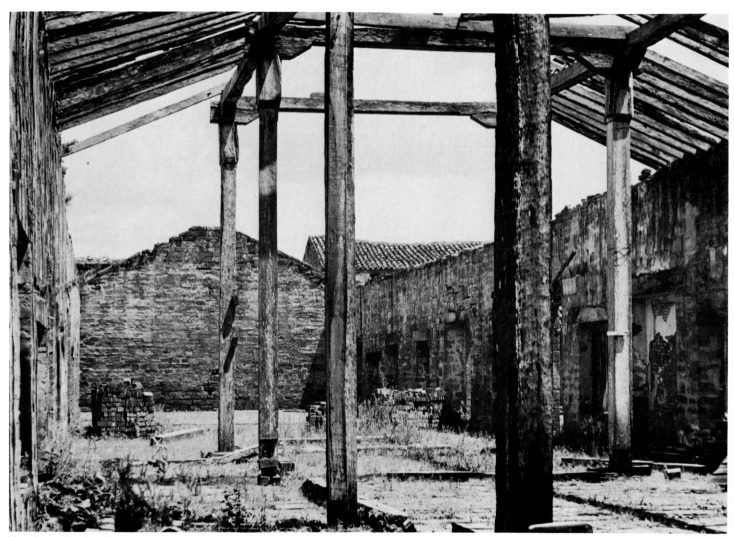

Church repairs, San Cosme

From the city of Posadas I crossed the giant Paraná River, some three times as wide as the Mississippi in Louisiana, and I came to Encarnación, in Paraguay. There another colleague of mine, Ricardo Romero, was good enough to show me two other spectacular ruins, Trinidad and Jesús. I then went on by bus toward Asunción, briefly visiting my brother Jesuits who work in San Ignacio Guazú. They were living in the ancient structure which was then being converted into what is today an important museum.

In Asunción I was fortunate to be able to spend several days with the distinguished scholar, Antonio González Dorado. He introduced me to some of the key literature on the Reductions and put me in touch with Monsignor Augustín Blujaki, rector of the cathedral and curator of a splendid museum of mission art. He also introduced me to José Maria Blanch whose photographs I particularly wanted to see, since they had just been given a very important showing. Neither Blanch nor I ever dreamed that five years later we would be collaborating on this book.

When I later returned to the United States, I was delighted to discover that my own color slides of the Reductions had turned out far beyond my expectations. A number of my friends suggested that a documentary film could be made about the Reductions. Rev. Daniel L. Flaherty, S.J., now Director of Loyola University Press in Chicago, expressed his enthusiasm for the project with more than words. He secured the grants which made the film possible.

One of the people who had suggested the film was Robert M. McCown, S.J. He was an experienced documentary filmmaker and he offered to make this one. He and his brother, James H. McCown, S.J., and I came to Paraguay in January of 1978 and immediately went to work on the project. We profited by sunny, not to say sweltering, weather. Few such films, I suspect, have been done by so diminutive a crew: one cameraman, one factotum, and one "actor" who walked around the ruins and pointed things out. We were helped enormously by our Paraguayan Jesuit confreres, to whom the film was eventually dedicated.

The skills and labor of Robert McCown produced a documentary film titled *The Jesuit Republic of Paraguay* which has been enthusiastically received by many groups of people on four continents. The film also won the coveted Golden Eagle Award. While acknowledging my personal bias, I highly recommend the film. Most Jesuit institutions in the United States possess a copy, which the reader may ask to see. It is now also available with a Spanish voice-over done by Casimiro Irala, the same Paraguayan Jesuit who first urged me "to see for myself" and who contributed much of the music for the film.

At the time we made the documentary film, none of us had any idea that before long I would be working in Paraguay on indefinite assignment and even guiding friends around the ruins of the Reductions. Nor had we any idea at that time that this book would be written. Again it was Rev. Daniel L. Flaherty, S.J., who instigated this undertaking and made it possible. Fortunately, the photographs of José Maria Blanch were as yet unpublished, and we have been able to fill in a few gaps in his original collection, notably in the three new museums and at the important ruins of São Miguel in Brazil.

Architecture and the other visual arts have been serious interests of mine since childhood. For some thirty years I have lectured on art history at several universities on various continents. My ten years as fine arts editor of *America* magazine in New York took me to almost all parts of the world and enabled me to experience first hand most of the great buildings and museums of the world.

Saint Barbara
Santa María

This broad and varied experience has led me into a sort of minor career as tour guide, especially for groups of students and pilgrims visiting Europe and the Holy Land. Such groups still use my book *A Guide to Christian Europe* (Hawthorn, 1963, reprinted by Loyola University Press). My small book, *Rome, A Jesuit City Too,* grew out of some thirty visits and many months in residence in my favorite city. I have also written *Crescent of Christianity,* with photographs by Elmo Romagosa. All of these, along with my articles in *America* magazine, testify to my eagnerness to share the joy of discovery.

I need hardly say that the present volume is no sort of dissertation. I am not attempting to prove anything. If a thesis does seem to emerge and take some sort of shape, it is, I hope, that the Jesuit Reductions of Paraguay still speak to us. Even their ruins speak eloquently. For through the Blanch photographs one can feel the bittersweet sense of a heroic moment of mission history, an endeavor that flourished gloriously and then was lost.

Fortunately we have abundant documentation to clarify what would otherwise remain ambiguous. We are not in the situation I felt myself in, for example, when I was visiting the paleolithic caves of Altamira or Lascaux, or even the hypogeum of Malta. These sites are immensely evocative but often nebulous and unclear in their ultimate meaning. The Reductions, of course, are not nearly so remote in time, but they can be quite obscure to those who have not done much reading about them.

While many readers of the Spanish edition of this book will be able to visit the Reductions themselves, it would be illusory for me to expect that many of my English readers would be so fortunate. For them, this can only be a picture book, an imaginary pilgrimage, a walk through another gallery of the Museum Without Walls.

C. J. McNaspy, S.J.
Asunción, Paraguay
Feast of the Assumption, 1981

Saint Joachim
Santa María

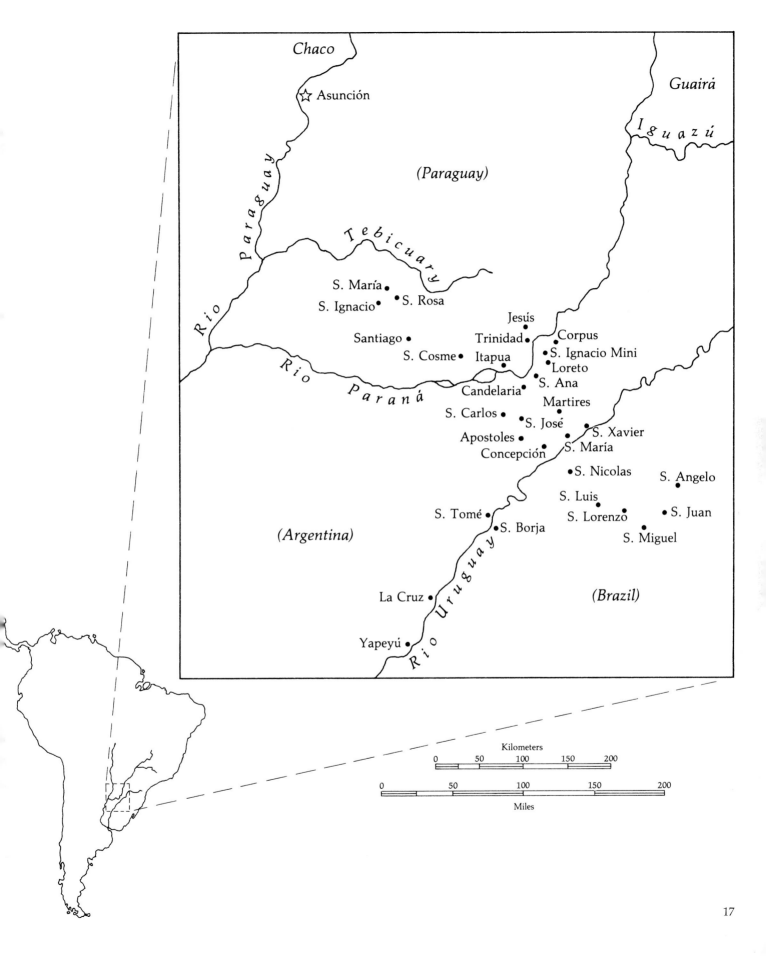

Chaco

☆ Asunción

Guairá

I g u a z ú

R i o P a r a g u a y

(Paraguay)

T e b i c u a r y

S. María •
• S. Rosa
S. Ignacio •

Jesús •

Santiago •

Trinidad •

Corpus •
• S. Ignacio Mini

R i o P a r a n á

S. Cosme • Itapua •

Loreto •

• S. Ana

Candelaria •

Martires •

S. Carlos •
• S. José

S. Xavier •

Apostoles •

S. María •

Concepción •

• S. Nicolas

S. Angelo •

S. Luis •

S. Lorenzo •

• S. Juan

(Argentina)

S. Tomé •
• S. Borja

S. Miguel •

R i o U r u g u a y

La Cruz •

(Brazil)

Yapeyú •

Kilometers

0 50 100 150 200

0 50 100 150 200

Miles

17

THE PARAGUAY MISSION:
SOME PLACES AND PEOPLE

Modern Paraguay occupies an area roughly the size of California. It is surrounded by Brazil, Argentina, and Bolivia. Its population is somewhat less than that of metropolitan San Francisco, and most of the people live in the southern third of the country.

Of the thirty mission towns known as the Paraguay Reductions, only eight lie, in various states of ruin, within the borders of present-day Paraguay. Another fifteen, generally more dilapidated, are located in the tongue of land between the giant Paraná and the Uruguay Rivers. This area, which today belongs to Argentina, is appropriately called Misiones. It is also called Mesopotamia, the land "between the rivers."

The remaining seven Reductions, even more decimated, lie beyond the Uruguay River in the Brazilian state of Rio Grande do Sul. This region is now largely inhabited by third or fourth generation Germans, many of whom still speak German as fluently as they speak Portuguese.

To the early Spanish colonists fired with the lust for gold, Paraguay was to prove an utter disappointment. Nowhere was there the profusion of precious metal found in the Andean or Mexican empires or among the Chibchas in Colombia. Much of this fabulous treasure is still displayed in Bogota's unique Museo de Oro.

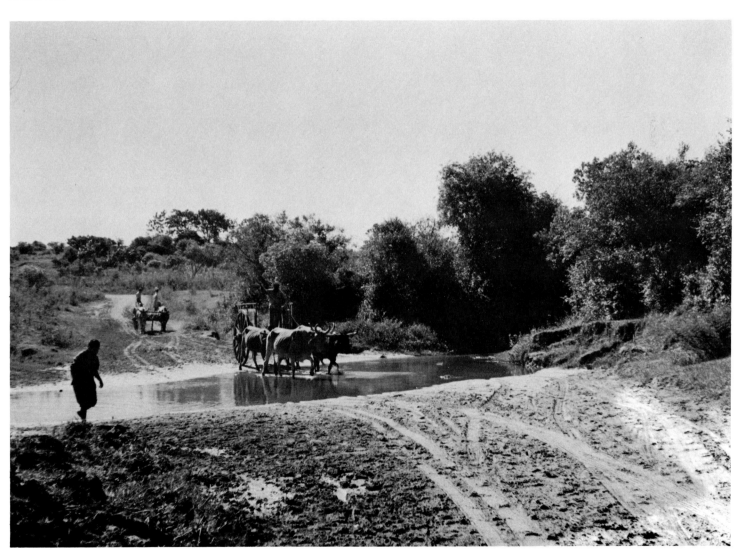

Countryside near Santa María, Paraguay

Even the eighteenth century Gold Rush to Brazil's Minas Gerais state found no counterpart in Paraguay. It has only been in our own time that rumors have been heard of oil reserves in the Chaco. And just recently there has been speculation about uranium deposits in Paraguay. The Chaco is the vast semidesert which covers most of Paraguay and much of Bolivia and Argentina. If either of these rumors about oil or uranium should prove true, South America's second poorest country may yet discover worldly wealth and its concomitant problems.

Meanwhile, Paraguay's people are its principal resource. They are almost all mestizo descendants of the indigenous Guaraní Indians and their Spanish conquerors. We foreigners find these people lively but gentle, courteous but neither obsequious nor class-conscious, proud yet neither aloof nor xenophobic. They are so open and warm that we are not even tempted to smile when they call their country the "Heart of South America." The people look strikingly similar, as though almost everyone were related to everyone else. And given the fact that few of their men, only five percent by

some estimates, survived the slaughter of the Triple Alliance War, 1865-70, this may indeed be so. I have visited or lived in many countries that boast of being bilingual, but I know of none other than Paraguay where almost everyone is at home in the same two languages, Spanish and Guaraní. One acquainted with other Latin countries is delighted to find neither mendicancy nor malodorousness among the Paraguayan people. Even the poor are impeccably clean.

Houses from the original Reduction at Santa Rosa

Together with the *Conquistadores,* priests and friars came to Latin America and engaged in perhaps the greatest and most enduring missionary enterprise since the days of the Apostles. There were Franciscans, Dominicans, Augustinians, Mercedarians, and secular priests. The Society of Jesus, founded by Ignatius of Loyola a generation after the Conquest, quickly sensed the call. On March 14, 1540, six months before Pope Paul III formally approved the Society of Jesus, Ignatius had sent his outstanding companion, Francis Xavier, to work in Asia.

The vague immensity of Brazil and its challenges beckoned to Ignatius and led him to send six Jesuits there in 1549, among them was the celebrated Manuel de Nóbrega. The next year four more Jesuits were sent. One of them, José de Anchieta, was to become a national hero and poet of Brazil. He was recently declared "blessed" by the Roman Catholic Church. Both of these charismatic giants, Nóbrega and Anchieta, assisted in founding the mission of São Paulo which is today the business metropolis of the continent but then was about to attract slave traders and other international riffraff. Ironically, in the history of the Reductions the very word "Paulista," inhabitant of São Paulo, came to describe the slave-trading enemy of the Indians.

Across the continent in Peru Jesuits engaged in work among the Indians as early as 1567. They mastered their languages and founded schools. Lima's college of San Pablo, established in 1568, was the first Jesuit school in Spanish America and for centuries played a major role in Peruvian cultural life.

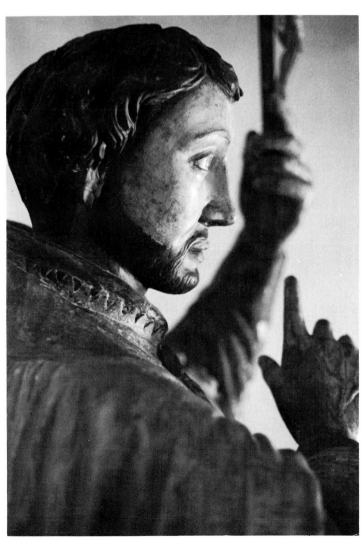

Saint Francis Xavier, detail
Museum of San Ignacio

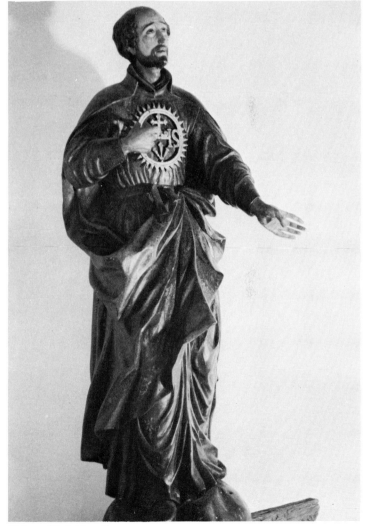

Statue of Saint Ignatius
Museum of San Ignacio

21

The Jesuit missionary thrust in South America was two-pronged. It was described by the historian William Bangert as having "movement and stability." Some missioners were constantly on the move while others saw the need to establish permanent indigenous communities. It was not enough to preach briefly, baptize quickly, and then move on. Unless some continuity in the converts' spiritual development were assured, it was too easy for them to lapse from the faith they had acquired.

In Paraguay the first Christian missionaries were Franciscans. They arrived on August 15, 1537 with the founders of Asunción. That day marked the annual feast of the Virgin Mary's Assumption into heaven, and hence the city's name. At first the ministry of the Franciscans was largely restricted to the Spanish colonists and to those Guaraní Indians who lived in the vicinity of Asunción.

In 1575 the Franciscan Luis de Bolaños arrived. He mastered the Guaraní language and began organizing the Indians into settlements. He also produced the first grammar, dictionary, and prayer book in their language; all of which, unfortunately, are now lost. In many ways Bolaños is, if not the father, at least the grandfather of the Jesuit Reductions in Paraguay. Another Franciscan who might lay claim to the title was Martín Ignacio de Loyola, coincidentally a grand-nephew of Ignatius Loyola who founded the Society of Jesus. Martín Ignacio de Loyola became bishop of Asunción on November 19, 1601 and not surprisingly did much to secure Jesuits for the missionary work in Paraguay.

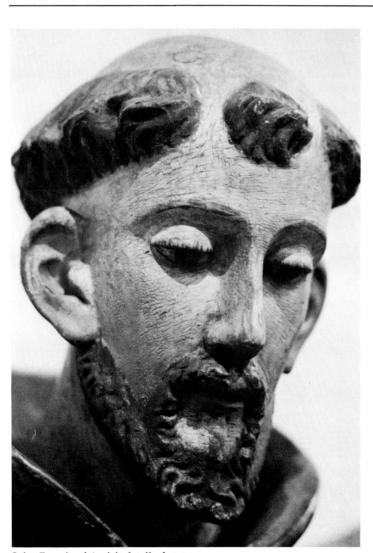

Saint Francis of Assisi, detail of statue
Museum of San Ignacio

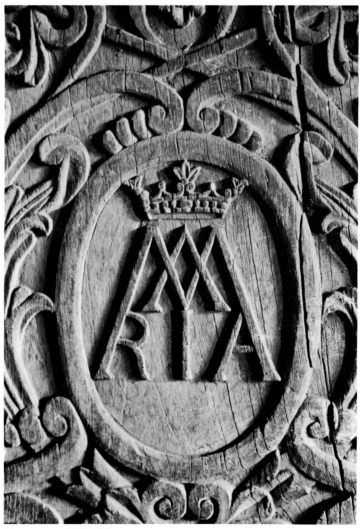

Monogram of "Maria"
Museum of San Ignacio

The first three Jesuits to arrive in Paraguay came by way of Brazil. They were Manoel Ortega, Juan Saloni, and Thomas Fields. They were Portuguese, Catalan, and Irish respectively; and it is not altogether fanciful to regard them as typical of the international character of the hundreds of Jesuits who would work in Paraguay throughout the history of the Reductions.

To clarify missionary jurisdiction in this part of the world, Rome designated Paraguay in 1604 as a distinct "province" for Jesuits to work in. This missionary territory encompassed an immense area which included present-day Argentina, Chile, Uruguay, Bolivia, parts of Brazil, and Paraguay. The province was approximately the size of the contiguous United States west of the Mississippi River. The first provincial superior of this mission was a Spaniard, Diego de Torres, a man of singular imagination and initiative who already possessed some missionary experience. The people to whom the Jesuit missionary effort was principally directed were the Guaraní Indians.

The Guaraní were an important tribe who lived in the area roughly included in modern Paraguay and large parts of Brazil and Argentina. The Jesuits who worked among the Guaraní faced two formidable hazards over and above the problems normally associated with new missions. One was the *encomendero* system; the other was the westward push of Portuguese Brazilians.

As early as 1537, Pope Paul III had unequivocally condemned enslavement of the indigenous peoples of America, and the kings of Spain had promulgated humane laws in their defense. But

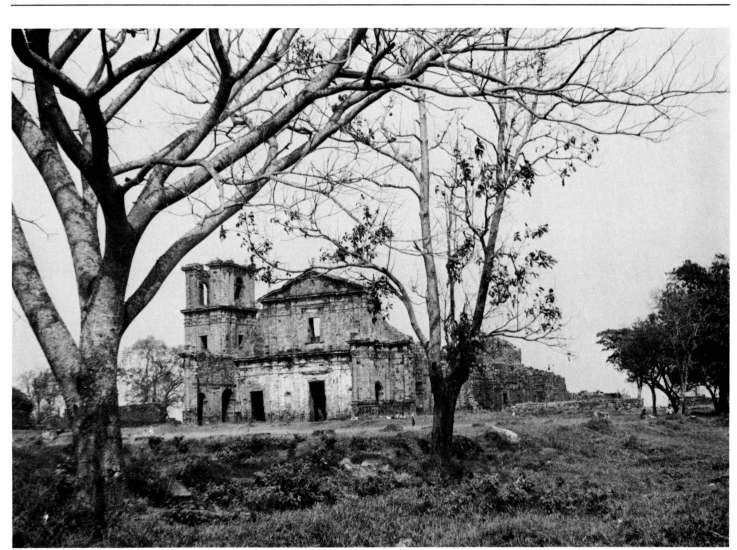

Church of São Miguel, Brazil

23

distance was the great enemy. All too easily the *encomenderos,* colonials in charge of day labor, treated the Indians as slaves. Protests took many months to reach Madrid and thus were highly ineffective.

The Jesuits realized that the only way for the Indians to enjoy freedom and dignity in a world of colonialism would be to have their own separate communities. Here they could live and work for themselves, semi-autonomously, while owing fealty and paying taxes to the Crown. The system was not new; it had been used in Mexico, the Philippines, and other parts of the Spanish empire.

A minor body of literature has been written dealing rather sensationally with the "communistic" nature of the Reductions. This explains some of the enthusiasm of writers like Paul Lafargue, Karl Marx's son-in-law, for these settlements. More temperate is the assessment given by historian Philip Raine: "The Reductions were one of the world's nearest approaches to pure communal living—and one of the few examples in history of a society built from the ground up and operated successfully over a period long enough to leave no doubt of its accomplishments."

In most respects the Reductions were not a radical creation out of nothing. Communist features, such as collective farms and cattle herds, were simply a natural development of tribal customs adapted to urban living. Most community property was called *abambaé. Aba* means Indian or people; *mbaé* means things or property. Those things that were reserved for emergencies and the goods that were kept for the support of the church and *colegio* were called *tupambaé; tupa* meaning God. These things, then, roughly translated, were "God's acre." In fact, the cemetery alongside the church was included in this latter category.

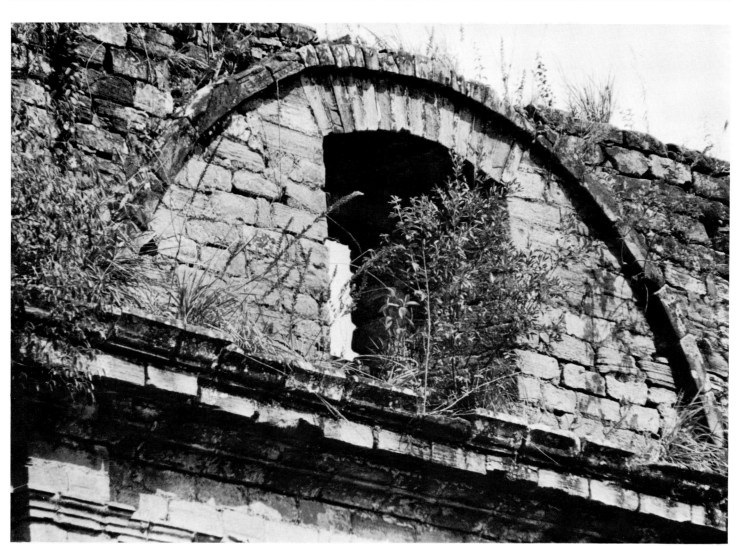

Wall of the church, detail showing stonework
Mission of Jesús, Paraguay

The institution known as *Coty-guazú* was specifically Christian. This was, literally, a big house opening onto a patio and dedicated to the needs of widows, orphans, and others requiring special social security. The whole economic system of the Reductions has been studied by impartial economists. Perhaps the easiest to read is the work of Oreste Popescu.

Writers with a strong capitalist inclination deplore the practice of communal property and fretfully blame the Jesuits for not pressing the Indians, despite their traditions and preferences, toward a stronger attachment to private property. With some irony, Arnaldo Bruxel notes that while the Reduction system could hardly have survived nineteenth century republicanism, it might very well be seen as "anticipating, some centuries before its time, the ever increasing socialization and nationalization of the present world economy."

Contrary to certain expressed hypotheses, there is not the slightest evidence that the Reductions were consciously modeled on St. Thomas More's *Utopia* or on Tommaso Campanella's *City of the Sun,* or on other Renaissance paradigms of the perfect society. One scholar, Eberhard Gotheim, proposed the ingenious notion that since the first two missioners who founded Reductions in the Guayrá area were Italians, Giuseppe Cataldini and Simone Mascetti, they had probably come under Campanella's influence and went to Paraguay explicitly to put his City of the Sun into practice.

Alberto Armani, however, undermined the Gotheim hypothesis when he discovered letters from the two missioners asking their Jesuit superior in Rome simply to send them to any foreign mission, "to India, Japan, China, Turkey, or Moscow;

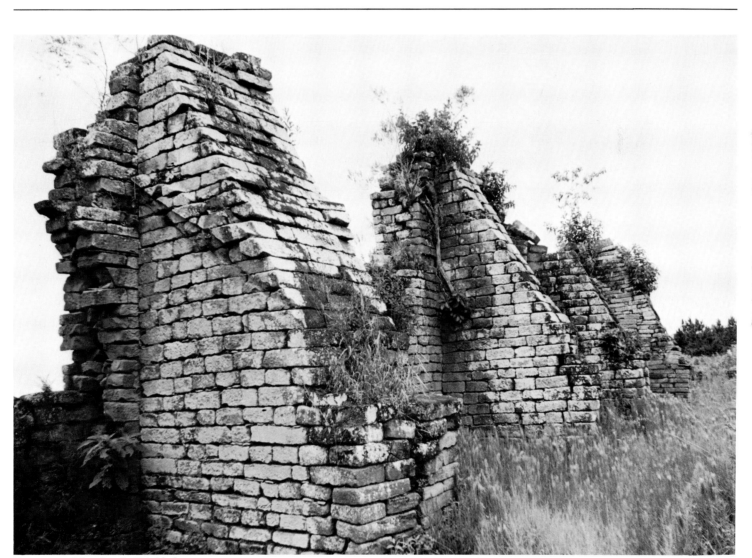

Buttresses of the church, Trinidad

wherever you judge most for the glory of God!" Moreover, anyone who is at all acquainted with missionary working conditions, even today, knows that abstract, preconceived plans have little effectiveness. Missioners must be experimenters, realistic improvisers. They must always be developing new plans as they gain new experiences.

PAULISTAS

The second continuing threat to the Reductions came from the São Paulo area. Adventurers called Paulistas set out from there and pushed back the Brazilian frontier. They were much like the frontiersmen who later opened the West in the United States. These adventurers, who were known as *bandierantes* by the Brazilians, fell upon the Indians of the early Reductions and enslaved thousands of them, some 300,000 in all, according to the missioner Francisco Díaz Taño. Other estimates are higher still. In fact, the first eleven Reductions built in the territory that was then Spanish, but today lies within the Brazilian state of Paraná, were totally destroyed by the Paulistas.

Thanks, however, to the enterprise of Father Antonio Ruiz de Montoya and his associates Cataldini and Mascetti, the populations of two or three of these early Reductions managed to escape. In 1631, just days before another Paulista onslaught, Ruiz was able to persuade some twelve thousand Guaranís to abandon their homes and embark on a journey that has often been described as an Exodus, over one thousand miles down rivers and over portages through hostile territory.

Nevertheless, the Paulista raids continued. In 1638 Ruiz sailed to Spain and secured the exceptional permission for the Guaranís of the Reductions to arm and defend themselves. So skilfully, in fact, did

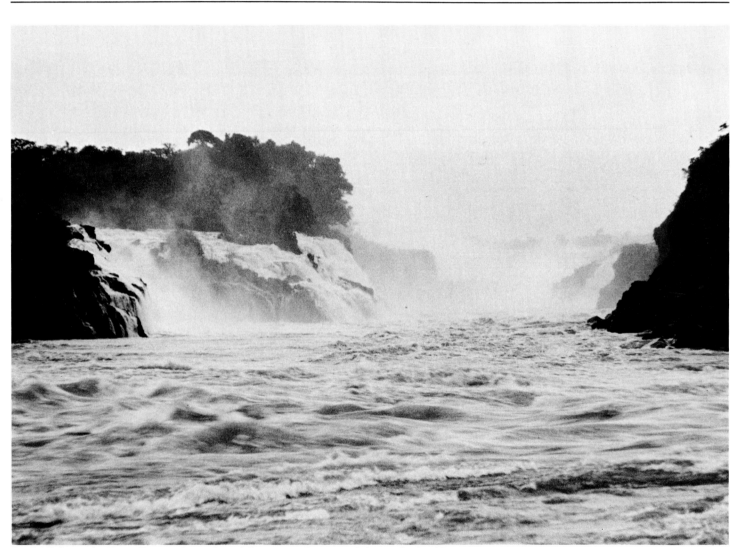

Guairá Falls on the Upper Paraná River. These falls were on the route of the Exodus lead by Ruiz de Montoya in 1631.

they do this that again and again they were able to fend off the invaders. Thus for a time the Reductions enjoyed relative security.

RUIZ DE MONTOYA

Antonio Ruiz de Montoya, a truly exceptional Jesuit missioner, is little known to the world in general. He was born in Lima, Peru on June 13, 1585 and was early orphaned. He experienced a tumultuous youth, was apparently involved in some sort of assassination fracas, and fled the country. He later underwent a dramatic spiritual conversion,

somewhat like that of Ignatius Loyola, and he entered the Society of Jesus in 1606.

While still a novice Ruiz was attracted by Father Diego de Torres, the first Jesuit provincial superior of Paraguay, and he volunteered for the demanding Guaraní missions. After his theological studies in Córdoba, Argentina, Ruiz de Montoya went to work among the Indians on the frontier missions.

After the Exodus of 1631 mentioned above, Ruiz made the four-month journey to Madrid where he had to spend another twenty-three months waiting to see Philip IV. He did other

work for the missions in the meantime. "I don't like this exile," he wrote. "All this brouhaha, hand-kissing, and court etiquette is not for me. It's a pure waste of time." While he was waiting he wrote five books, some two thousand pages, which were published in the Guaraní language. His grammar, dictionary, and spiritual books contributed notably to the stability of the Guaraní language and are still in use today. These books helped to make the Reduction Indians literate. They were, indeed, probably the first indigenous literate society of our hemisphere.

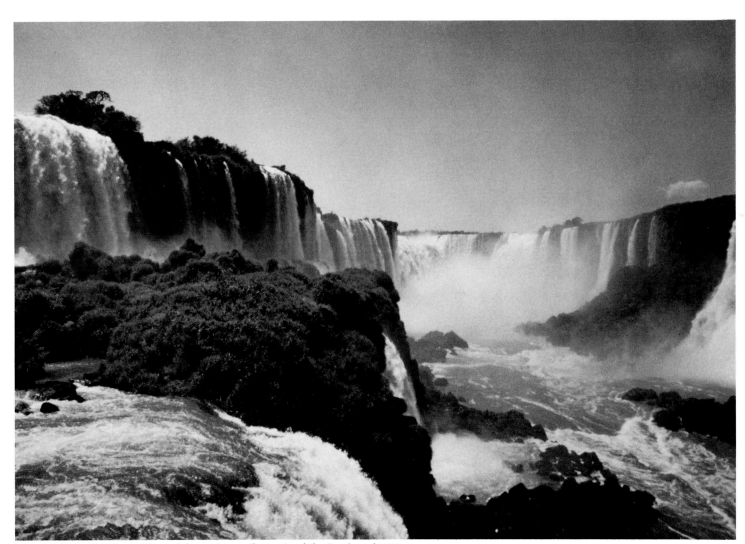

Iguazú Falls on the Upper Parana River, also on the route of the Exodus of 1631.

Ruiz at this time was also able to work on his *Conquista Espiritual,* a classic of spirituality which contains useful lore about Guaraní customs and the establishment of the early Reductions.

Ruiz was a man of action. But he was also a man of vision and direction: "Our purpose in establishing the Reductions is to achieve peace between the Indians and the Spaniards. This is a difficult task, not yet accomplished today, after more than a century since the discovery of America."

After many years of mission work and some sixty thousand miles of travel on foot, this Xavier of South America died in Lima, Peru on April 11, 1652. When the news of his death reached the Reductions, some forty of his Guaraní Indians trekked several thousand miles across the Chaco and across the Andes mountains to ask for his remains. Their request was granted. The Indians brought the Jesuit's body triumphantly back to Loreto Mission, one he had saved and refounded, and there he was buried. Perhaps some day this giant of the missions will be canonized.

ROQUE GONZÁLEZ

Roque González de Santa Cruz, popularly known as "Beato Roque" or simply "El Beato," is another first-generation hero of the Reductions. He too was born in South America in Asunción, Paraguay in 1576. Roque was ordained a priest at the age of 22, and not long afterwards he was placed in charge of the cathedral of Asunción by Bishop Martín Ignacio de Loyola. On May 9, 1609 Roque entered the Society of Jesus and two years later became superior of the first Paraguay Reduction, San Ignacio Guazú. A large but unimpressive statue of "El Beato"

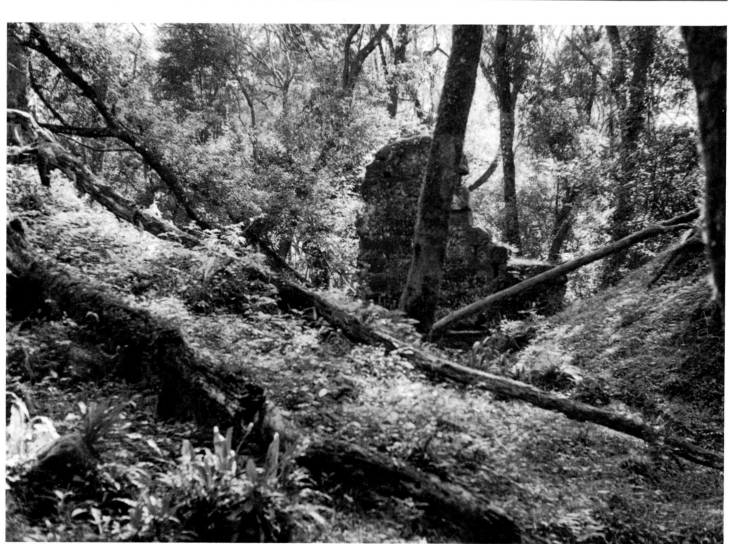

Ruins of Loreto, burial site of Father Ruiz de Montoya

stands in the town square of San Ignacio Guazú today. Roque is known as "El Beato" because he has been beatified, and soon, we hope, will be canonized by the Roman Catholic Church.

Roque was a born founder. On March 22, 1615 at Itapua, on the spot now occupied by the Argentine city of Posadas, he established another Reduction. Somewhat later the population moved across the river to what is today Encarnación. Thus Roque is recognized as founder and patron of both cities, and one hopes that the bridge now under construction to link the two cities may bear his name.

Roque expressed his vision of the Reductions in an interesting letter to his brother Francisco: "We work for justice. The Indians need to be freed from the slavery and harsh personal servitude in which they now exist. In justice they are exempt from this by natural, divine, and human law."

Two other Reductions founded by Roque González were Concepción (1619) and Candelaria (1627). On November 15, 1628, after celebrating Mass at what was to be a new Reduction near Caaró, in what is today Brazil, Roque was murdered by a cacique or cheiftain named Nezú. The Jesuit's heart was brought to Rome five years later together with the stone tomahawk that was used to kill him. In 1931 he and his two martyr companions, Alfonso Rodríguez and Juan del Castillo, were beatified.

In 1960 Roque's heart and the tomahawk were returned to Paraguay and are now simply enshrined in the Chapel of the Martyrs in Colegio Cristo Rey, Asunción. On a nearby wall, a marble plaque lists the names of twenty-three other Jesuit missioners who were martyred in the area, none of them, of course, by the Guaraní

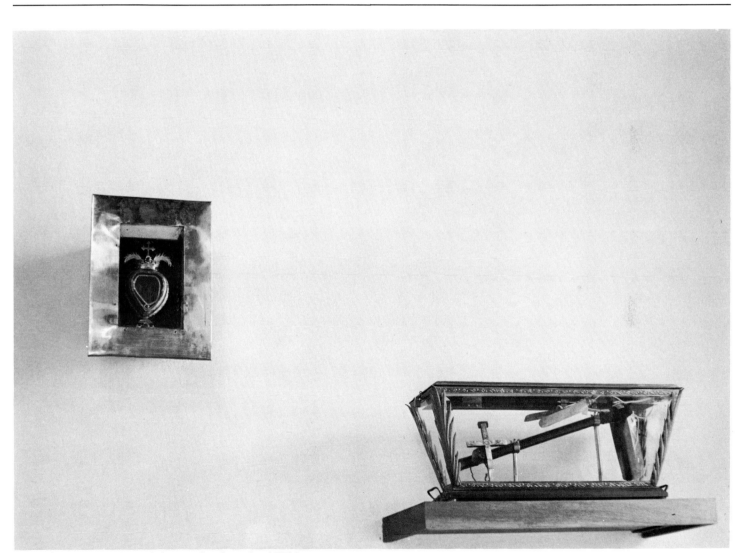

Heart of Roque Gonzalez and the tomahawk used to kill him Chapel of the Martyrs, Colegio Cristo Rey, Asunción

Indians of the Reductions, but rather by Paulistas or hostile Indians from other tribes. My colleague, Antonio González Dorado has recently published precise, unadorned accounts of all the Jesuit martyrs of Paraguay.

Ruiz de Montoya and Roque González were by no means the only notable personalities among the missioners who served the Reductions. In his monumental work *Misiones y Sus Pueblos de Guaranies*. Guillermo Furlong Cardiff lists together with Ruiz and Roque, 104 other men whom he describes pithily as "Some of the Great Missioners."

While the majority of the missioners were Spanish, given the fact that the Reductions functioned within the Spanish empire and each of the missioners had to receive governmental approval, among the most eminent were surely Anton Sepp, Bernard Nussdorfer, Sigismund Aperger, Martin Dobrizhoffer, Thomas Fields, Thomas Falkner, Peter Pole, Jean Vaisseau, Nicolas du Toit, Gianbattista Primoli, Giuseppe Brasanelli, and Domenico Zipoli — variously, German, Austrian, Czech, Belgian, French, Irish, English, and Italian. This was surely as international a team as has ever worked together on a remote and hazardous venture.

This is not to suggest, of course, that all of the men were of equal stature. But it must be remembered that for a task of such herculean difficulty as the Paraguay missions, only persons of tested spiritual and psychological quality could be selected. Bruxel points out that some fourteen thousand young Jesuits volunteered for work in Paraguay and their names can still be found in the Jesuit archives in Rome. But only a few hundred would be chosen for the one-way, fearsome journey. According to Hugo Storni's recent research, 1,565 Jesuits altogether worked in the Paraguay Province before the expulsion. Most, though not all of them, were born in Europe.

**Monogram of the Society of Jesus, stone carving
San Ignacio Mini, Argentina**

The exact number of men selected for work in the Reductions has not been calculated.

This work required incredible physical and psychological stamina, not to mention intense spiritual dedication. No mere youthful idealism or enthusiasm would carry one beyond the preparatory stages. For one thing, before being sent, one had to demonstrate proficiency in the complex, agglutinative Guaraní language which even with modern linguistic techniques remains enormously difficult for those who were not brought up on it.

Nor can the material hazards of life on a foreign mission be easily exaggerated. The quality of life in the tropics is marginal by most standards, with multitudes of mosquitoes, assortments of diseases, and the like. Yet Furlong points out that during more than 150 years of the Paraguay mission, only five or six men had to be recalled: one because he could never master the language, another because of "melancholy," and two for reasons of insomnia or downright fear of the ever-menacing Paulistas. Almost all who went out to serve in the missions remained there for the rest of their lives.

Even a vivid imagination is not always capable of grasping another vexing problem associated with life in the Reductions, that of physical distance. When I glanced at the National Geographic Society's map of the area of the missions, I had no true realization of the spaces involved, even the distance between one Reduction and its nearest neighbor. Though roads were probably better then than they are today, it is not easy, even with a jeep, to reach Santa María from relatively nearby Santa Rosa. It is hardly less difficult to travel from one ruins to another in Argentina.

Ruins of the church, Santa Ana, Argentina

Still more wrenching must have been every migration of a Reduction to a new site. How much sensitive diplomacy and sheer coaxing must have been required every time a Reduction became too large for what was considered to be the ideal size for a good community? Several chieftains and their families would have to be presuaded to emigrate and found a new settlement.

Another very real difficulty for the Jesuit missioners must have been that of working on an international team. Anyone who has lived in a community of men or women where a majority belong to a different nationality knows that however enriching the experience may be, it is hardly an unmitigated picnic. A letter which I happened to run across brings out, almost humorously, some of the feelings of Brother Joseph Klaussner. Writing from Córdoba to his compatriots in Munich, he mentions in passing: "Though this is a big city and our college even bigger than yours in Munich, I find no sort of real craftsmanship here. In part I attribute this to ignorance and in part to laziness. The Spaniards have little love for manual work, which they leave to foreigners, mainly to us Germans!" This mild complaint represents, I suspect, only the tip of the iceberg.

Among the ruins of the cemetery in San Ignacio Mini is the inscription, barely decipherable, on the grave of a now anonymous missioner. It reads, *Padre muy grando y muy bueno*, A very great father, and very good. This seems to me to be the appropriate epitaph for many of the missioners who worked in this part of the world and who here gave their lives for God and for the Guaraní Indians.

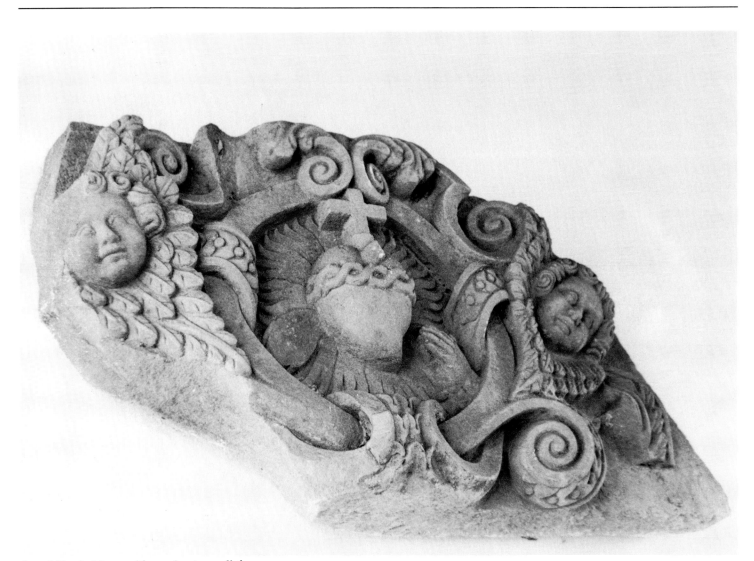

Sacred Heart of Jesus with angels, stone relief
São Miguel, Brazil

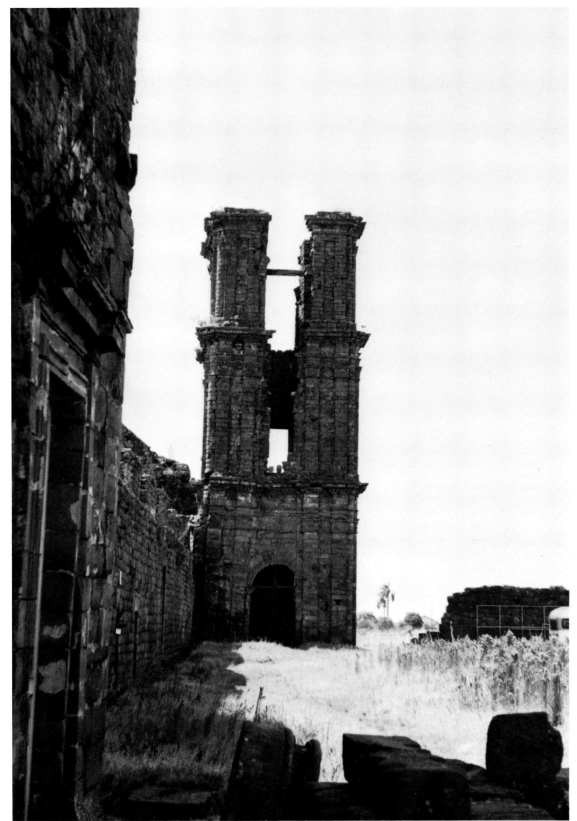

Tower of the church viewed from the rear
São Miguel, Brazil

REDUCTIONS IN PARAGUAY

If this were a history of the Paraguay Reductions, we should quite naturally begin at the beginning. Since it is rather a pictorial record of what remains of the Reductions, we shall simply sketch a brief account to help situate the pictures in an historical and geographical context.

The Jesuit province of *Paracuaria,* the Latin approximation of Paraguay, was established in 1607. This is not an early date in Latin American history, but it is the year Jamestown was settled in Virginia. As we have mentioned above, the first superior of the Paraguayan province was Father Diego de Torres. He was a man of wisdom and experience, and he personally explored a good part of the territory for which he was responsible.

De Torres arrived in Asunción toward the end of 1609. The diminutive capital at that time had only 650 inhabitants. The provincial met with the governor there, Hernando Arias de Saavedra, more commonly known as Hernandarias. The governor was a native-born South American and a person of rare sensitivity. Together with Bishop Reginaldo de Lizarraga, the provincial and the governor worked out a division of labor.

Broadly speaking, the Tebicuary River served as a convenient line of demarcation for the missionary orders. While the Franciscans, Dominicans, and Mercedarians continued to work near Asunción and in the villages west of the river, the Jesuits undertook mission work among the Guaraní Indians in the undeveloped area between the Tebicuary and the Paraná Rivers.

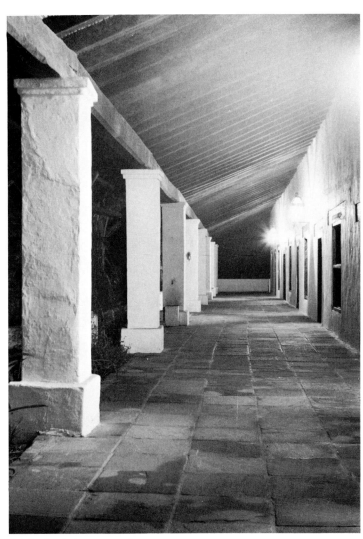

Original *galeria* or veranda
Museum of San Ignacio Guazú

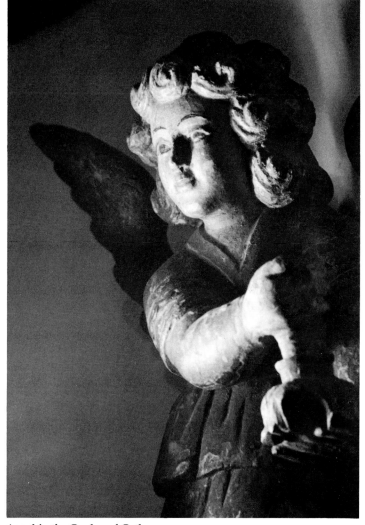

Angel in the Garden of Gethsemane
Museum of San Ignacio

The northeast territory known as Guairá, roughly 450 miles from Asunción, included what later became part of the Brazilian state of Paraná. This is the area with the waterfalls where the giant Itaipú hydroelectric dam is now located.

The area just northwest of Asunción was inhabited by the warlike Guaycurú Indians.

The Paraná region to the south and east of Asunción later became known as the land of the Thirty Cities. It was also known as the Guaraní-Jesuit Republic or simply the Paraguay Reductions.

Fathers Giuseppe Cataldini and Simone Mascetti were the first Jesuits to go to the northeastern Guairá territory and they were later joined there by Father Ruiz de Montoya. Their story is linked with that of the later Reductions.

Fathers Vicente Griffi and Roque González were at first sent to the Guaycurú Indians living northwest of Asunción. But their mission met with so little success that after two years they withdrew and went to work among the Guaranís between the Tebicuary and the Paraná Rivers.

From the beginning this latter area proved to be exceptionally fertile for missionary efforts. Even while Torres, Hernandarias, and Lizarraga were conferring, a leading Guaraní cacique or chieftain named Arapizandú arrived and announced that he and "many other caciques" wished to have priests and wanted to be instructed in the Christian faith.

On December 16, 1609, Fathers Marciel Lorenzana and Francisco de San Martín accompanied Arapizandú to his

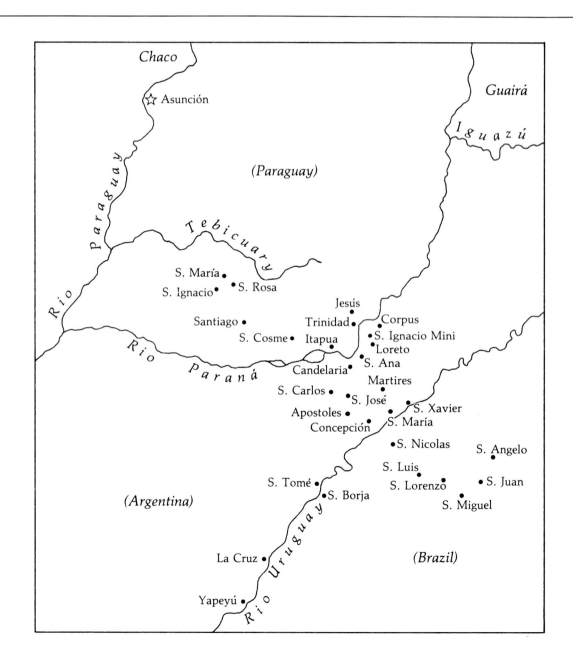

rancho across the Tebicuary River. They arrived there on Christmas eve. Within a few days they were able to improvise a chapel and they celebrated the first Mass in the area on December 29, 1609, the feast of St. Thomas of Canterbury. In 1610 the mission was officially established and named San Ignacio. Father Lorenzana is credited with founding this mission, though "Beato Roque" is naturally better remembered there.

Roque, in fact, was to arrive in San Ignacio the following year, in 1611, after his fiasco among the Guaycurús. In addition to teaching the Guaranís the elements of the Christian faith, he personally taught them how to farm and raise cattle. In 1613 he wrote, "We now have about 40 head of cattle, about the same number of sheep, and 14 goats." That same year he managed to get a school going, "instructing the Indians in reading, writing, and arithmetic." This twofold insistence on a stable food supply and on education would be characteristic of all the Reductions.

San Ignacio, called "Guazú," the Guaraní word for "big," was not originally located on the site where it stands today on Highway 1 between Asunción and Encarnación. It was probably situated at or near the present village of Santa Rita. In 1628 the population moved, perhaps to the place now occupied by Santiago. Finally, in 1667, San Ignacio moved again to its present site.

It should be no surprise that nothing remains today of the original buildings of San Ignacio Guazú, nor indeed of any of the very early Reductions. Life

Saint Ignatius Loyola, detail of statue
Museum of San Ignacio

Guardian Angel, detail of statue
Museum of San Ignacio

there, as in other frontier settlements of the world, was largely a matter of survival, not of permanent architecture. Again and again the quest for better lands or the desire to escape the raids of the Paulistas dictated a change of location.

To the north, in the Guairá country, just a few weeks after Lorenzana had founded what was to be San Ignacio Guazú, Fathers Cataldini and Mascetti established the Reductions of Loreto and another San Ignacio, this one called "Mini," the Guaraní word for "little." The latter was officially

dedicated on July 31, the feast of Saint Ignatius, in 1612.

As we have mentioned above, these last two Reductions would later be transferred by Ruiz de Montoya to just about their present locations on the Paraná River. Ruiz also helped to found eleven other Reductions in the Guairá area, but all of these were later destroyed by Paulista attacks. Thus it is that in the list of founders of the Thirty Cities given by Bruxel, the great missioner, Ruiz de Montoya, possibly the greatest in Paraguay, does not appear at all.

SAN IGNACIO GUAZU

The church of San Ignacio Guazú which was completed in 1694 survived in a somewhat dilapidated condition until 1911 and then totally collapsed in 1921. Perhaps it should be pointed out that in the early twentieth century there were no Jesuits in Paraguay. They were to return, after several expulsions, only in 1927.

We have photographs both of the interior and the exterior of the church of San Ignacio Guazú. They suggest that it somewhat resembled the

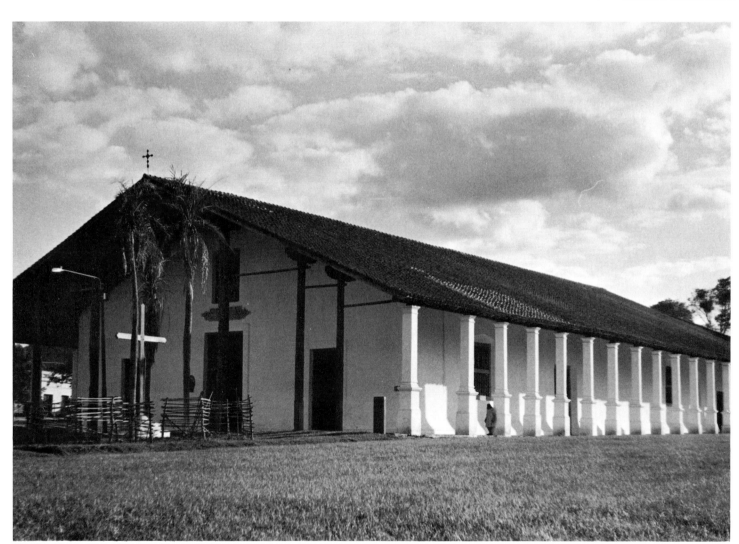

The Franciscan-style church at Yaguarón, Paraguay

splendid Franciscan-style church which stands today at Yaguarón on Highway 1 between Asunción and San Ignacio. The interior of the church was of wood. The ceiling contained some sixteen hundred paintings which are now gone, some irretrievably scattered in private collections, others simply destroyed. An idea of what this church looked like may be obtained from three faded photographs which appear in Alejandro Brugada Guanes' volume *Paricuaria;* the originals are exhibited in the museum of San Ignacio.

"Fine Museum in San Ignacio" was the headline of the November 28, 1980 edition of *Radio So'o,* an American weekly newsletter published in Asunción. The article read as follows: "San Ignacio? Who ever heard of San Ignacio, much less a museum there? We were a little skeptical when C. J. McNaspy, the Jesuit who narrated the documentary film on the Jesuit ruins, told us to stop off at San Ignacio on our way to Encarnación and the ruins of Trinidad. 'It will only take you about a half hour to see the whole museum, but it is the finest small collection of

indigenous art from the Jesuit period in existence,' he told us. 'There aren't many pieces left,' he explained, 'because most have disappeared into private collections long since.'

"Well, we did stop off, pushing our skepticism aside, and were delighted with what we found. The museum is in the block next to the church which can be seen from the highway. It is located in a beautiful old colonial building, which the American priest there, Father Charles Thibodeaux, was quick to tell us is the oldest building in Paraguay.

Statue of the Child Jesus called "Alcalde"
Museum of San Ignacio

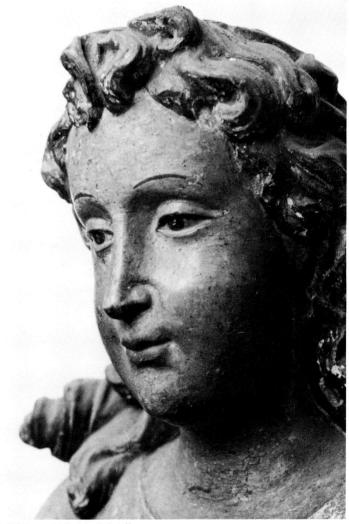

Child Jesus "Alcalde," detail
Museum of San Ignacio

"Made from mud and strong wooden beams, its thick sparkling whitewash walls provide an interior that is cool in the summer and warm in winter. The pieces in the collection are for the most part statues of saints painted in gay polychromatic patterns. The work, all done by the Indians under the tutelage of the Jesuits, is of the highest artistic standards. None of the crude, somber, disproportionate work found in the Andean Indian art from the colonial period. These are smiling saints, bright cheery, happy works of art, obviously reflecting the spirit of the artists themselves.

"A visit to San Ignacio is the perfect cap for a visit to the Jesuit ruins of Paraguay."

While I would take exception to some details in this unsigned appraisal, I find its enthusiasm is well founded. The quip, "museum-mausoleum" has some validity for many museums. The small museum of San Ignacio is a happy exception. True, the statues are not set in their original locations, nor do they fulfill their original functions, save for the reredos in the small chapel which is still used as it was originally intended. I may mention in passing that the high altar in the cathedral of San Juan Bautista, a few miles from San Ignacio, was originally the altar of the chapel on a farm which served the San Ignacio Reduction.

The San Ignacio museum is, in fact, a recent creation. In his *Paracuaria* (1975), Guanes laments "the precarious state of the old *colegio* with its statues, retables, and pulpits in a bad state of preservation and crying for restoration." When I first visited San Ignacio in 1976, the work was

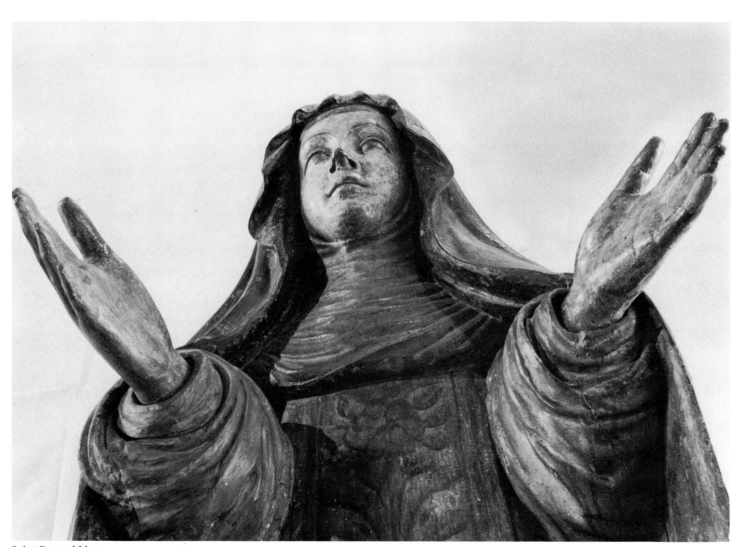

Saint Rose of Lima
Museum of San Ignacio

just under way, thanks to the Paracuaria Foundation; it is now a gem of tasteful arrangement.

Upon entering the museum one sees a large stone plaque, a copy of the one in Cristo Rey Chapel of the Martyrs in Asunción. It bears the names and dates of the three martyrs of Paraguay who have been declared "blessed" by the Church: Roque González, Alfonso Rodríguez, and Juan del Castillo. Then follow the names of twenty-three other martyrs not yet beatified. Their diverse national origins are once again typical of the missioners: two were natives of Asunción, one was an Argentine, one a Peruvian, one a Bolivian, two were Italians, one a German, one Hollander, and of the twelve others, we find representatives of most of the regions of Spain: Catalonia, Castille, Andalusia, the Basque country, the Balearic and Canary Islands.

The rooms in the museum are arranged to suggest a spiritual journey or pilgrimage. The first room is devoted to themes of Creation: a pulpit suggests the Word of God and stresses the name of Jesus (IHS). On the retable that once graced San Ignacio church, one sees reliefs of fruit and other gifts of creation. A child led by an angel points to the creation of mankind. The battle of good and evil is depicted by St. Michael as he defeats Satan.

Pulpit, detail of wood carving
Museum of San Ignacio

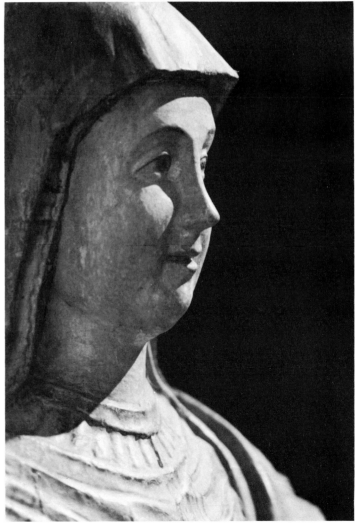

Virgin Mary meeting Jesus, detail of statue
Museum of San Ignacio

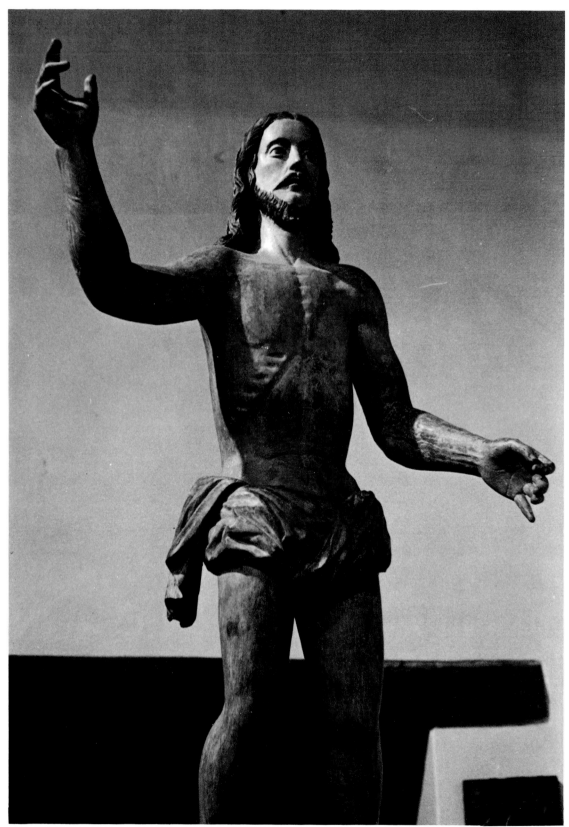

Risen Christ
Museum of San Ignacio

The theme of the second room is Redemption, the sufferings and death of Christ and His resurrection. Mary is presented as sharing in the joy of the risen Christ.

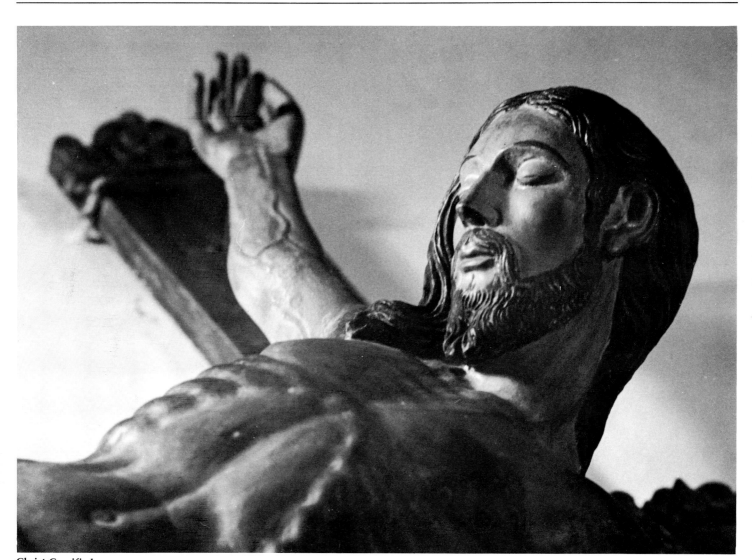

Christ Crucified
Museum of San Ignacio

The third room continues the history of Christ in the Church. Here the focus is on Mary, Mother of Jesus, with her mother, St. Anne. St. Peter, with the keys of the kingdom, is the rock upon whom the church was founded. St. Paul, the Apostle of the Gentiles, is portrayed pointing to new lands and holding the book of Epistles and the sword of martyrdom. Saints Francis and Dominic represent the great medieval orders and missioners, while a female saint (variously identified as St. Theresa of Avila or St. Rose of Lima) suggests the contemplative vocation.

In accord with this progression of church history, the fourth room is dedicated to the Society of Jesus. It focuses on a statue of St. Ignatius, founder of the order and patron of the mission. I find this a remarkable statue, perhaps my favorite among the many I have seen of St. Ignatius in Europe and Latin America. The emblem, IHS, the first three letters in the Greek name of Jesus, is placed on Ignatius' heart. This composition expresses the saint's mysticism in a remarkable baroque vision. He was a "contemplative in action," to use the traditional phrase.

Josefina Plá, Paraguay's leading connoisseur of Reduction art, is also particularly fond of this statue. She writes: "It is an eloquent work. The saint, in a dynamic attitude, gathers the folds of his mantle with his left hand, pointing with his right to the emblem IHS. The face of Ignatius is serene but energetic. In his features there is no ecstasy but the tranquil energy of one who has penetrated the depth of his mission, and while remaining in God's presence does not leave that of man. There is no haughtiness, but the convinced radiance of one totally given to the Lord's greater glory."

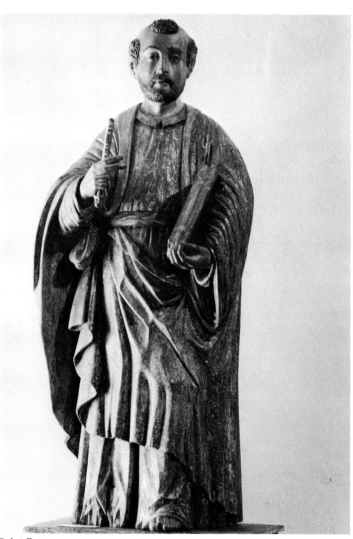

Saint Peter
Museum of San Ignacio

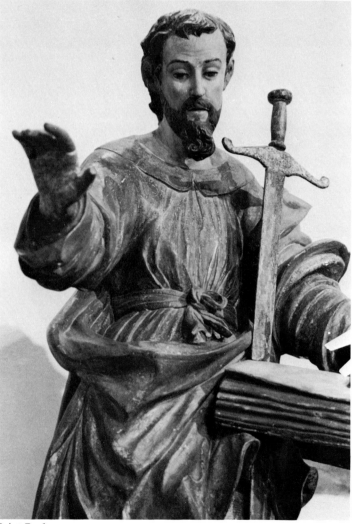

Saint Paul
Museum of San Ignacio

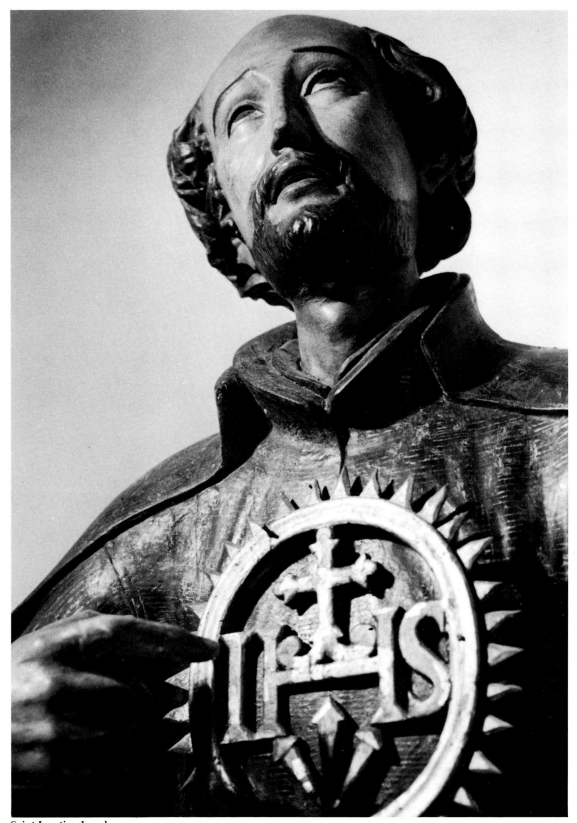

Saint Ignatius Loyola
Museum of San Ignacio

Other Jesuit saints portrayed in this room of the museum are Francis Xavier, the Society's first missioner, Francis Borgia, the superior who launched many missions, and Stanislaus Kostka, the young Polish nobleman who died while still a Jesuit novice. Several interesting documents, including pages superbly copied by Indians, and a 1635 letter from King Philip IV, are enclosed under glass. Large copies of early mission maps and a photograph of the original mission church complete this room.

While not all of the exhibits are of equal artistic quality and are surely not the work of a single sculptor, most of the statues here are genuinely representative of the baroque style as described later in this book and encapsulated in our Glossary. The restorations done by the Chilean artist Tito González and sponsored by the Paracuaria Foundation are of major importance to our theme. The Paricuaria Foundation is headed by Dr. Paul Frings, and much basic work was done by Paraguayan architect Bernardo Ismachovicz. The latter has cataloged all the Reduction statues.

The building in which the San Ignacio museum is housed is actually a wing of the original *colegio*. This building had many rooms and served a multitude of functions in the mission. It contained classrooms, storerooms for liturgical vestments, a library, living quarters for the missioners, guest rooms, and the like. The *colegio* always flanked the church which was always the heart and center of the Reduction. The church was located not at the middle but at the "top" of the plaza. Commercial

Saint Paul, detail of statue
Museum of San Ignacio

Saint Stanislaus Kostka with Child Jesus
Museum of San Ignacio

visitors, occasionally admitted for a short time, were apparently housed on the outskirts of the Reduction.

One mission guest, the French Capuchin priest Florentin de Bourges, left an eyewitness account of his visit to the Reductions in 1716. On his way to Pondichéry, India, while stopping off in Buenos Aires, he decided to venture across the continent to Chile and visit the Jesuit Reductions on the way. I came across his letter in a library in Lima, Peru, and would like to quote it here as a corrective to the notion sometimes expressed that the missioners lived in palatial comfort while the poor Indians lived in squalor.

Florentin de Bourges writes: "The Guaraní Indians make wonderful Christians, since there are no Europeans living among them!

"Some of the older Jesuit missioners, who told me they were 'resting,' were doing as much work as three priests together in Europe.

"Back in Europe I had heard a great deal of praise for the Jesuit missions, but now that I have seen them with my own eyes, I must say that they surpass their fame.

"The Jesuit house itself is simple, with no ostentation. The church, however, is done gorgeously and in polished stone, done with such art by the Indians that the church could be held in honor in any European city."

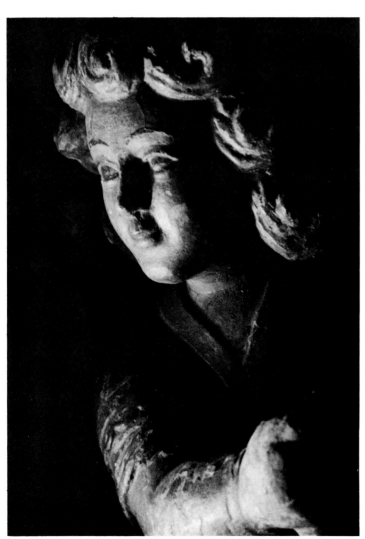

Angel in Gethsemane, detail of statue
Museum of San Ignacio

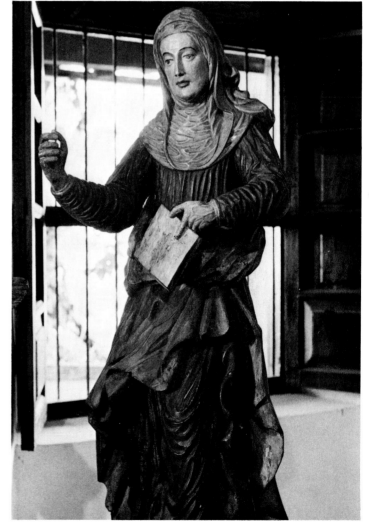

Saint Anne
Museum of San Ignacio

SANTA MARÍA

A few miles off Highway No. 1 is the Reduction of Santa María. It had first been established in 1647 by Father Emmanuel Berthod and refounded here in 1669. Berthod was a Frenchman devoted to the famous image of Notre Dame de Foy in his native country. Hence the full Spanish name of this mission was Santa Maria de Fe. *Foy* and *Fe* both mean "faith." I have read glowing accounts of the church by people who saw it in its glory. It was destroyed by fire, however, as recently as 1889.

Happily, a good number of statues were preserved from the original church of Santa María and can be seen in the present church.

In 1980 the Paracuaria Foundation began a tasteful restoration of a block of houses once occupied by the Guaraní Indians in Santa María. The houses were in fair condition and purchased thanks to generous benefactions from people in Hays, Kansas who had "adopted" Santa María in a "sister city" relationship.

Mrs. Ross Beach of Hays assisted graciously in the complex work involved. Actual reconstuction was done under the direction of Jesuit Brother Antonio Fernández Mateo. Mateo is a many-faceted builder reminiscent of the brothers who built many of the early Reductions. In 1981 I was privileged to observe Brother Mateo at work directing local personnel who were probably descendants of the Guaranís who did the first construction. Patiently teaching by example, Mateo prodded the Indians into an achievement of real quality.

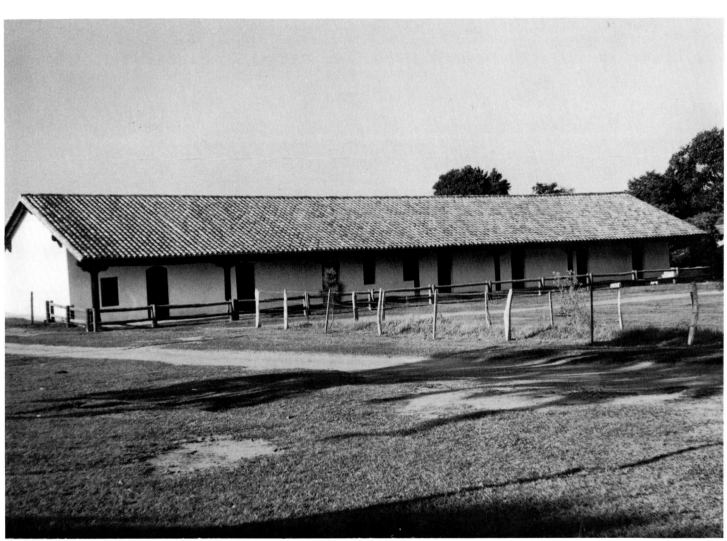

Restored Indian houses currently housing the Reduction museum
Santa María

They used precisely the same materials and tools used in the seventeeth century. The tile roofing is from the original Reduction. It was cleaned and restored to such splendor that I immediately thought of it as a work of Op Art.

This restored building now houses a museum which contains many of the finest statues preserved anywhere in the missions. The new museum rivals that of San Ignacio, while offering a pleasant complement and something of a contrast. Santa María's statues are different, and the setting of the museum, right off the plaza that is still in use, is very much like it was in the days of the Reductions. True, the town is far poorer than San Ignacio is today, and it is less humanly comfortable than it had been as a Reduction. For one thing, today's water supply is precarious.

The theme of the Santa María museum may be broadly described as Christocentric. The statues are arranged roughly as follows. First, a nativity scene, the infant Jesus with Mary and Joseph. The Three Wise Men are there too, still the object of popular devotion in Paraguay. There are also scenes of Christ's sufferings and His resurrection. Another room focuses on Christ as the center of the apostolate. There is an unusual number of statues of the apostles here. The prolongation of Christ's life and work in the Church appears in another room. Christ is shown surrounded by several founders of missionary orders. And, unsurprisingly, there is a room filled with Jesuit saints surrounding the figure of Jesus.

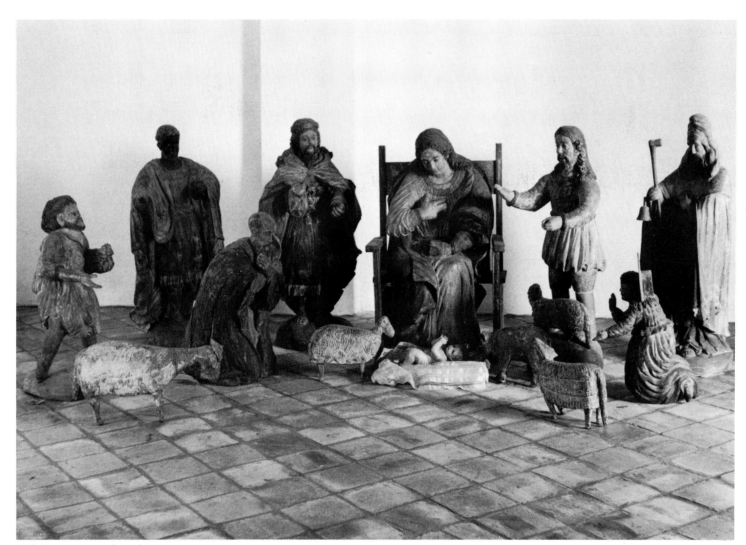

Nativity scene, wood carving
Museum of Santa María, Paraguay

To repeat once again, the original structure which survives here gives the lie to charges about the Indians being forced to live in hovels. We have, moreover, document after document which indicate that, as far as possible, the tastes of the Indians were respected. The phrase often used is, "*como gustaren los Indios.*"

Before the Jesuits came to Paraguay, the Guaranís, still semi-nomadic, often lived in log cabins about 15 feet wide and sometimes as much as 150 feet long. These were covered with palm branches and housed a number of related families. While accepting this strong community orientation, the missioners taught the Indians to subdivide their new homes into semi-private dwellings for single families. Doors opened onto covered *galerias*, providing sheltered areas for easy communication. Ramón Gutiérrez points out that, though few studies have been made on the subject, the internal structure of the Reductions was related to the social and political structure of the tribes with their caciques or chieftains. And so real "neighborhoods" existed within each Reduction.

Thus the charge of "barracks style" living takes no account of the communitarian, tribal character of Guaraní society. So little had privacy been reckoned a value that even a rudimentary sense of private property was something that had to be acquired. Even today we foreigners who live in Paraguay are struck by the

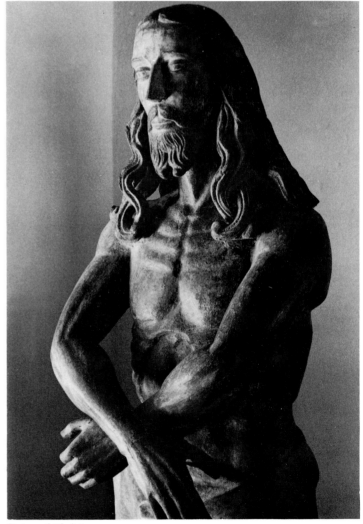

Detail of Virgin, Nativity scene
Museum of Santa María

Statue of Christ
Museum of Santa María

strong sense of community that exists among the people. Neighborhoods, especially in the poorer areas, seem almost like one big family. People walk freely into their neighbors' houses. Celebrations, serious illnesses, and deaths are extraordinary rallying points. Again and again my neighbors have summoned me to assist the ill or the dying, quite spontaneously. The traditional drink, *yerba mate,* sometimes called "Jesuit tea," is normally drunk in community with everyone sharing the same straw or *bombilla.* At first this startles the foreigner, but we learn. As far away as Porto Allegre on the coast of Brazil, I have seen blond German-speaking people quaffing *mate* on a *bombilla* and I have readily joined them.

While no Reduction remains at all intact today, we still find hundreds of Indian houses, grouped in sixes and joined by covered *galerias,* still used in the towns of San Ignacio, Santa María, San Cosme, and especially Santa Rosa.

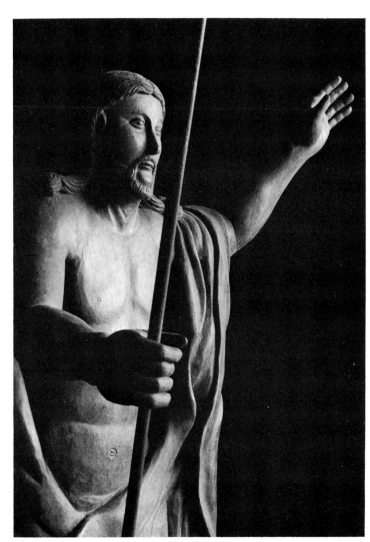

Risen Christ
Museum of Santa María

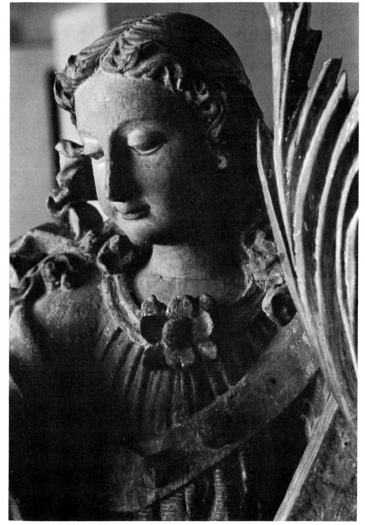

Saint Barbara, detail of statue
Museum of Santa María

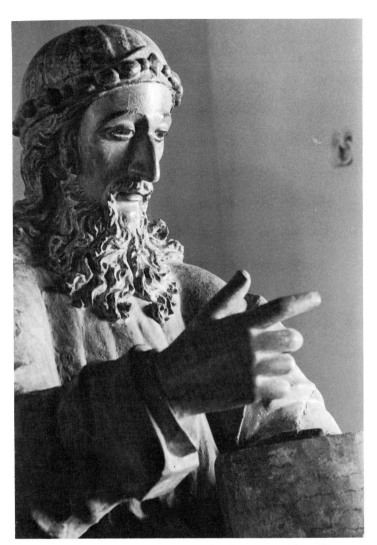

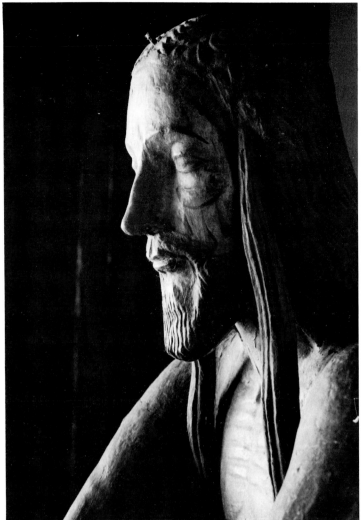

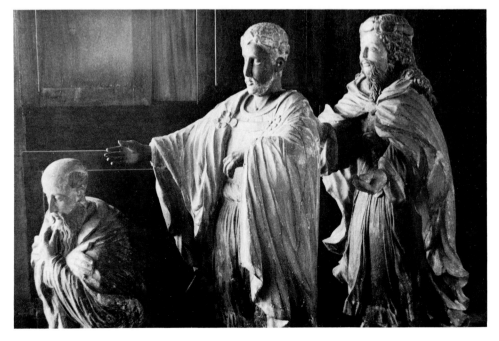

Above left: Saint Joachim, detail
Above: Christ at the Pillar, detail
Left: Wise Men, Nativity scene
Right: Christ at the Pillar
All in Museum of Santa María

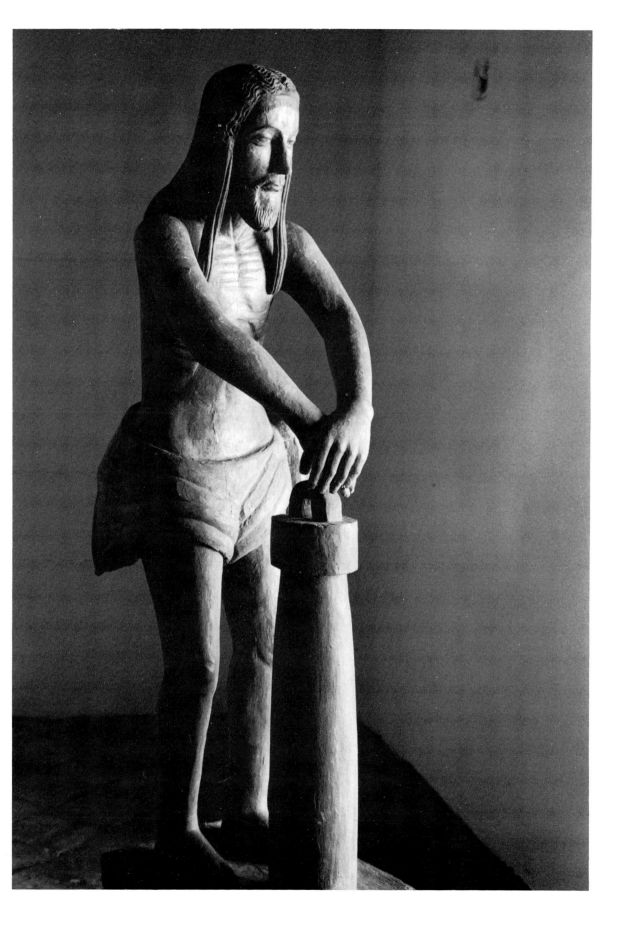

Left: **Christ on Palm Sunday**
Below left: **Saint Francis Borgia**
Below: **Saint Francis Xavier**
Right: **Virgin with Child Jesus**
All in Museum of Santa María

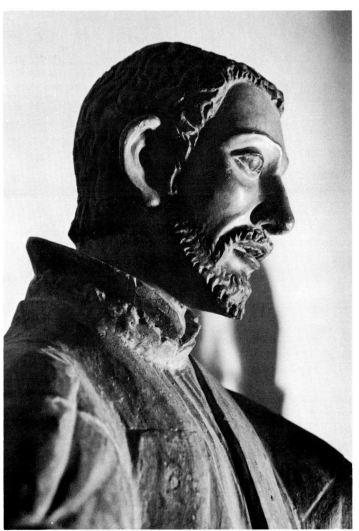

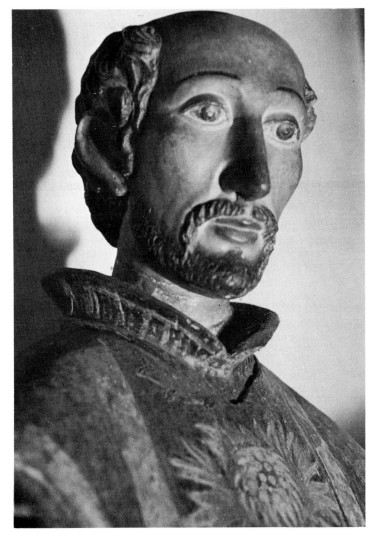

54

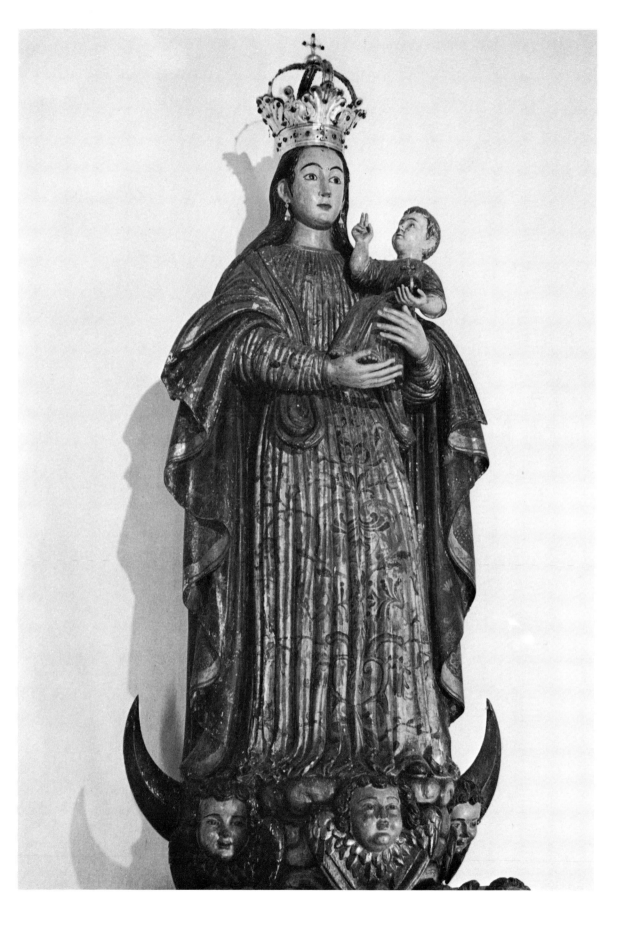

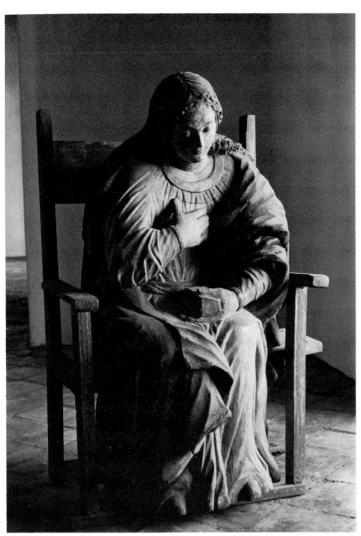

Virgin Mary, Nativity scene
Museum of Santa María

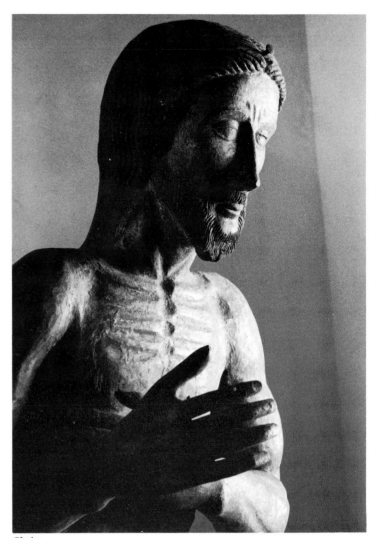

Christ
Museum of Santa María

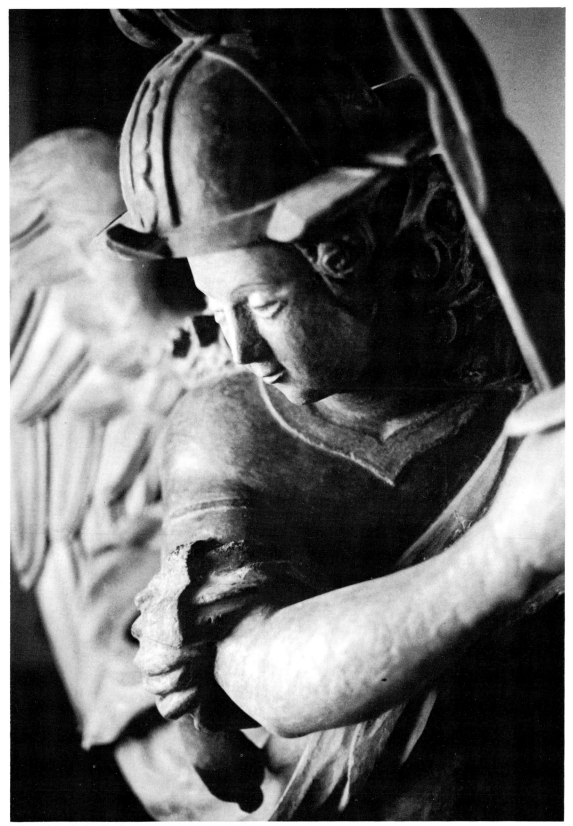

Saint Michael, detail of statue
Museum of Santa María

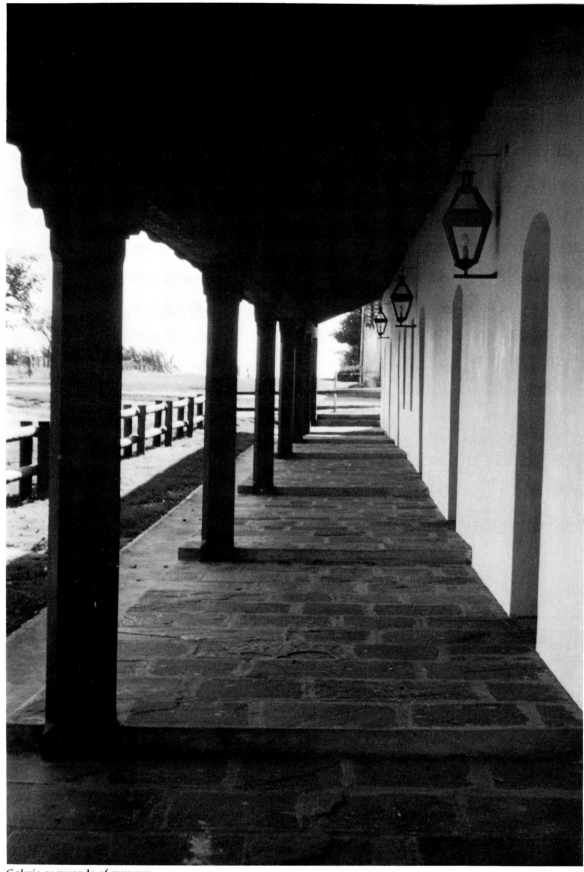

Galeria or veranda of museum
Santa María

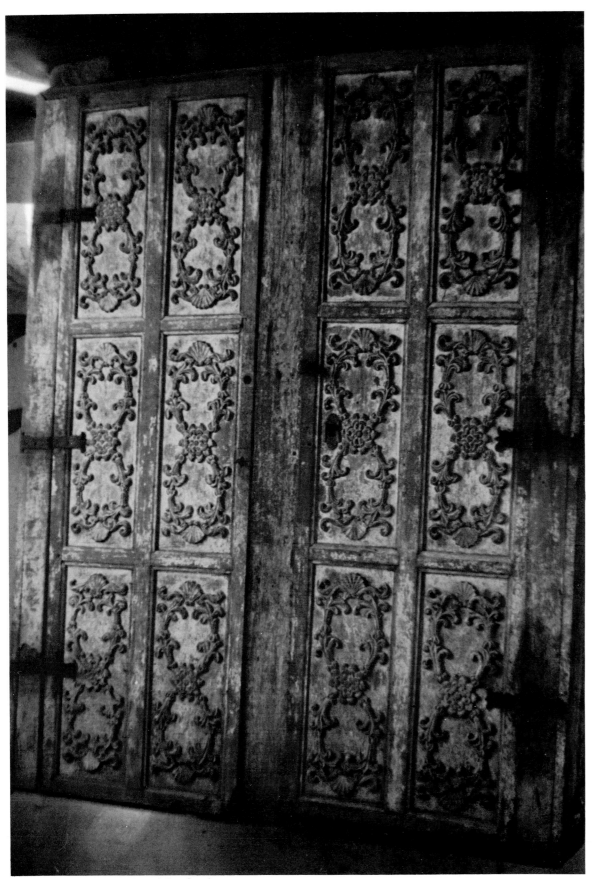

Closet door from the sacristy of the church
Museum of Santa María

SANTA ROSA

Named after the popular Dominican St. Rose of Lima, the town of Santa Rosa forms a triangle with San Ignacio and Santa María and surpasses both in charm. It also gives a sense of the Reductions as they once were. As recently as 1860, travellers described Santa Rosa in terms that seemed exaggerated. The mission church was destroyed by fire in 1883. Some pilasters from it are included on the facade of the present unimpressive building. But what captivates the visitor is the sturdy old tower of red stone which is still used as a belfry.

The only distinguished feature of the present church is the reredos behind the main altar. It was originally on a side altar, but it is impressive enough to serve as a main altar decoration. It was saved from the fire of 1883.

Next to the church is an interesting chapel dedicated to Our Lady of Loreto. Even in their state of deterioration and partial restoration, the original murals in this chapel retain a certain flavor from days gone by. The sculpture group of the Annunciation is deemed by Bartolomeu Meliá to be "among the great works of hispano-american baroque, while in other statues there appear the perfection and sensitivity of Guaraní artisans."

Perhaps more enlightening to the visitor is the long block of houses, to the right as one faces the church. These flank the entire plaza and are linked by a *galeria*. Again the architecture is functional, with thick walls and tiled roofs providing shelter against heat and cold. This is better adapted to Paraguay's fickle climate than the modern building I live in. These houses on the plaza are still in use, and a visit to any one of the friendly families carries one back in history.

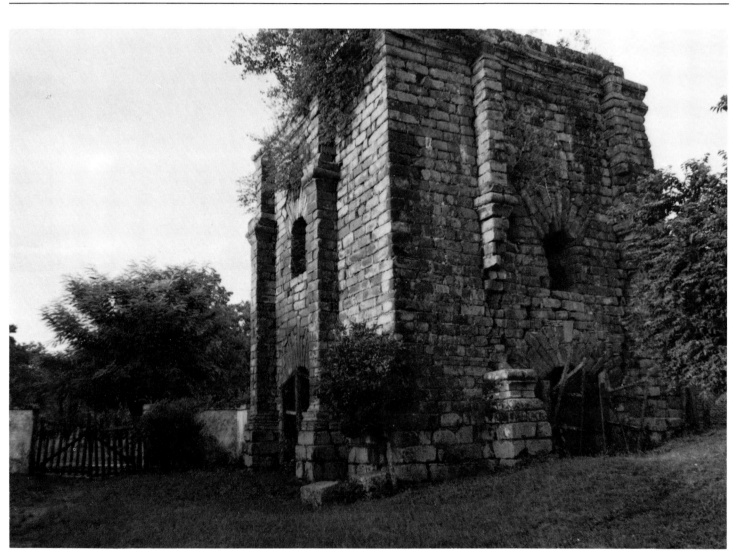

Bell tower, Santa Rosa

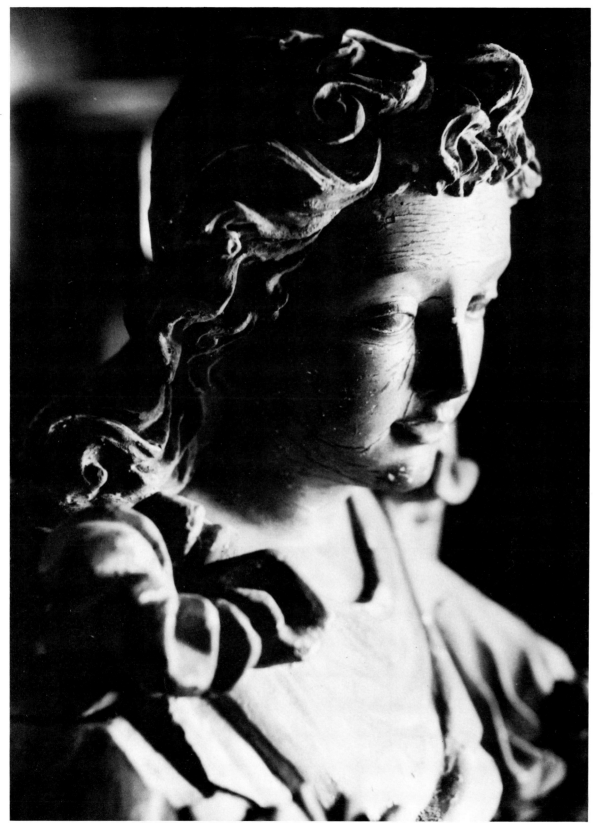

Angel of the Annunciation, detail of statue
Our Lady of Loreto Chapel, Santa Rosa

The plaza of Santa Rosa may be taken as typical. In most Latin American cities the *Plaza de Armas* was or is the focus of city life, both ecclesiastical and civic and often commercial as well. The Reduction plaza was more specifically a *mission* plaza. Ramón Gutiérrez called it "sacral space" because it focuses on the church. This was part of the Jesuit missionary pedagogy, the ritualization of life in the missions which strengthened "the innate mysticism of the Guaranís." We shall discuss this further in a later chapter.

Thus the plaza was like an extension of the church; it served as sort of an atrium to the basilica-style church. The plaza was a place for meetings, processions, and it even served as a center for recreation and for large community meals. One of the missioners, Father José Peramás, mentions that on such occasions "each family would bring food and share it with others." I find the same custom today.

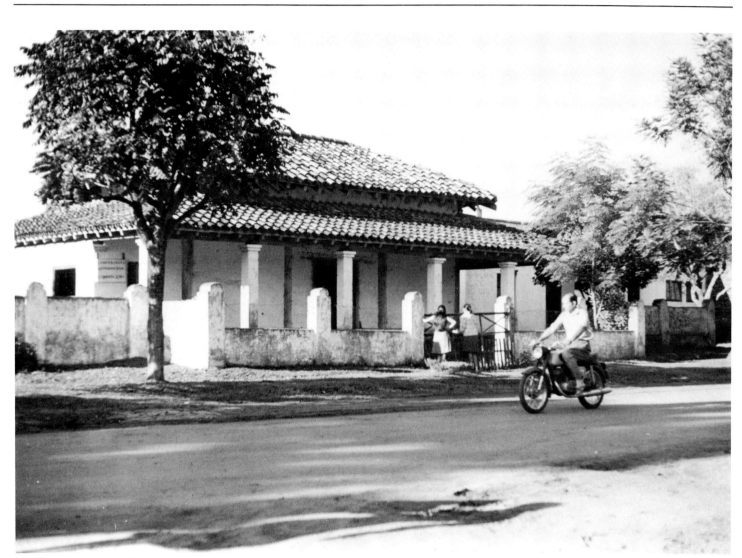

House of Loreto, Santa Rosa

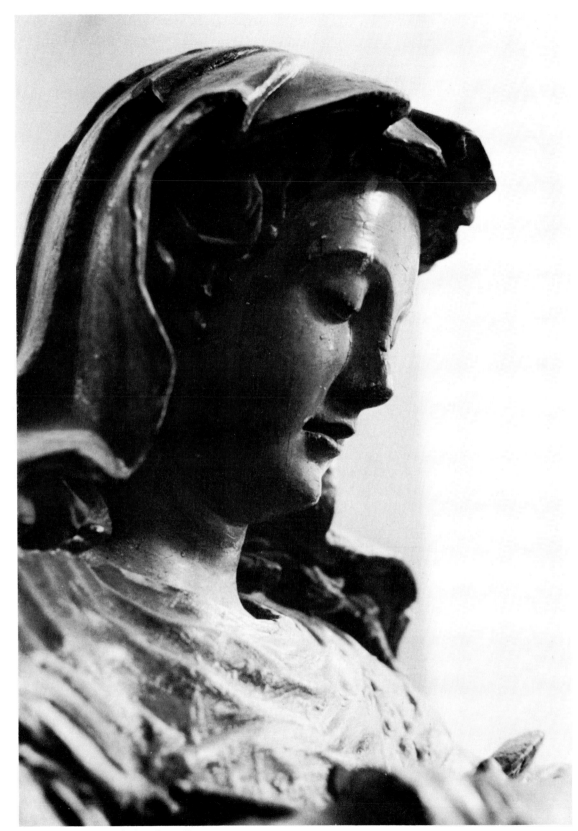

Virgin of the Annunciation, Santa Rosa

SANTIAGO

Santiago is a bit more out of the way, although a new paved road leads from Highway No. 1 to Ayolas and the Yacyretá works nearby. The modern town of Santiago has some seven thousand inhabitants. It has recently appeared in the Asunción newspapers because of its new museum and its status as a former Reduction.

The restoration work, once again, is under the auspices of the Paracuaria Foundation. The parish priest in Santiago, Father Justo Gaona, will happily introduce a visitor to the town's treasures which are at last effectively housed and displayed. The new museum is an almost exact replica of the museum in San Ignacio, except that this one is in a new building and contains only three rooms. Quite impressive and reminiscent of the museum at São Miguel is the large window opening on the ruins of the original Reduction. This helps the visitor to feel in touch with the past.

Santiago is no mere redundancy. Its statuary collection is at least equal to those of San Ignacio and Santa María. The entire crèche, for example, a nativity scene containing many statues, is unique among all which survive. There are, of course, the Jesuit themes. These are expected, but they are present here with a difference. None of this is Saint-Sulpice art. The statue of St. Ignatius, for instance, portrays him during his vision at La Storta, the little chapel near Rome where Christ uttered the encouraging words to Ignatius, ''I will be propitious to you in Rome.''

Unusually interesting, too, are the two statutes of Santiago himself, St. James the Elder. It was quite normal for the Spanish missioners to bring to Paraguay their traditional devotion to St. James their national patron. It is to

Ruins of the Reduction seen from museum
Santiago, Paraguay

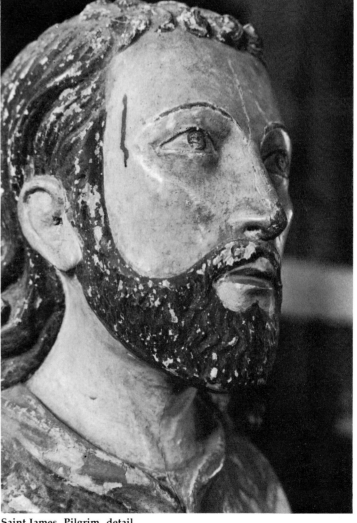

Saint James, Pilgrim, detail
Museum of Santiago

St. James that the incomparable shrine in northwestern Spain is dedicated. Santiago de Compostella is surely one of the jewels of Europe and long a rival of Jerusalem and Rome as a pilgrimage center of the world.

Santiago, under whose aegis many battles were waged in Spain's long effort to recover their country from the Moors, was naturally thought of as the patron of defense against the Paulistas and other menacing forces.

One of the Santiago statues vividly portrays the saint-warrior overcoming the enemy, much as other statues of St. George portray his victory over Satan. I find it curious that in most of Paraguay St. Blase, so venerated in Jugoslavia, is thought of as a national protector. His statue is seen in this museum too.

Yet another popular saint in the Reductions was St. Isidore, San Isidro, the patron of farmers. This is not, of course, the famous Spanish bishop of Seville, called "Isidoro" in Spanish, but a humble laboring man born in Madrid toward the end of the eleventh century. His feast is celebrated in Spanish-speaking countries and in the United States on May 15. The Jesuits may have promoted his devotion not only because he was a model for workers but also because he was canonized in 1622 together with Ignatius of Loyola, Francis Xavier, and Philip Neri.

The Santiago collection of statuary is exceptional, too, for its Flemish influence. The missioners in Paraguay were an international lot and each of the national groups made a distinct contribution. While Madrid was reluctant to admit French or Belgian-

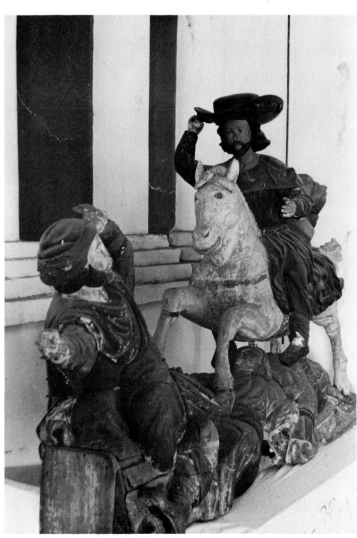

Saint James conquering the Moors
Museum of Santiago

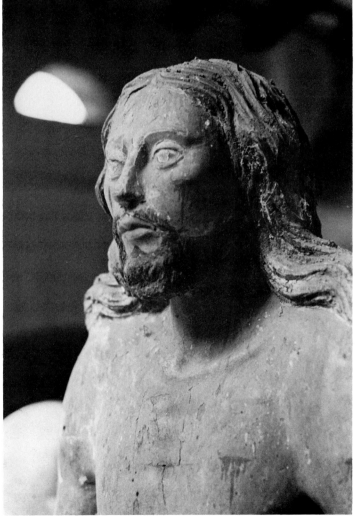

Risen Christ
Museum of Santiago

French Jesuits to its missions—France had aided the Lowlands in their fight against Spain—there was no problem with the Flemish. And as early as 1616 Peter de Boschere from Ghent began to evangelize the Uruguay River area with Roque González.

Other eminent Flemish missioners were Jean Vaisseau and Louis Berger, both musicians; Van de Vyvere, a painter; Adrian Knudde, Nicolas du Toit, Anton Van Surck, Ignace Chomé, and a score of others. Several were craftsmen, but I find it impossible to credit the clearly Flemish style of the statues at Santiago to any particular individual. Seldom if ever did the Jesuits sign their art work. Like much medieval art, that of the Reductions is largely anonymous, often a collaboration between the European Jesuits and the Guaraní Indians.

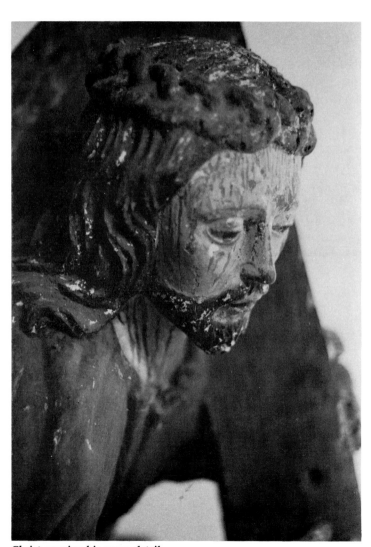

Christ carrying his cross, detail
Museum of Santiago

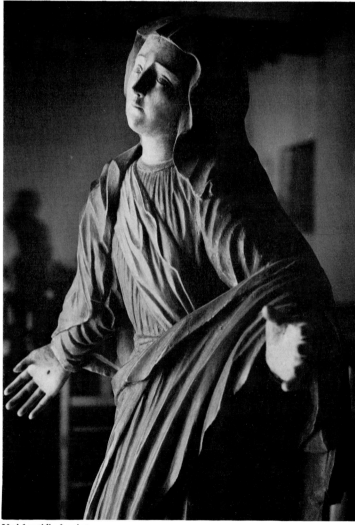

Unidentified saint
Museum of Santiago

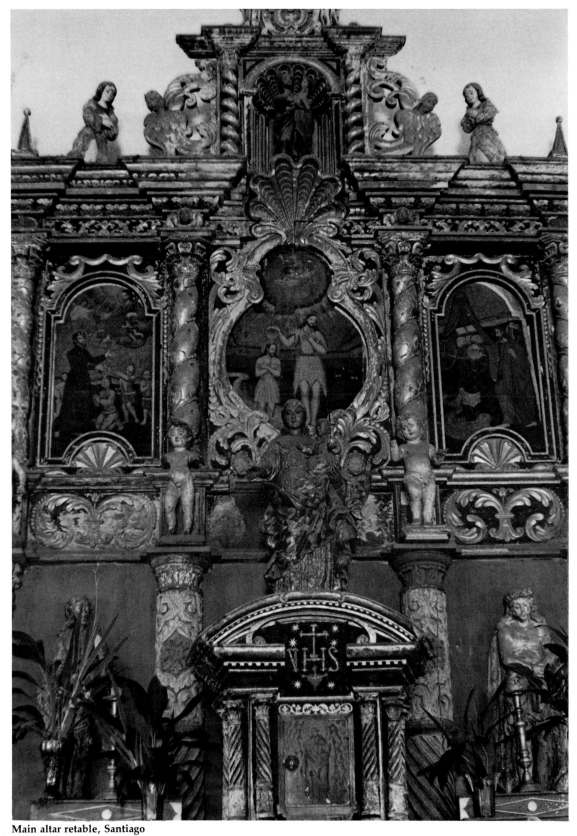

Main altar retable, Santiago

SAN COSME

The Reduction of Santos Cosme y Damián, or more simply San Cosme, offers more architectural interest than Santiago. It was once known, even in Europe, for its astronomical observatory, set up by Buenaventura Suárez. Suárez was famed for his study of the satellites of Jupiter. Today, however, only a sundial remains to suggest that San Cosme was once an important place in the international scientific world.

Even so, the church has been somewhat restored and the wing of the *colegio* is in rather good condition and is used as a workshop for restorations. But if a visitor has little time and must skip some of the ruins in Paraguay, San Cosme, being somewhat off the beaten track, would be the place to postpone for a later visit.

Paraguay's principal port today, Encarnación, was once a Reduction. It was, in fact, one of the very largest Reductions, at one time including almost seven thousand people. Nothing remains today of the Jesuit settlement, though the town plaza does occupy the same site as that of the Reduction. A modern basilica dedicated to the mission's founder, "Beato Roque," is of some minor interest.

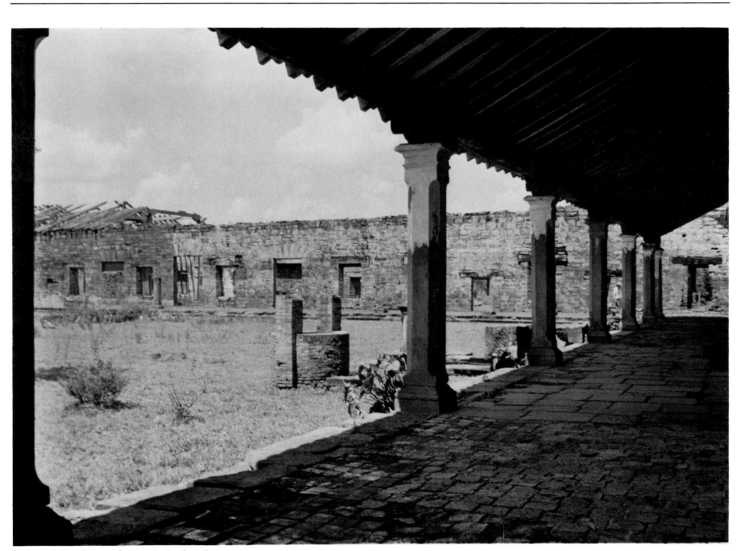

Ruins of church seen from *colegio*, **San Cosme**

Left: **Detail of church doorway San Cosme**

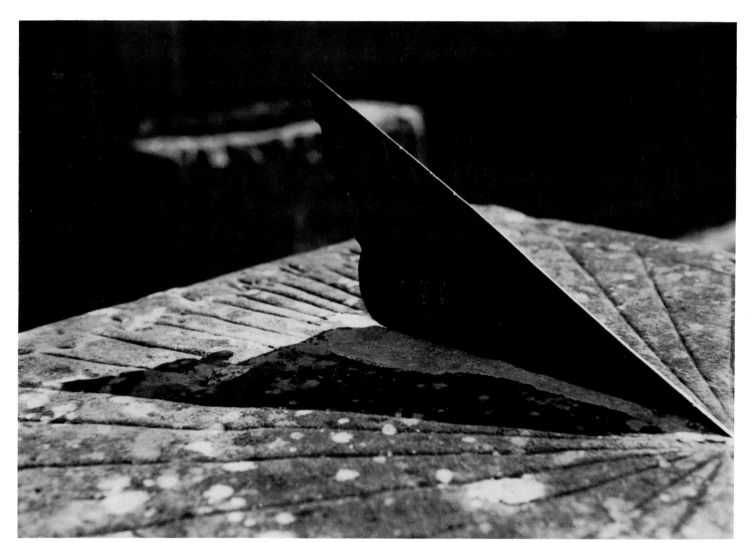

Sundial, San Cosme

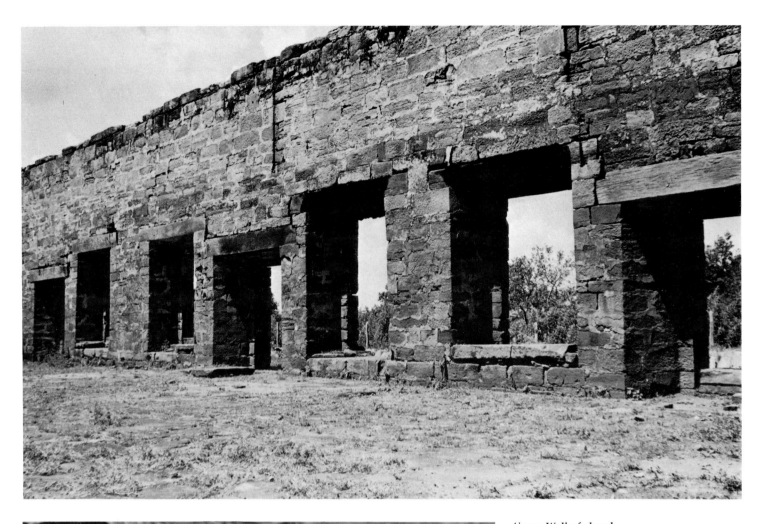

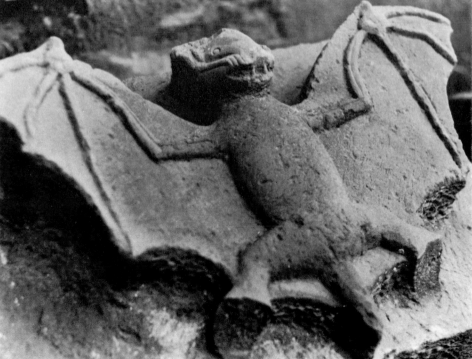

Above: **Wall of church**

Left: **Stone relief of bat**

Right: **Chair, leather covered**

All in San Cosme

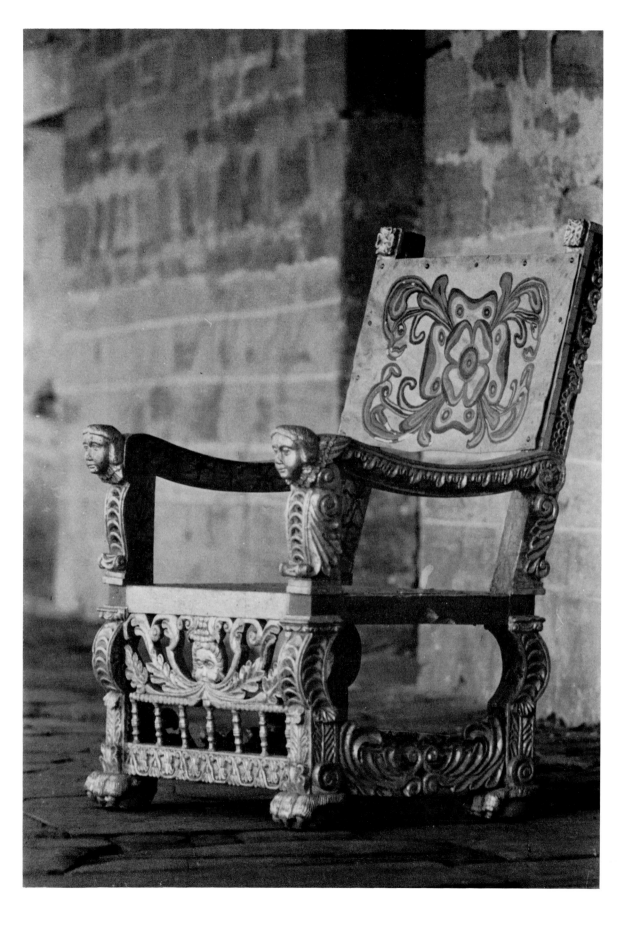

TRINIDAD

To the north and slightly east of San Cosme are the two high points of Reduction architecture still standing in Paraguay, Trinidad and Jesús. They are identified on road markers as *Ruinas Jesuiticas.* Trinidad, located twenty-five miles from the city of Encarnación, comes first in time, place, and interest.

In mid-March of 1981 Asunción newspapers heralded in almost screaming headlines the major new discoveries made at Trinidad. Articles and photographs have followed in abundance recording the new interest.

While excavating amid the rubble covering most of the nave and crossing of Trinidad's once great church, workmen stumbled upon a treasure trove of polychrome statuary in what may have been a tunnel for burials. The custom in the Reductions was to bury the missioners in or near the church sanctuary. The faithful, in turn, were buried in a cemetery usually situated to the right of the church as one faces it. The cemetery shared in the sacred nature of the entire church area.

On March 18, 1981, the newspaper *ABC* editorialized as follows: "Our Artistic Patrimony. With the expulsion of the Jesuit Order by Charles III from Spain and all its dominions in 1767, the work accomplished by the Jesuits in the thirty towns of the Jesuit Province of Paraguay . . . was abandoned. The aborigines left their Reductions, and time and nature have done the rest. The whole achievement fell into ruins and was covered by the forest. Recently, however, thanks to an important project sponsored by the National Ministry of Tourism, it was

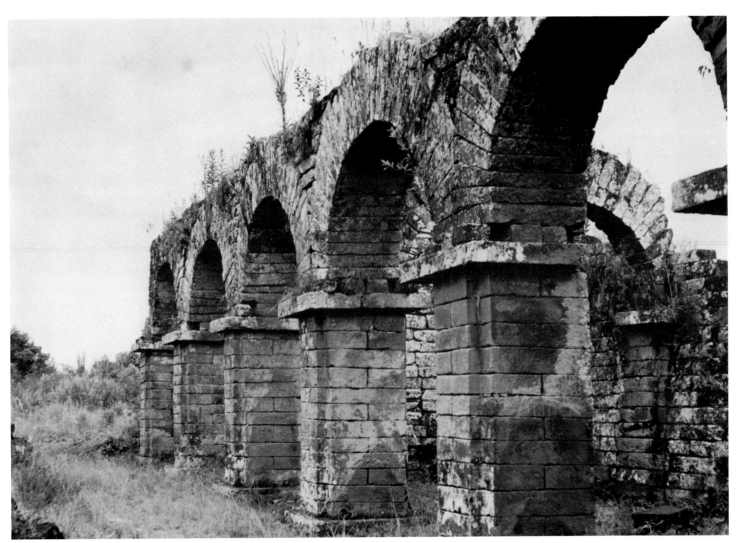

Arches of *colegio,* **Trinidad**

decided to do whatever is possible to save what remains of these works from the certain loss to which they were doomed by time and nature, not to mention theft and vandalism. The preservation work will be done in collaboration with UNESCO.

"During this century many people, motivated by foreign collectors and traffickers, have exploited the Jesuit works of Paraguay to such an extent that the churches and families preserving these works of undoubted value began to lose them either by simple theft or by commerce. Those who possessed these works failed to realize their true value and meaning. . . . Recent findings by a company of engineers in charge of preserving the ruins of the church at Trinidad have brought about an enrichment of our Jesuit artistic patrimony. These discoveries are of unimaginable value."

As of May, 1981, as this chapter is being written, it is too early to evaluate the findings in Trinidad. The editorial just quoted already needs considerable revision. But there is growing interest in the Jesuit Reductions. Almost every day tours to Trinidad are being advertised in the newspapers. The Ministry of Tourism is obviously interested in anything that might attract tourists. For Paraguay is a country most of whose historic treasures have already perished.

But even in its ruined state, Trinidad has immense value and interest. The mission church is of comparatively recent and quite sophisticated construction. It was begun in 1706. The design of the building is usually credited to the famous Brother Gianbattista Primoli, S.J., a Milanese,

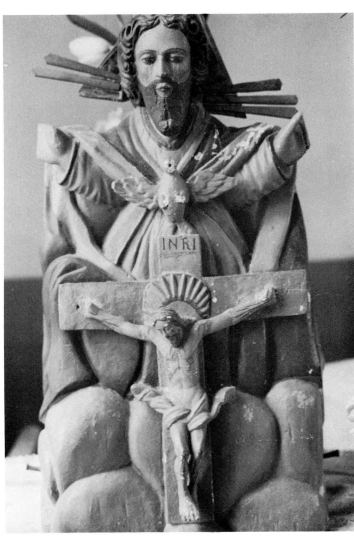

The Holy Trinity, Trinidad

The Father, detail of statue at left
Trinidad

born in 1673. Primoli arrived in the Rio de la Plata area in 1717. He was already an established architect and professor of architecture. In the following year, 1718, he was commissioned to complete the cathedral of Córdoba. Contemporary accounts described him as "incomparable and tireless."

In Córdoba Primoli built the church which is connected with the Jesuit college. He also designed and constructed a church for the Franciscans there. In Buenos Aires, the Mercedarian Fathers appointed him architect for their church.

After this, in the same city, he built the churches of San Francisco, Pilar, and several others. His best known work in Buenos Aries is doubtless the old Cabildo or City Hall which faces the famed Avenida de Mayo. This building is pictured on the popular fifty peso Argentine stamps. From that time on Brother Primoli worked in the Reductions building or collaborating in a number of major works. He died on September 15, 1747 in Candelaria, the capital city of the Reductions.

It is difficult to say how much Brother Primoli contributed to the construction of the church in Trinidad, since he died some years before it was completed. In any case, Busaniche considers him very likely "the genius" behind the architectural work there.

I personally find it interesting that Primoli and Zipoli, the "genius" of the music of the Reductions, were both in Seville together awaiting embarkation for South America. Another respected architect, Andrea Bianchi and the physician Sigismund Aperger were part of the same group of fifty-five Jesuits who travelled to South America together. Bianchi and Primoli are

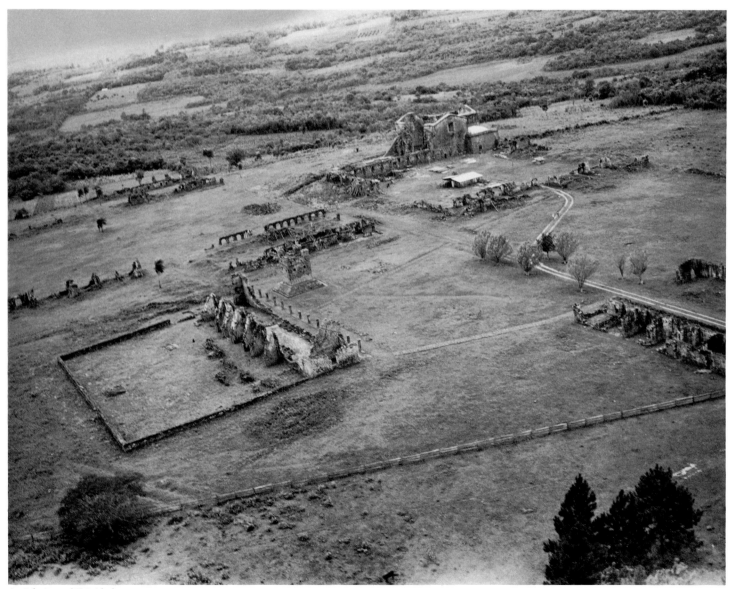

Aerial view of Trinidad

credited with the facade and towers of the cathedral of Buenos Aires.

It may seem strange that we cannot be sure about the identity of the principal architect of the church of Trinidad. Domingo Muriel, a contemporary, is our source for the following statement, "The architect of the churches of São Miguel (Brazil) and Trinidad is a brother of the Society." Contradicting previous authors, Ramon Gutiérrez believes that this was either Antonio Forcada or José Grimau, or perhaps Juan Antonio de Ribera. Ribera seems to have been the architect of the churches of Santa Rosa and Jesús and possibly of Santiago. In any case, he was a well-trained architect and son of the distinguished Spanish architect Pedro de Ribera. Pedro was the official city architect of Madrid and the designer of the magnificent tower of the new cathedral at Salamanca.

The remains of the Indians' houses in Trinidad are especially noteworthy. While the grouping of the houses in blocks is typical, the *galerias* linking these houses are adorned with massive Roman arches rather than with simple classical posts. At first glance one is reminded of the Roman aqueducts, with imposts and intricate molding, well-joined voussoirs, and over each arch, if not stolen, a carved stone rosette. These dwellings must have been particularly enviable to visiting Spanish colonists. They are very impressive even today.

The visitor to Trinidad is also struck by the ruins of a tower and a chapel. The tower is exceptional, situated at some distance from the church. It may have served as the belfry for a temporary church that was used while the permanent building was under

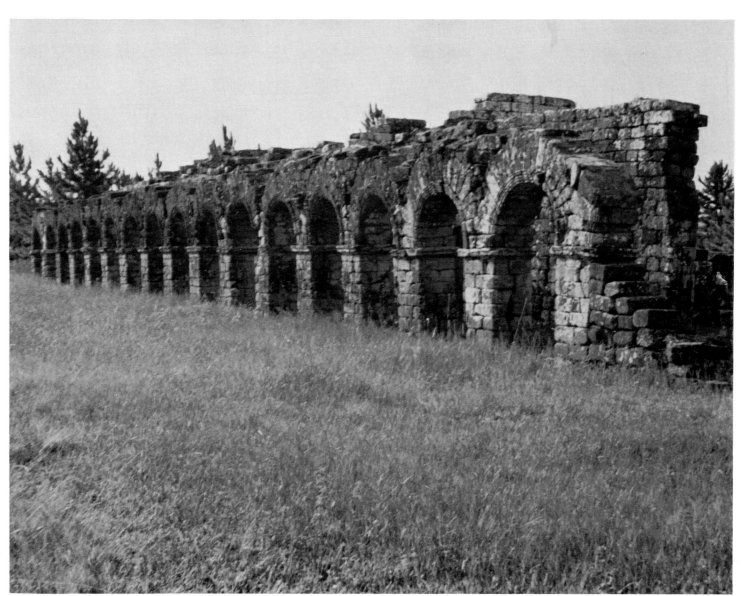

Galeria **linking houses of Indians, Trinidad**

construction, or it may have served as a watch tower. The tower has a square base and is very substantially built. The ruins of the chapel reveal that it was a building some 200 by 35 feet in size.

But the church itself in Trinidad, even in its ruined condition, is one the most magnificent of all in the Reductions, perhaps the crown of all Reduction architecture. São Miguel is its only surviving rival. The central nave and crossing of the church were covered with vaulting. The central nave measured eleven meters wide; the side aisles, also vaulted, were six meters across.

All the walls of the church were constructed of sandstone, carefully hewn. The capitals of columns and pilasters are in composite style, with original leaves and flowers suggesting Guaraní inspiration. Although the architrave is unadorned, one's attention is immediately captured by a frieze virtually alive with angels playing musical instruments of the period, among them the Paraguayan harp. I am reminded by this frieze of the procession of saints in mosaic adorning Sant' Apollinare Nuovo in Ravenna. But these Indian angels are in stone, done in high relief. This frieze is now being restored by Tito González. But even in its ruined state, it is phenomenal. I was reminded, and perhaps the anonymous sculptor was too, of Giovanni Balduccio da Pisa's angel musicians playing sundry instruments. In any case, these angels reinforce visually the many contemporary accounts about the complexity and quality of baroque music in the Reductions.

Interior of bell tower, Trinidad

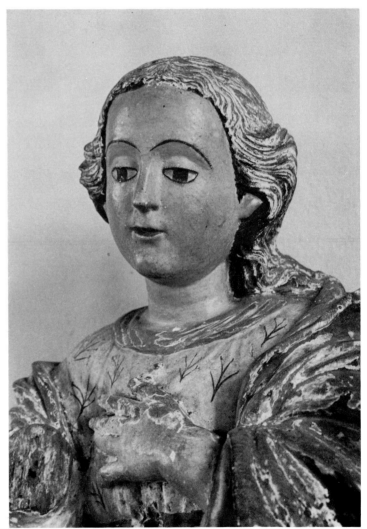

Mary Immaculate, Trinidad

Particularly striking are the two doors in the church which link the sanctuary and sacristies. These are done with such profusion of local flora as to possess, as Busaniche judges, "an originality that cannot be confused with any other." I agree with him that they are broadly Churrigueresque—Ribera's father was famous for Churrigueresque work—and even Manueline. This makes me think of that masterpiece of Portuguese architecture, the church of Belém on the Tagus River, past which other Jesuit missioners sailed on their way to China, Japan, or India. But the special opulence of these doors suggests that if the craftsmen who carried out the details were not Guariní themselves, they surely wanted to give the doors a Guaraní or at least an Amerindian flavor. Busaniche rightly reckons these doors "among the finest examples of colonial art." Only in one or two doors of San Ignacio Mini do we still have anything comparable in the Reduction ruins.

A note of poignance with regard to the Trinidad church is added by the historian Fernando Pérez Acosta. Unlike many other Reduction churches, this one was not destroyed by fire or even by neglect, but by the secular administrator who took charge when the Jesuits were expelled. He was apparently unaware of the thrusts and pressures of a stone vaulted structure, or perhaps he didn't care. But he simply removed stones from the buttressing, as though it were a handy quarry, to build a house. The mighty building accordingly collapsed.

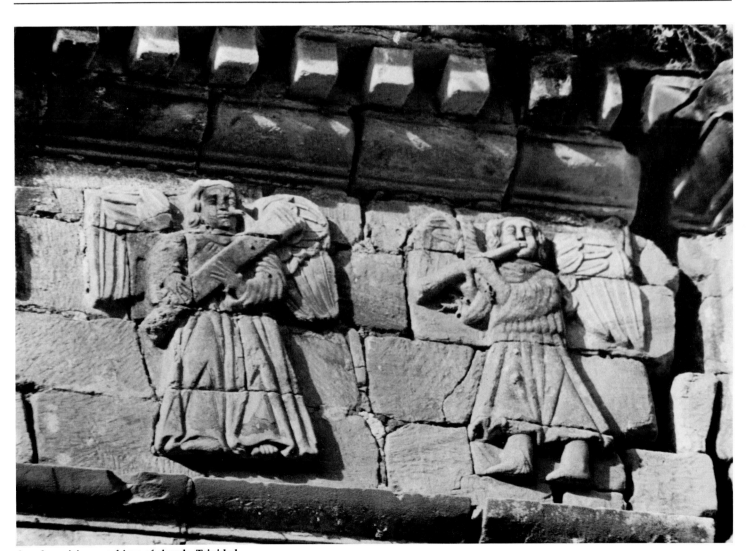

Angel musicians on frieze of church, Trinidad

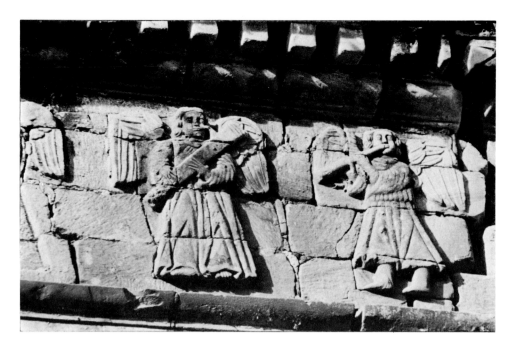

Left: Angels playing bassoon and flute, frieze of church, Trinidad

Below: Angels, Trinidad

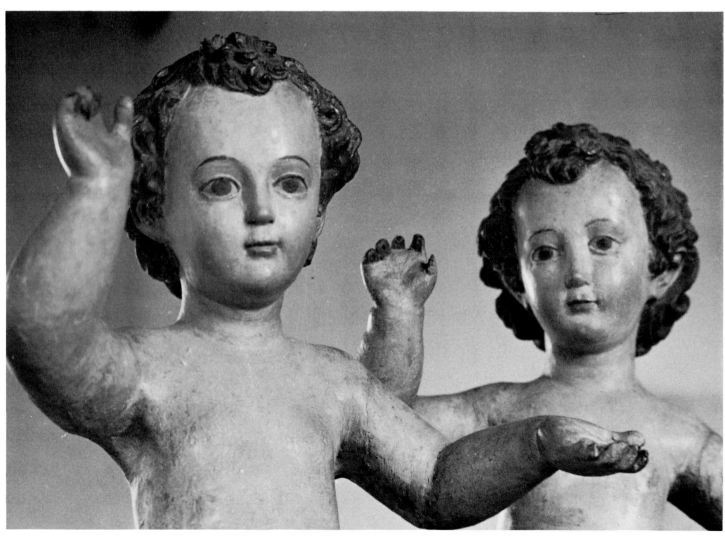

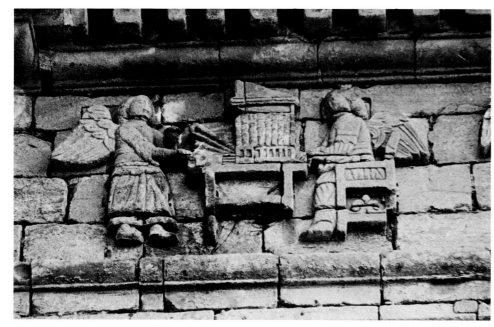

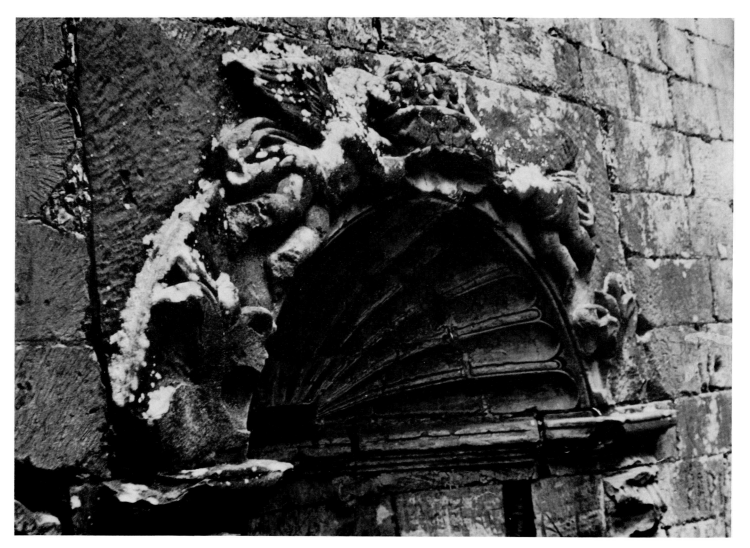

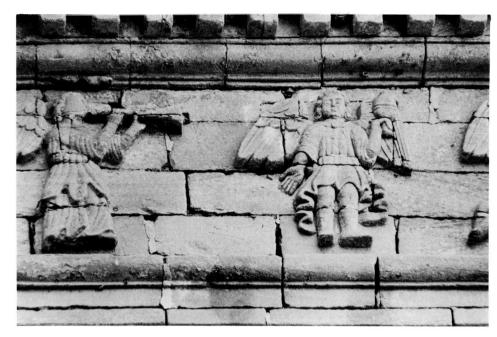

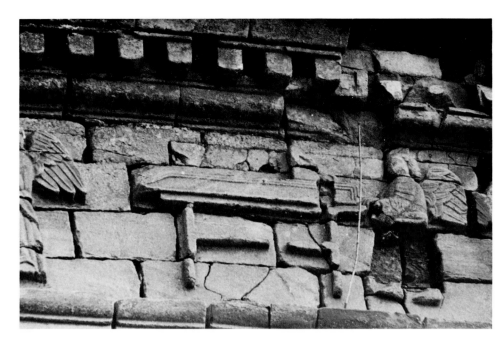

Left: **Angel playing a clavicord, Trinidad**
Below: **Crucifixion, Trinidad**
Below right: **Vaulting detail, Trinidad**

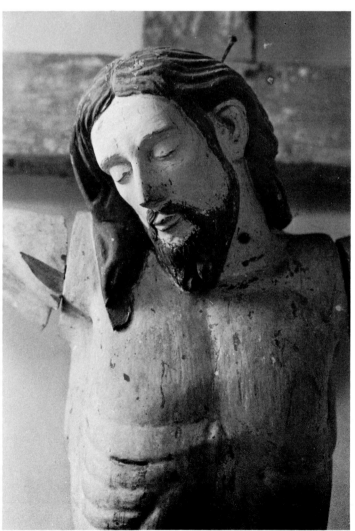

JESÚS

The last Reduction in Paraguay can be found a few kilometers beyond Trinidad in the direction of Hohenau. Another *Ruinas Jesuiticas* sign points left to Jesús. Then, in dry weather, the visitor wanders along a dirt road for some ten kilometers to the town of Jesús, follows markers, and suddenly approaches the side of a huge stone structure, almost two hundred feet long. This was the church of Jesús.

The three doors of the entrance to the church are exceptionally impressive. They are framed in trilobate or trefoil arches in mudéjar (Moorish-Christian) style. The arches almost match those inside Córdoba's famed mosque-cathedral in Spain. Documents indicate the Catalán José Grimau designed this building, though we know that Ribera worked here also.

Jesús was unique in design. It was not intended to have a wooden superstructure nor the type of stone vaulting used in Trinidad. As Busaniche suggests, it was to have been a "mixed style" with wall buttressing as well as large central pillars. Perhaps we shall never know exactly, since Jesús is the only remaining Reduction that was still incomplete when the Jesuits were expelled in 1767.

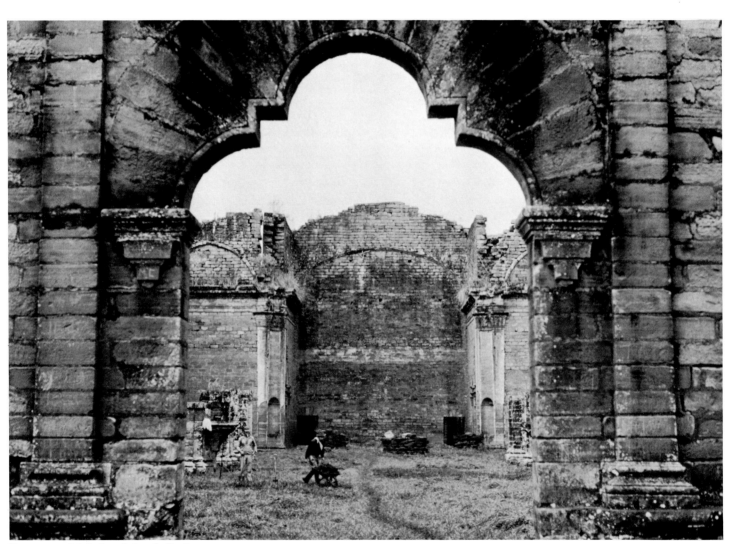

Doorway and interior of church, Jesús

There is evidence, however, that the Franciscans, or possibly the Dominicans, tried to salvage the operation. High in the cornices of the sanctuary, roughly inscribed, are the names of St. Francis of Assisi, dated 1776, and St. Dominic of Guzman, dated simply, February 13. But lack of architectural skills or lack of manpower or both meant Jesús was never finished. While there is less to see here, what remains is eminently worth seeing.

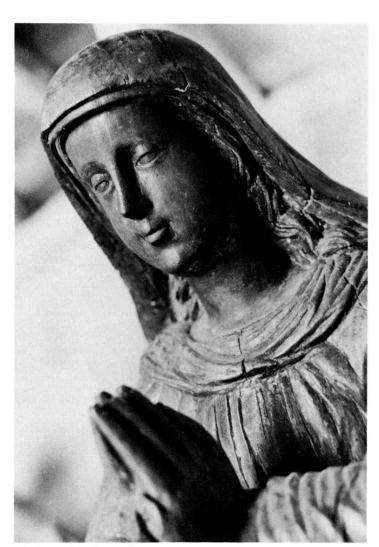

Virgin praying, detail of statue
Jesús

Interior of baptistry, church of Jesús

The interior of the church is of singular grace. On either side of the principal nave, seven pillars, roughly three by three feet, rise just over six feet. They are done in carefully worked stone, resting on bases molded according to the classical orders. On either side, however, the fifth pillar from the rear has a pedestal which indicates that it served as a pulpit as well. Approaching the sanctuary we find sturdy pilasters in bevel arrangement at a 45-degree angle.

The pilasters lining the side walls are exceptional in their originality. Unlike those of the classical orders, these pilasters taper from top to bottom and are, in the judgment of Busaniche, "antirational and eminently baroque" in style. I was immediately reminded of the bizarre shape of the columns of the Knossos palace in Crete, though this shape is also found in other places.

The capitals, too, are arresting. They depart from classical styles in favor of local flora and each is topped by a second capital. Almost everything, in fact, about Jesús is fresh and original indicating architects of considerable resourcefulness and daring. There is a certain irony in the fact that Brother Antonio Forcada, one of those who worked on Jesús, died in 1767, the very year the order was expelled. He died before his work could be completed.

Interior of sacristy, church of Jesús

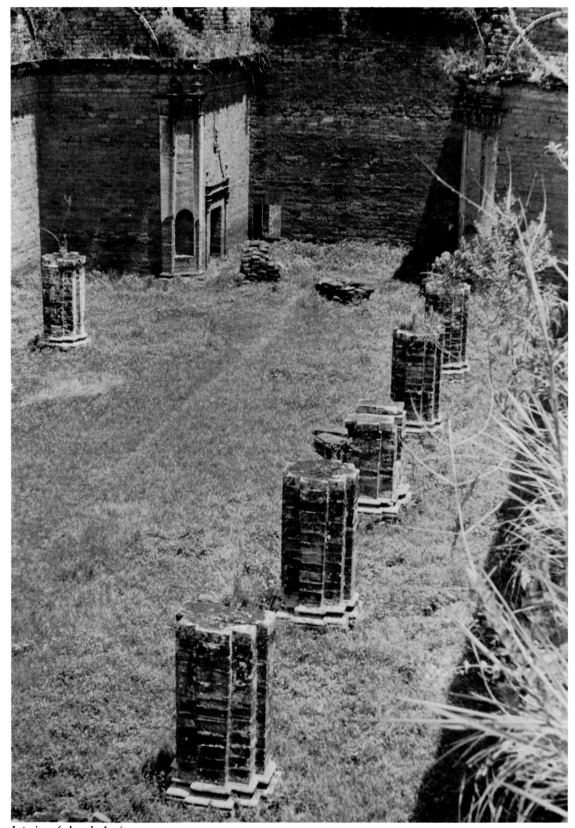
Interior of church, Jesús

MISSIONS IN ARGENTINA

Back in Encarnación one takes the ferry across the giant Paraná River to Argentina. It is hoped that the international bridge now under construction will be functional by 1983. It will link Argentina with Paraguay and make the entire area a single center of Reduction interest.

Nothing in Encarnación or in the town of Posadas remains of the Reduction founded by Roque González. In Posadas, however, there is a splendid modern structure housing the university. It is suitably named Instituto Ruiz de Montoya. Suitably, I suggest, since it was Ruiz de Montoya who led the Exodus from the Guairá area to what is now the Argentine province of Misiones. The province was named after its first towns, the Misiones or Reductions.

Provincial highway No. 12 links Posadas with the north and leads all the way to that marvel of nature, the Iguazú Falls. On the way it is particularly distressing to pass the road marker for Candelaria, once the capital of the Reduction "republic." This is where the superior or general director of all the thirty Guaraní cities lived.

The site was near the river, equally accessible to all the Reductions. Today Candelaria is little more than a heap of stones covered with debris and tropical vegation. While visiting it, I was reminded of a forgotten village I had once walked past near Oxford in England. The village was nothing more than a low hill now; it had been ravaged by the plague that swept through Europe in the 1330s. Although the destruction of Candelaria and a dozen other Reductions in Argentina can hardly be compared to the medieval calamity, yet in another sense

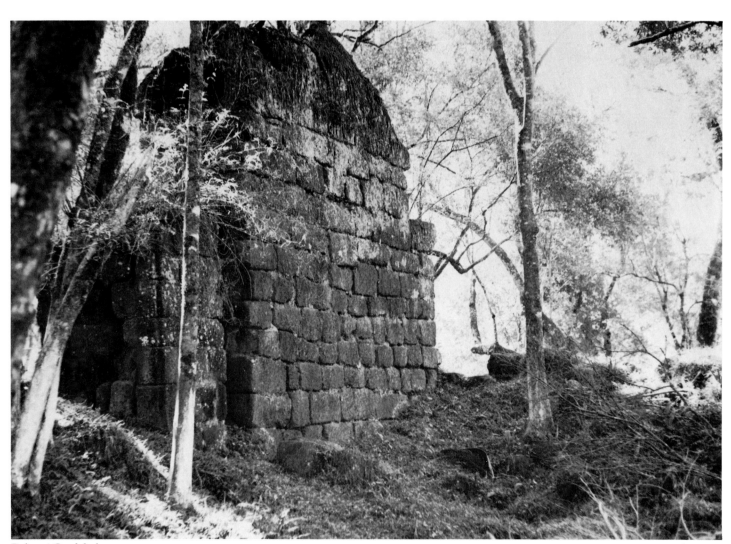

Ruins at Candelaria

it was worse because it was brought about not by the plague, but by man.

We still have, however, an excellent drawing done in the year of the Jesuit expulsion, 1767, which shows what Candelaria once looked like, with its spacious plaza, majestic church, *colegio*, and stone houses linked by *galerias*. This was once the nerve center of all the Reductions.

Farther to the north, near the river, are the almost imperceptible ruins of Corpus Christi, once the admired creation of Brother Brasanelli. Even more thoroughly destroyed by time and human ruthlessness is the Reduction of the Holy Martyrs or Santos Mártires. This mission was dedicated to the Jesuit martyrs of Japan, Paul Miki, John de Goto, and James Kisai, who were crucified in Nagasaki on February 5, 1597.

Holy Martyrs was one of the many Reductions pillaged by the Portuguese commander Francisco de Chagas in 1817.

The Reduction of San José can point to nothing of its former glory. In Santo Tomé only the town plaza can be identified as once the plaza of a Reduction. The once important Reduction of San Javier has also almost totally disappeared.

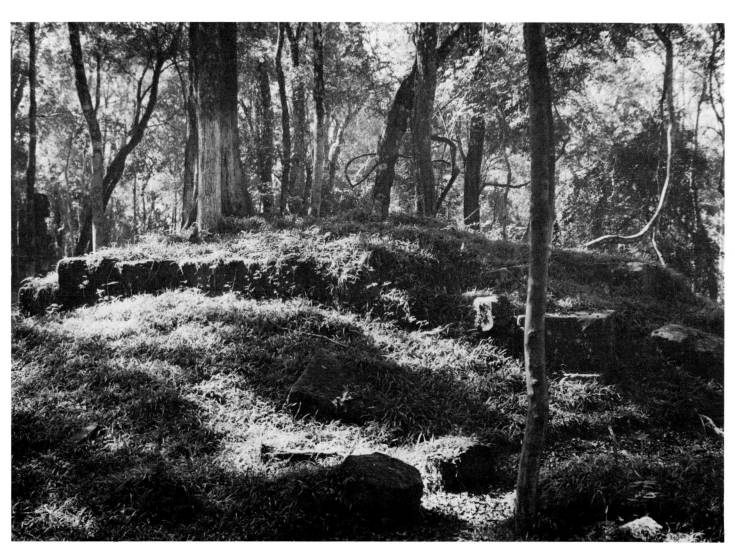

Ruins at Candelaria

The modern town of Concepción is built on the ruins of a Reduction which bore the same name. It was founded by Roque González in 1618 and was the first in this area. Like so many others it was sacked and burned by the troops of Francisco de Chagas in 1817. The church, constructed by Brasanelli and Primoli, is believed by Josefina Plá to have been one of the very finest. Concepción was renowned among the Reductions for it claimed the ashes of Roque González and his associate Diego de Alfaro, both shot by the Paulistas in 1639. Even their relics have now disappeared.

While the mission of Apóstoles is graced today by a valuable collection of Reduction art, it is itself almost a total ruin. As recently as 1920, however, several of the original buildings were still standing and we have photographs of them. But the stones of these buildings were subsequently sold for twenty centavos apiece, and thus, as Busaniche puts it, "was swept away the last trace of the ancient Reduction."

Slightly more may be observed in Santa María la Mayor. This mission was so named to distinguish it from Santa María de Fe in Paraguay. Here a school opens onto what was once a patio of the *colegio*. And the remains of the *galerias* show a few handsome pillars with their capitals. These ruins indicate a plan somewhat different from those of the other Reductions; but this is only of interest to specialists.

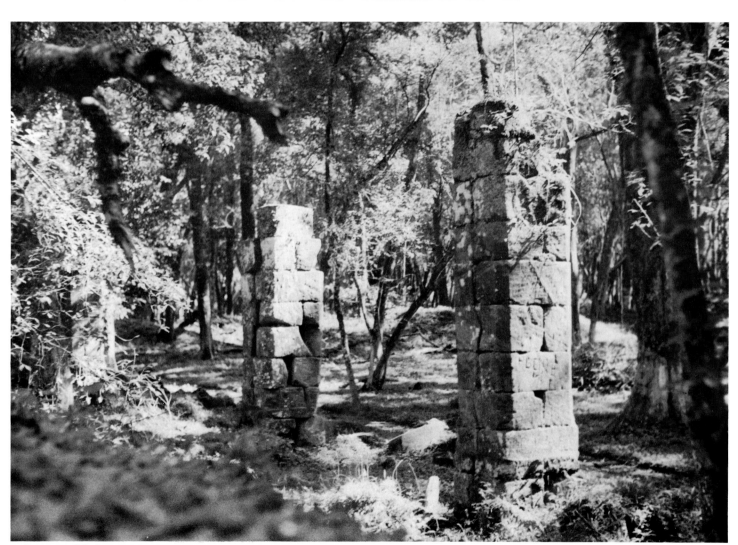

Ruins at Candelaria

Near the boundary line separating the provinces of Misiones and Corrientes is the mission of San Carlos. Again there are only sparse remnants of what once were its walls. Much the same may be said of La Cruz, except for the sundial which now stands in the police station and is clearly inscribed with the scriptural quotation, "From the Rising of the Sun Even to Its Setting the Name of the Lord Will Be Praised. March 27, 1736."

The southernmost of the Reductions was called Nuestra Señora de los Reyes Magos, Our Lady of the Magi Kings. It was more popularly known by its location, Yapeyú. Here, in a settlement which was once the music center of all the Reductions, only a few stones and a sundial survive.

Back near San Ignacio Mini, we turn off the highway, drive for two kilometers, pass an agricultural school, and with some difficulty discover heaps of stones and jungle overgrowth. Stones from what was once a wall, some ten feet high, outline the church of Loreto. It was the work of Brother Giuseppe Brasanelli, S.J., described by his contemporaries as a veritable genius. I find these ruins at San Ignacio Mini perhaps the most

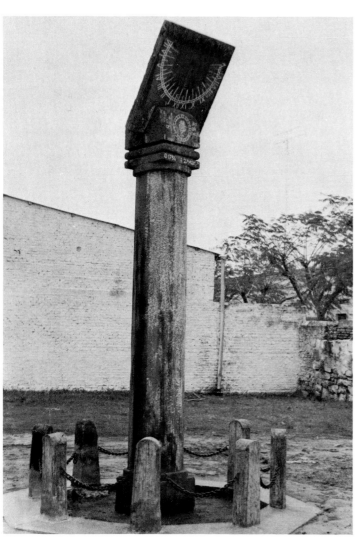

Sundial, Santa Cruz

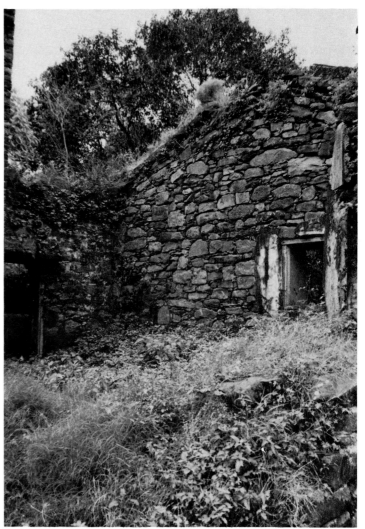

Indian house, Santa Cruz

poignant of all because they cover the grave of Father Ruiz de Montoya. The grave, as yet undiscovered, must lie somewhere beneath the rubble which covers the scarcely discernable sanctuary of the church.

Amid all this devastation there are two Reductions in Argentina that are eminently worth visiting. Santa Ana is one. Its ruins include the old cemetery near the remains of the church. The cemetery is still used by the people who live in the neighborhood. The church, once judged to be among the most impressive in all the Reductions, is vaguely outlined by rather nondescript walls. This had been the important construction of Brother Brasanelli. It was eighty-five paces by twenty-eight, plus the sanctuary.

Needless to say, the retables and statues done by Brasanelli and reckoned exceptional are long since gone.

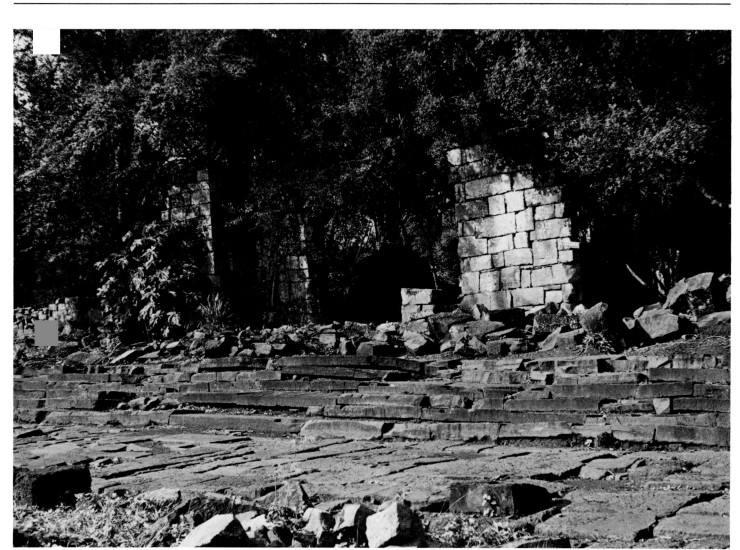

Entrance to church, Santa Ana

SAN IGNACIO MINI

Today the gem of Reduction architecture still extant in Argentina is San Ignacio Mini. Mini, it will be remembered, means "little." This mission, together with Trinidad and Jesús, was featured in our documentary film. As we mentioned in the Preface, the parish priest here is Father José Marx who, in addition to energetic pastoral work among Argentines and scattered groups of Indians in the forest, is very much a Reduction buff and has published an attractive illustrated brochure in Spanish and English for visitors to San Ignacio. Every time I visit him, I meet adventurous students, lending a hand, and eagerly picking up lore about the Reductions.

A small but representative museum containing Reduction artifacts marks the entrance to the ruins of San Ignacio Mini. Its guest book is revealing, with signatures of visitors from many European and South American countries. During Holy Week of 1981, for example, more than five thousand people came to see the ruins of San Ignacio, one of Argentina's most historic sites.

Entering the grounds, one walks among the stone houses of the Indians. They are impressive even in their ruined state. They stand today bereft of the paved streets and covered *galerias* which once linked them together. But other than this, the houses are almost as noteworthy as those seen in Trinidad.

Beyond the houses is the great plaza, crowned by the church facade which is only slightly restored. The architects of this "jewel of American art," to use Busaniche's phrase, were Brother Giuseppe Brasanelli and Father Angelo

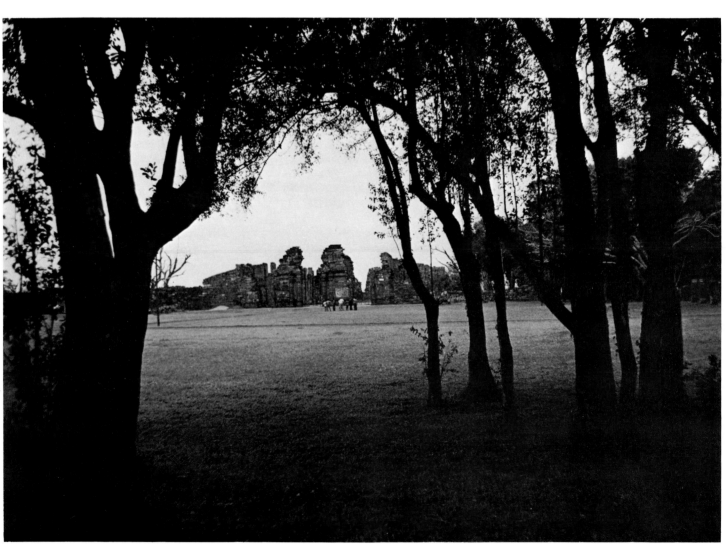

Plaza and church, San Ignacio Mini

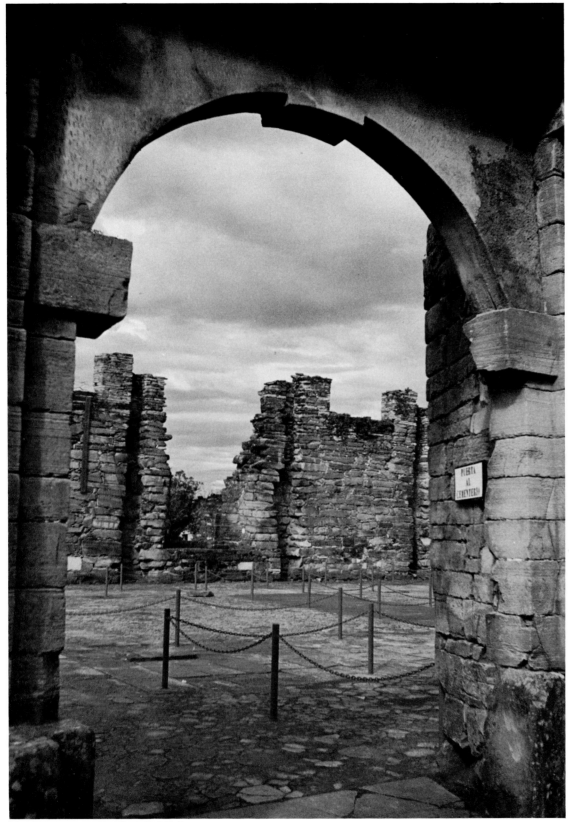

Door to cemetery, San Ignacio Mini

Camillo Petragrassa, both Italians. They arrived in 1690 and were among the few professional Jesuit architects to work in the Reductions.

Having used the word "professional," I find this as good a place as any to stress that few of the missioners, despite truly gigantic achievements, were professionally trained. Most were, like good missioners everywhere, resourceful, creative men, pushed by circumstances into becoming expert improvisers.

With her customary balance, Josefina Plá puts it this way: "With the exception of Primoli, a man of notable achievements before his arrival in America, Ribera and Grimau, capable architects; Brasanelli, a skilled architect and sculptor; Verger, La Cruz, and again Grimau, painters; Sepp, musician; and some others whom we may classfy as talented—of the Jesuits who did art work in the Reductions one cannot affirm that, as a rule, they were eminent artists, outstanding as they may have been in other aspects of mission work, pedagogical, organizational, catechetical. Many were men of whom it was said,

'Without being architects, they did build very handsome buildings.' " I would add another important exception, the musician Domenico Zipoli.

Thus when his contemporaries call Brother Brasanelli a "little Michelangelo," the title may be taken with at least the proverbial grain of salt. Like the great Tuscan master he was sculptor, architect, and painter, among other things; but he constitutes no real challenge to Michelangelo, nor for that matter do I find him even mentioned by art historians.

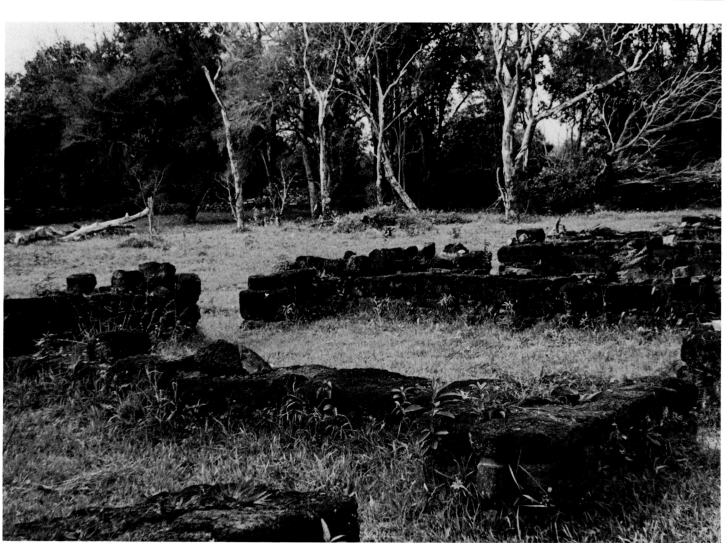

Ruins of Indian houses, San Ignacio Mini

Some of this exuberance may be the result of a once legendary tendency on the part of Jesuits to indulge in excessive *esprit de corps*. Jesuit superiors in the past have issued repeated cautions against this excess. The cautions seem less needed today, if needed at all. (If the reader has detected a whiff of chauvinism in this text, it may be put down to the writer's jubilarian status as a Jesuit.) In any case, to form a personal assessment of the art, the reader has the Blanch photographs to judge by which do not exaggerate any more than do photographs in other art books.

Even in its ruined state, the San Ignacio church-*colegio* complex is astonishing. And the Argentine government, treasuring it as a national monument, has done much in the way of restoration and tourist promotion. A handsome bilingual publication by the Secretaría de Información Pública dedicated its sixth issue (1977) to a feature story on San Ignacio.

The destruction of San Ignacio was not caused by the attrition of time, but once again by human vandalism. In this case the town was destroyed by that enigmatic Paraguayan dictator-president, Dr. José Gaspar Rodríguez Francia. During the confusing period of independence, 1817-18, the area was under the command of a Guaraní Indian known as Andresito. Dr. Francia's armies wrought devastation. But even as late as 1846, as Furlong reports, Guaranís still lived huddled ''next to the smoky walls of what once was the Reduction of San Ignacio Mini.''

Our photographs illustrate something of the richness of detail in both church and *colegio*. While the columns derive from the classic Greco-Roman style,

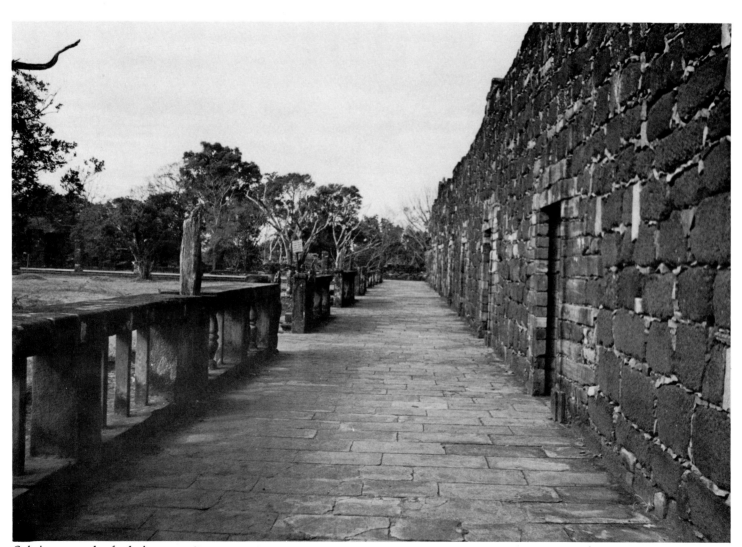

Galeria or veranda of colegio
San Ignacio Mini

they go far beyond most contemporary European baroque in fantasy. Much of this must be owing to Guaraní craftsmen; in any case the decoration evidently met the tastes of the Guaraní people. Those who lament the loss of Guaraní culture in the Reductions can hardly have studied the columns, pilasters, lintels, and other architectural-sculptural features of San Ignacio. Not merely the floral motifs, but the esthetic itself can hardly be thought of as European.

A particularly fine example of this mestizo art is provided by the door leading from the church to the *colegio* at San Ignacio. While the outer columns are comparatively classical, with fluted shafts but with a double capital and relief work on the base, the inner columns are sheer fantasy, a rampant vine with tendrils, runners, and clusters of grapes in profusion. "Singularly baroque," as one critic puts it. But I should add, baroque with a difference. The lintel itself is plain but is crowned with an abundance of winged sirens and serpents attempting

to devour the fruit. Higher up two eagles with wings outstretched as if in adoration surround the emblem IHS, representing the name of Jesus. This door, which I find comparable in quality with the sacristy doors of Trinidad and no less original, shows a freedom of expression, a personal sense of form, a native stamp that make it, in Busaniche's words, "one of the most accomplished examples of Jesuit missionary architecture."

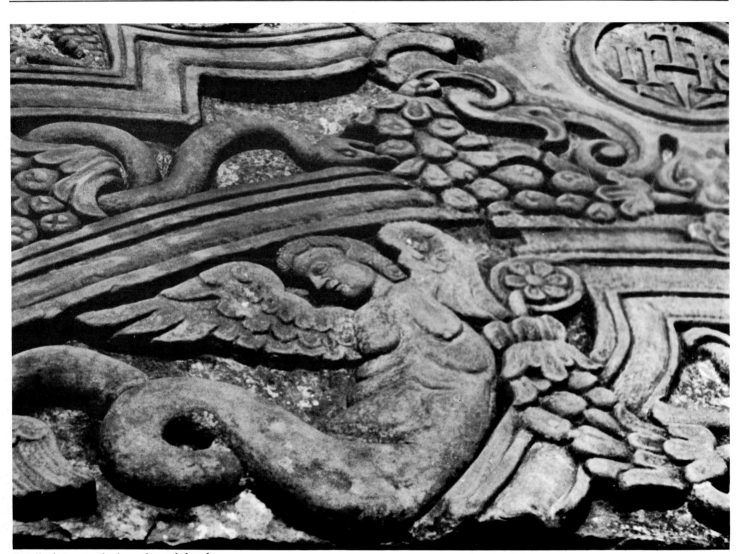

Detail of stonework above door of church
San Ignacio Mini

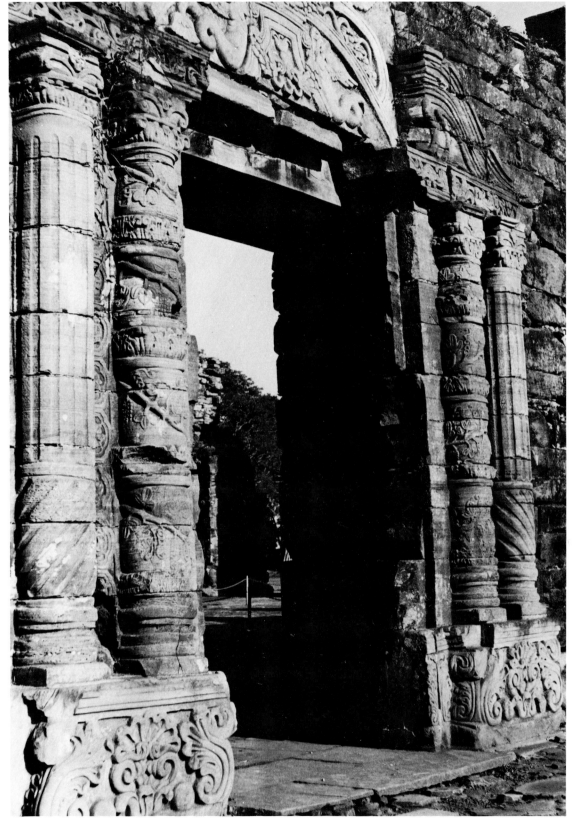

Door of church leading to *colegio*
San Ignacio Mini

The door which joins the sacristy with the patio, though somewhat more restrained, is only slightly less imaginative. Columns are set in front of large pilasters. The columns rise from bases which suggest baskets of leaves. The capitals are altogether Amerindian, with angel heads, so typical of Reduction art, in the center of each. The capitals seem to move upwards, first in quiet flutings, then swirling with moldings, and then volutes of wings and flowers. True baroque indeed; but again, baroque with a difference.

What remains of the *colegio* impresses one with its comparative sobriety and quiet elegance. The rooms of the individual missioners and the guest quarters are small and well proportioned. The largest room may have served as the community chapel or dining room. I find the remains of the porches, both north and south, refreshingly restrained. This may have been done to keep the focus of interest on the church and not on the less important *colegio*.

That we have such significant remains at San Ignacio, despite the ravages of time and Dr. Francia, is a curious turn of fate. For San Ignacio Mini was neither a large Reduction nor one of the most notable. It had, for example, nothing of the importance of Candelaria, capital of the "republic," nor was it remarkable for any special accomplishment, as Yapeyú was for being the musical center of the Reductions.

Nevertheless, San Ignacio did have some special interest. It was one of the very earliest Reductions, founded in 1610, by Giuseppe Cataldini and Simone Mascetti up in the Guairá area.

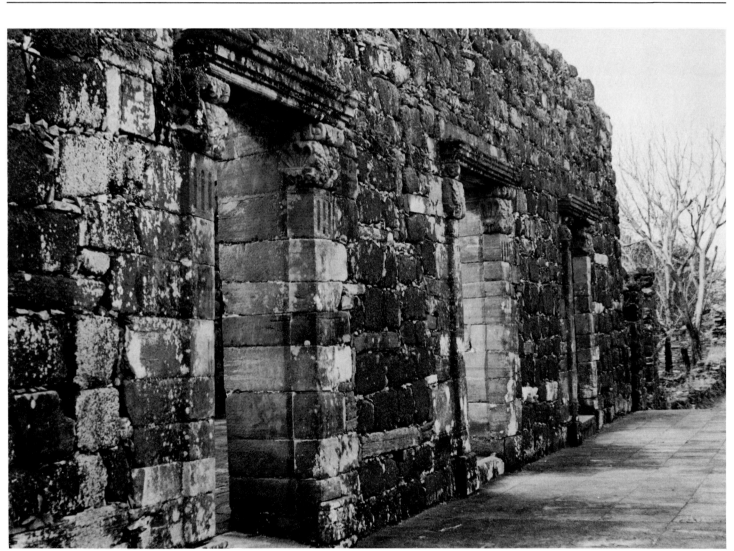

Doors of *colegio,* **San Ignacio Mini**

One recalls that when menaced by the Paulistas, its people participated in the Exodus under Ruiz de Montoya, arriving near its present site. On June 11, 1696, the settlement was transferred again some five miles upstream on the Paraná to its final handsome location. I suspect that one reason for the choice of the new location may have been the excellent quality of reddish stone nearby. It afforded a warm tone to all the buildings of the settlement. Even today, down near the river, one may visit the quarry from which this stone was cut.

The visitor to San Ignacio would do well to visit an unpretentious building popularly called Museo Don Miguel, or more officially Museo de Arte Jesuítico. The Don Miguel referred to is a sagacious elderly Hungarian named Nadasdy who has lived here for decades and accumulated a trove of bric-a-brac as well as some real artistic treasures related to the Reductions. The object that most captivated me is a statue that looks like a copy of Michelangelo's famed statue of Moses in Rome's St. Peter-in-Chains. Done in alabaster, this puzzling statue, some two feet in height, struck me

immediately as more than conventional.

I asked Don Miguel about it. Grinning confidently, he assured me that it was not a copy but the original model, *bozzetto*, done by Michelangelo between 1510 and 1515. According to Nadasdy, it was brought to the Reductions by Brother Brasanelli himself in 1690, hidden during the troubled times, lost, and finally rediscovered.

Politely but skeptically I smiled at this improbable story, despite the circumstantial details. Later, however,

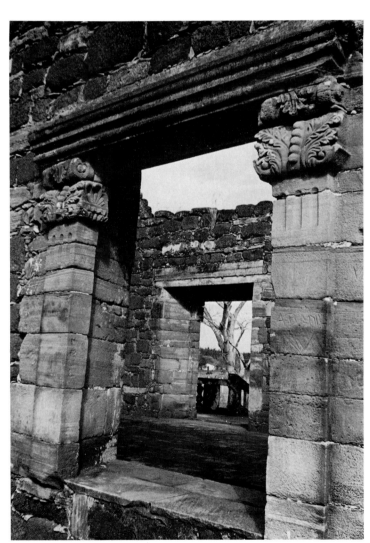

Doorway, San Ignacio Mini

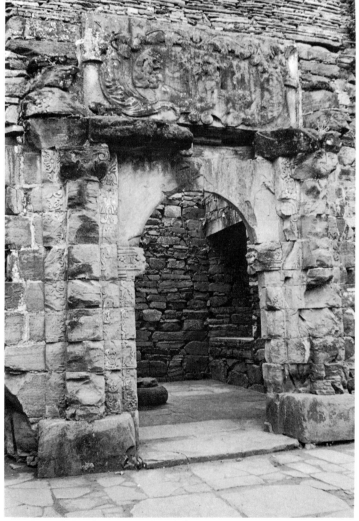

Side door of church, San Ignacio Mini

I have had second thoughts and have shared them with other serious art students. Don Miguel's bizarre account is no more improbable than is the very existence of the statue here in the jungles, discovered long ago amid rubble. If Brasanelli did not bring it, who did?

What is more, Michelangelo was a friend of Ignatius of Loyola and had even offered to build the Gesú church in Rome free of charge. We know, too, that the 79-year-old Michelangelo was actually present for the foundation ceremony of the Gesú on October 6, 1554, though he was then too old to do the work.

Did Michelangelo personally give Ignatius a *Moses* model either on that occasion or at some other time? Or did he give it to Francis Borgia, either personally or through their friend Cardinal della Cueva? In any case, if the little *Moses* has, in fact, been here for several centuries, who could have created it before the day of photography? If not Michelangelo himself, then obviously some very skilled copyist working right inside St. Peter-in-Chains. In this case, why did he copy it so faithfully, only to

introduce slight modifications? Such a gifted copyist would hardly, for example, have shortened Moses' "horns," whereas Michelangelo himself could easily have lengthened them when doing the final work in marble.

Whatever the truth may be, we are faced here with something of a riddle. To conclude this semiwhimsical bit of sleuthing, I am now inclined to believe that the Museo Don Miguel may quite possibly possess the original model after all. Fanciful as this may be, it hardly seems less probable than the very fact of so much significant art right here in the jungles of the Paraná.

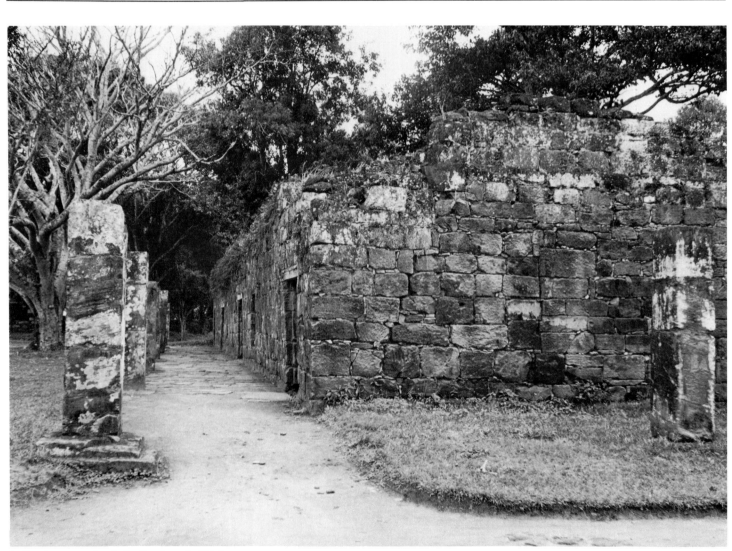

Indian houses and *galeria*, San Ignacio Mini

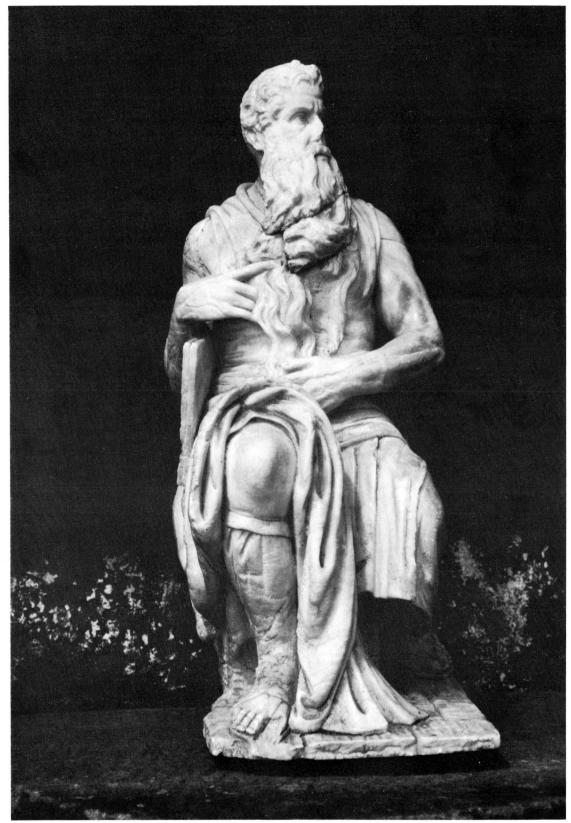

Moses model, Museum of Don Miguel, San Ignacio Mini

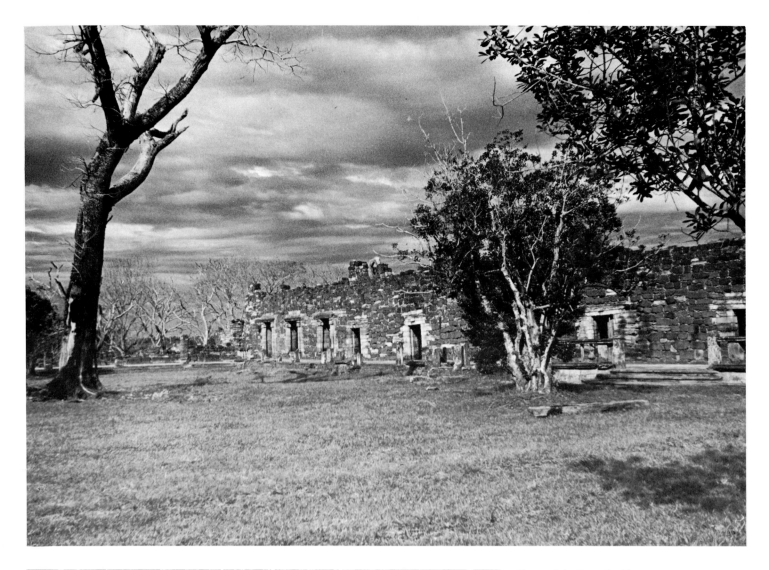

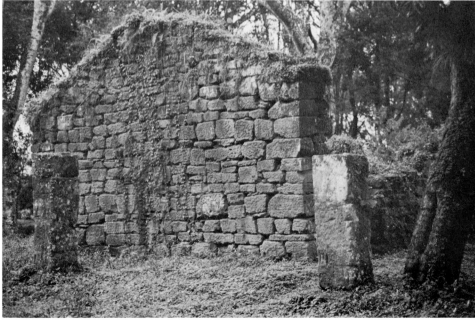

Above: **Colegio and patio**
Left: **Wall of Indian house**
Right: **Indian houses**
All pictures, San Ignacio Mini

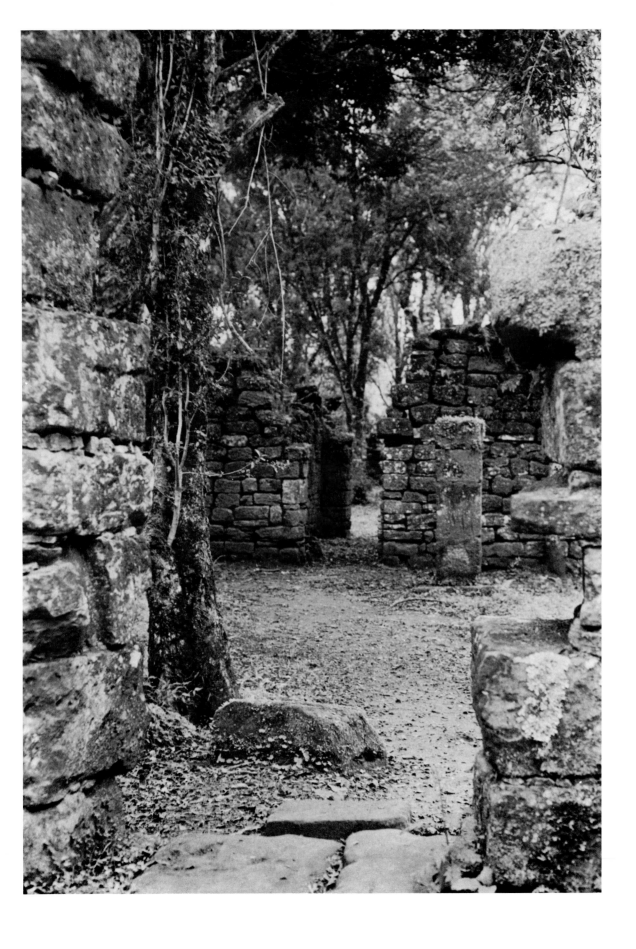

SEVEN CITIES BEYOND
THE URAGUAY

The journey from the Argentine Reductions to those across the Uruguay River in present-day Brazil is something of an adventure. The direct road from Posadas to São Miguel is largely unpaved and reminds the traveler of how difficult movement must have been from one Reduction to another. Even the ferry boat ride across the Uruguay is long and fairly awesome, and of course one has to put up with delays in the customs office.

So little remains of the actual Reductions in Brazil that it may be appropriate here to say something about the *estancias* or large community farms which supported the settlements. Obviously the Reductions could not subsist without a sure and steady supply of food. Each Guaraní family had its own garden near the Reduction. But given the improvident nature of the Indians, a fact attested to by just about every missioner who wrote on the subject, a larger community supply of food was needed. This was especially important to provide for emergencies, draught, or other disasters. Accordingly, large farms or ranches known as *estancias* were established where *yerba mate*, other crops, and cattle were raised in large quantities. What was not needed could be exchanged with other Reductions or sold in the colonies. The money thus gained was used to pay taxes to the Crown or to purchase such tools and other necessities that could not be produced at home. No money was used within the Reductions. Thanks to efficient organization, the Guaraní "republic" was almost self-sufficient. Besides the *estancias* connected with each Reduction, there were two common *estancias* which provided for any extraordinary

Uruguay River, looking toward Brazil from Yapeyú, Argentina

emergency which might arise. Anyone interested in the economic structure of the Reductions would do well to read the chapter "Economy" in Philip Caraman's book or the fuller studies of Popescu, Mörner, and Cushner mentioned in the bibliography.

Life in the Reductions was remarkably peaceful and secure from the time that Ruiz de Montoya secured permission from the Crown for the Guaranís to carry arms in self-defense until 1750. On January 13, 1750, however, a boundary treaty was signed in Madrid between Spain and Portugal which was to prove the beginning of the end of the Reductions.

This boundary treaty transferred to Portugal all the territory of the Reductions east of the Uruguay River, including the *estancias*. This meant some 100,000 square miles, an area slightly larger than today's West Germany. The area corresponded roughly to the modern Brazilian state of Rio Grande do Sul.

To kings and diplomats in far-way Iberia the disastrous human consequences were hardly imaginable. By the stroke of a pen each side felt it had gained an advantage: Portugal acquired title to a vast tract of land, while Spain secured Portugal's pledge to recognize the lands along the Plata River as officially Spanish. This treaty ended centuries of desultory but costly warfare.

The only ones destined to lose in this bargain, of course, were some thirty thousand Guaraní Indians settled in seven Reductions east of the Uruguay River. It was simple on paper, but the transfer of rights involved in the treaty brought incredible hardship on these people. These Indians were no longer stone-age nomads but modern city

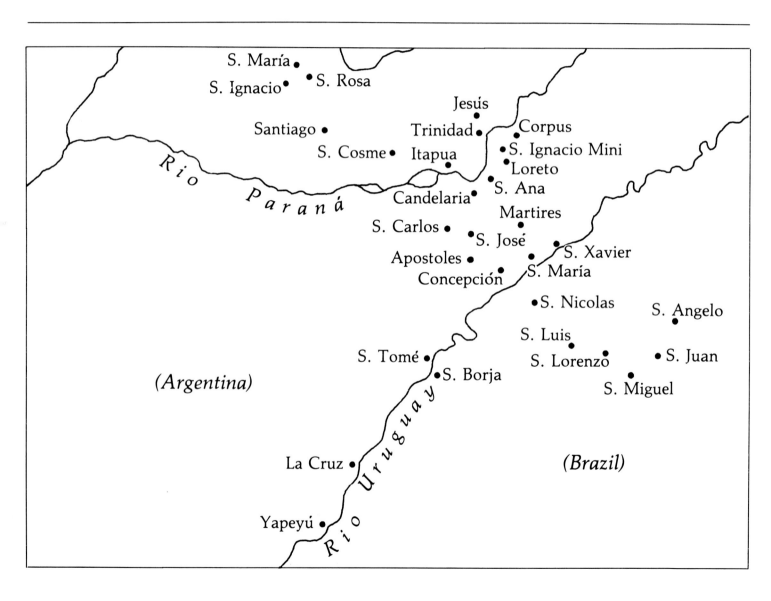

dwellers. Yet Clause 16 of the treaty states curtly: "Missioners will leave with all their movable property, taking with them the Indians, to settle in Spanish territories. . . . The towns with their churches, houses, buildings, property, and the ownership of the land shall be given to the Portuguese."

The shock felt throughout the Reductions can scarcely be imagined. Cooperative and loyal as the Christian Guaraní people had always been to the king of Spain, even going to war on his behalf, they found it hard to believe that His Most Catholic Majesty could thus betray them to their traditional enemies, the Portuguese.

Two Jesuits were dispatched to Europe to explain and plead their case, but they were detained in Rio de Janeiro. Communications with the Jesuit superior general in Rome were nearly impossible. The theological faculty of Córdoba University sent a formal protest to Rome in defense of the Indians' rights, branding the decision as "plainly in contradiction to the laws of nature, God, Church, and State." The letter, of course, arrived too late to have any possible effect.

Meanwhile, in what were known as the Seven Cities, the crisis became more confused and intense. An official visitor from Rome, Luis Altamirano, only made matters worse. Thereupon, despite the missioners efforts to keep the peace, a revolt, often called the Guaraní War, broke out against the Spanish and Portuguese authorities.

This catastrophic event—quite literally the turning point in Reduction history—has naturally attracted the attention of dramatists. Fritz Hochwälder's play *Das Heilige Experiment* ("The Strong Are Lonely")

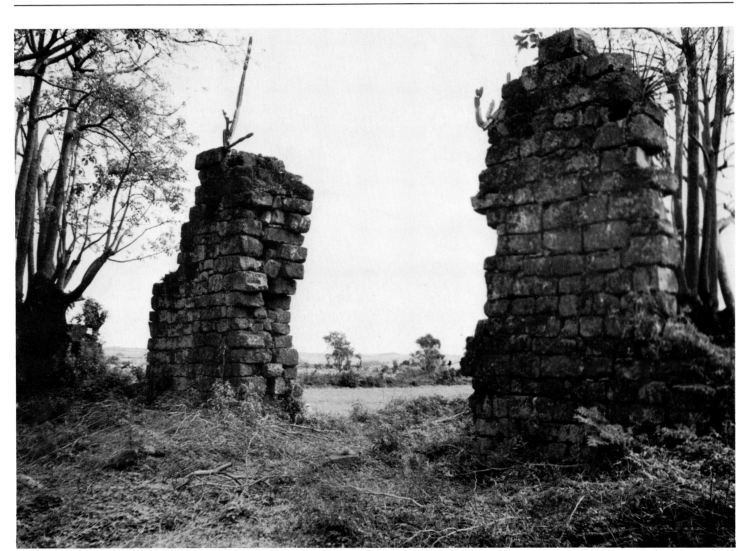

View from ruins of church, São Lorenzo

treats it movingly, though rather unhistorically. The play enjoyed long runs in Vienna, Paris, and London, but was less successful on Broadway. Robert Bolt, author of *A Man for All Seasons,* has done a superior and broadly historical film script titled *Mission.* When produced, this film should become a sort of classic on the subject.

I have seen just about every highly acclaimed Sound and Light program from the pyramids of Gizeh to those of Teotihuacán near Mexico City. To my delight, I have found the São Miguel presentation equal to most and at least as sophisticated as the finest elsewhere. It skillfully dramatizes the shattering moment of the Guaranis' dispossession and the immense calamity that followed. The show was produced under the direction of Darvin Gazzana for the Secretariat of Tourism of the State of Rio Grande do Sul. It uses actors in the sound track who must surely be among the finest in Brazil.

The night I attended the performance proved ideal. I sat facing the ruins of the Reductions. Hanging in the sky just above me were the Southern Cross and Centaurus, with Orion, Sirius, and Canopus near the zenith. Fortunately there were neither clouds nor moon to distract. When the program ended, the audience, largely a group of lighthearted college students, remained seated for some time in stunned silence. This was more eloquent, I felt, than applause or comment.

Of the seven Reductions in Brazil, only São Miguel has ruins of considerable visual interest. And the Brazilian government is promoting them as a

Cemetery still in use, São Lorenzo

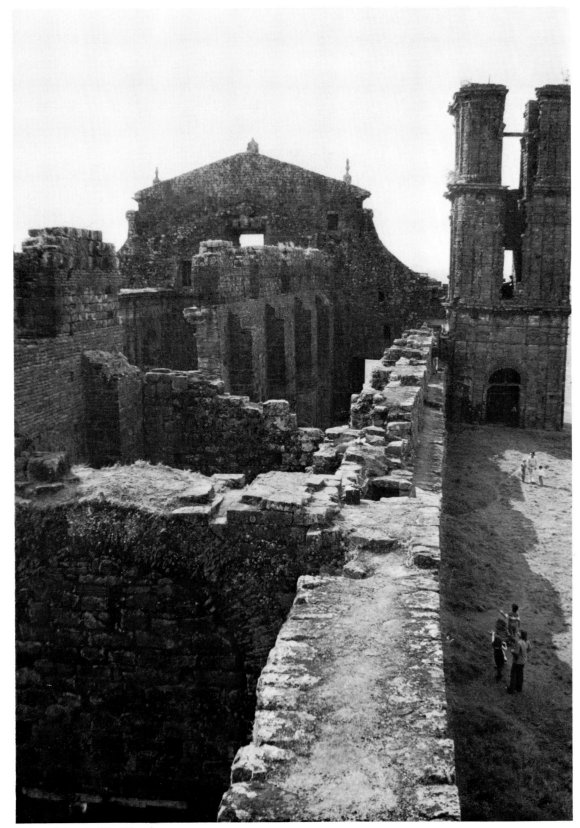

Ruins of church, São Miguel

unique tourist site. Visitors stay in Santo Angelo, today the capital of the region but originally itself a Reduction. Only bits and pieces remain of the former settlement.

The rather modern cathedral of Santo Angelo, however, is interesting as it is an obvious imitation of the old São Miguel church. The facade unmistakably resembles drawings of the older structure. Bruxel suggests that the portico of the latter, now totally destroyed but imitated in the cathedral, was altogether utilitarian, a shelter against rain, a place for gatherings before and after services, an area for solemn receptions for visiting governors, bishops, and provincial superiors, a sort of reviewing stand for plays, parades, and games. Most of the Reductions, with the exception of San Ignacio Mini, had some such covered portico.

The difference in quality of artistic work is nowhere more vividly illustrated than in the facades and towers of today's Santo Angelo cathedral and what remains of the church of São Miguel. Contrast, for example, the high sophistication of São Miguel, despite vandalism and centuries of neglect, with the relative naiveté and standardization of the cathedral. What remains of São Miguel suggests the mastery of a Borromini, as in Rome's *San Carlo alle Quattro Fontane,* as opposed to the mediocrity of latter-day neobaroque which can be found almost anywhere.

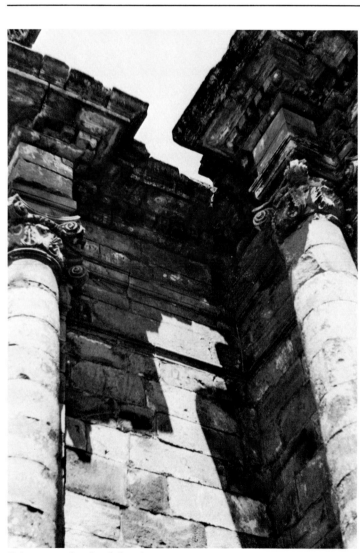

Columns on facade of church
São Miguel

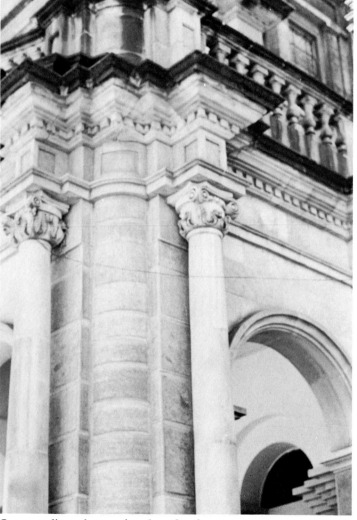

Corresponding columns of modern church
Santo Angelo

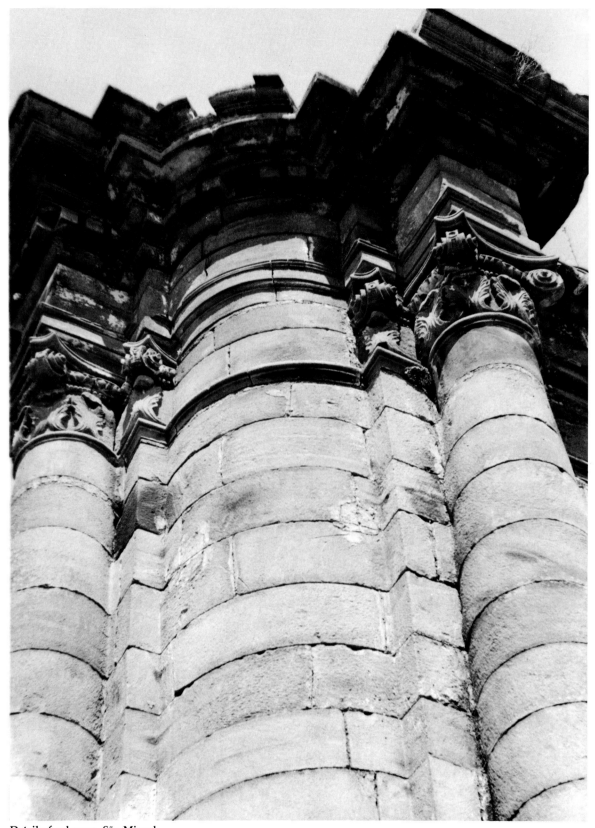

Detail of columns, São Miguel

SÃO MIGUEL

As we noted in the case of San Ignacio Mini, the importance to us of São Miguel is almost accidental. Other Reductions were esteemed greater, yet these others have almost totally perished. While here we have at least the facade, one of the towers, and the interior arches of the church. All are quite splendid.

Founded in 1632 by the martyr Cristóbal de Mendoza and Pablo Benavides, the Reduction of São Miguel, like so many others, had to move only a few years after it was founded to escape the slave-raiding Paulistas. Five years after that it was destroyed by a violent windstorm. It was quickly rebuilt, but grew so rapidly that it had to be moved again to a more fertile site across the Uruguay River to present-day Brazil before it was definitively settled in 1687.

As always, the houses of the Indians were built first, with only a provisional church. Thus it was not until 1700 that work began on the great structure whose ruins we admire today.

In any case, as Busaniche puts it, São Miguel is one of the most daring structures to be found in the Reductions. The facade is "of frankly Roman baroque inspiration, and apart from the arcaded porch, added later, is one of the most handsome and purest examples of colonial architecture, clearly the work of a great architect."

While Furlong states categorically that the architect was Francisco Ribera, he grants that the style hardly coincides with that of his other works. The only argument for a Ribera authorship is the fact that he was the parish priest in

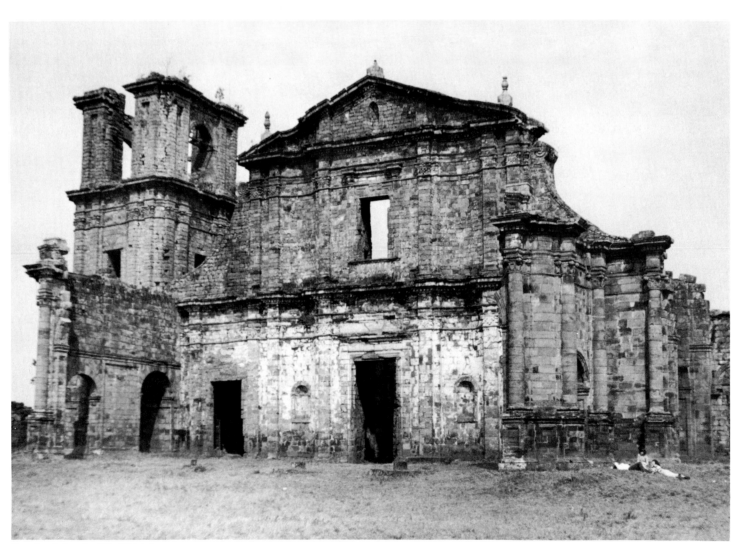

Facade of church, São Miguel

112

São Miguel from 1714 to 1747.

On the other hand, both Busaniche and Bruxel cite Brother Primoli as the architect. Quite possibly Ribera, respecting the superior talents of Primoli, served in the essential but more self-effacing capacity of patron and supporter.

The center of the facade corresponds logically with the great central nave within. The doors leading into the side aisles are linked to the center by volutes such as had become somewhat traditional in Jesuit churches after the construction of the Gesú, the mother church of the Society, in Rome. I find it interesting to compare and contrast the use of volutes in another great colonial building in Brazil, the cathedral of Salvador, Bahía, which had been the Jesuit church before the Society's expulsion.

In São Miguel there were initially two towers. The right one was totally destroyed, probably during the devastation wrought by the armies of Dr. Francia, but the left one has been carefully reconstructed, stone by stone. Its three stories are models of superimposed classical orders. According to Lucas Meyerhofer, the architect whose study and reconstruction work on the building have been invaluable, the church was to have been vaulted and crowned with a dome, much like the Gesú in Rome. He believes that the lack of lime in this part of South America made it impossible to consolidate masonry enough to construct a vault or a dome. This church, then, like most other Reduction churches, would have been completed in wood.

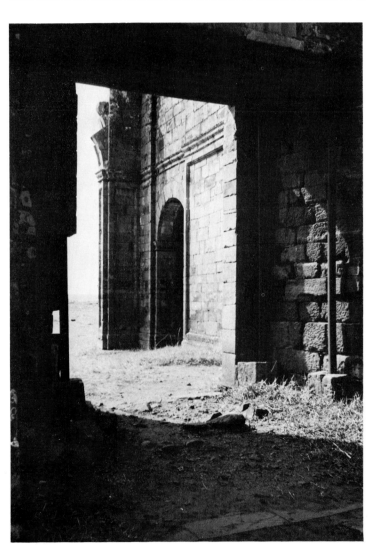

Part of facade of church seen from vestibule
São Miguel

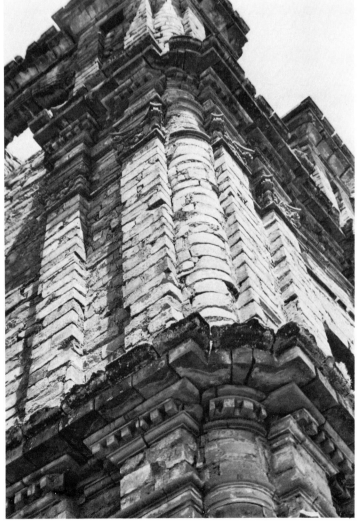

Detail of tower, São Miguel

Nevertheless, the interior must have been imposing. Remains show a central nave some forty feet wide; the two side aisles were each twenty feet wide. Massive pillars with their own pilasters suggest structural strength that would have supported stone vaulting. The sloping roofs, according to Meyerhofer, were covered with tile. The baptistry, long gone, was described as surfaced with glaze work with gilded molding.

My first awareness of São Miguel goes back to 1976 in Rio de Janeiro where I was privileged to meet Lucio Costa. He had worked with Lucas Meyerhofer on the restoration of São Miguel. Mr. Costa, more famed for his work with Oscar Niemeyer in designing the modern capital of Brasilia, was kind enough to spend hours with me pouring over his hundreds of photographs of São Miguel. He obviously relished the opportunity to do this. Though I was not to visit São Miguel for another five years, this introduction proved fascinating and enlightening to me.

The present museum of São Miguel, a replica of a typical Indian house on the corner of the great plaza, was sponsored by the Directors of the National Historic and Artistic Patrimony. The building was erected according to plans drawn up by Lucio Costa. It contains some of the finest Reduction statues accessible to the general public, four of them are included in Germain Bazin's volume *The Baroque*.

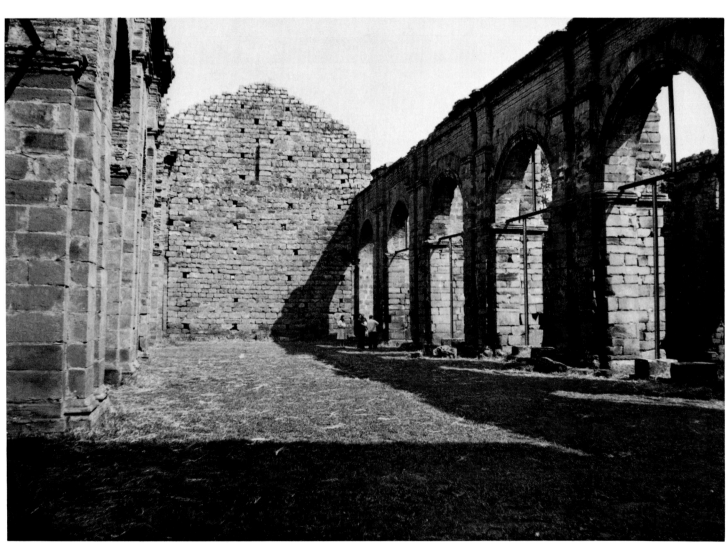

Nave of the church, São Miguel

Cross and museum seen from the plaza
São Miguel

115

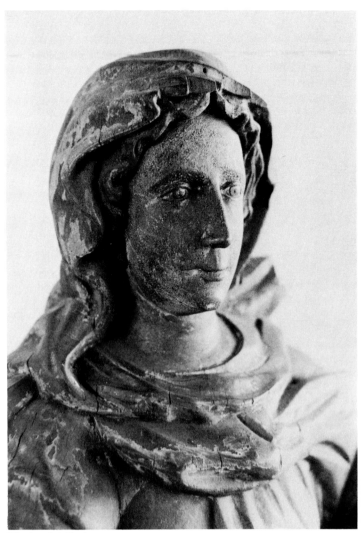

Virgin, detail of statue
São Miguel

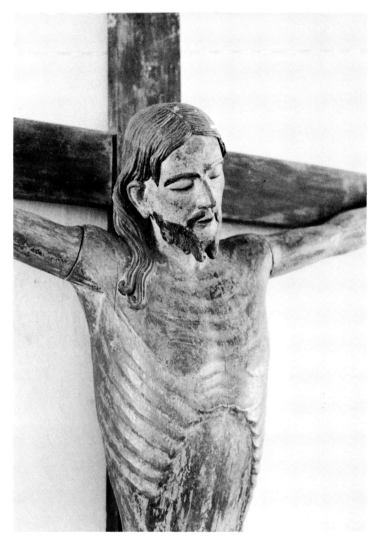

Crucifixion, São Miguel

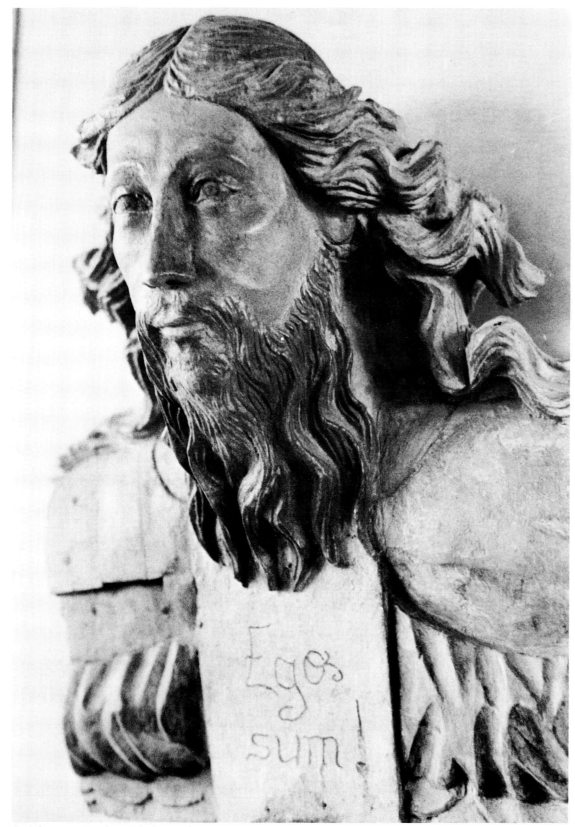

God the Eternal Father with the words "I Am"
São Miguel

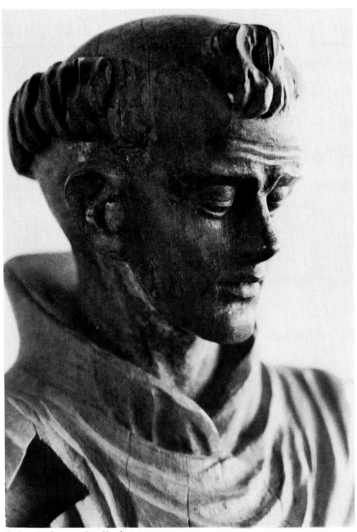

Saint Anthony, detail of statue
São Miguel

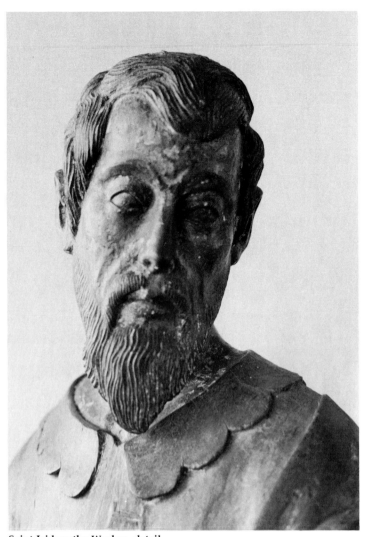

Saint Isidore the Worker, detail
São Miguel

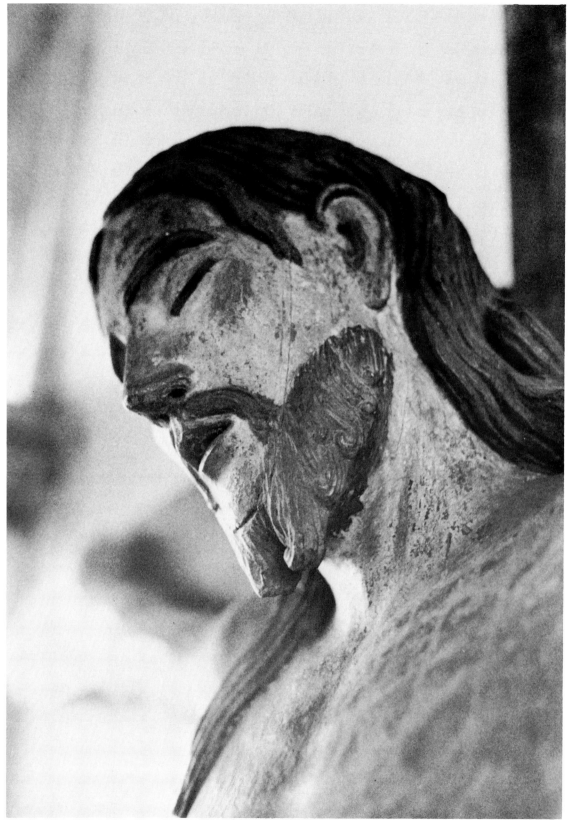

Detail of Crucifixion, São Miguel

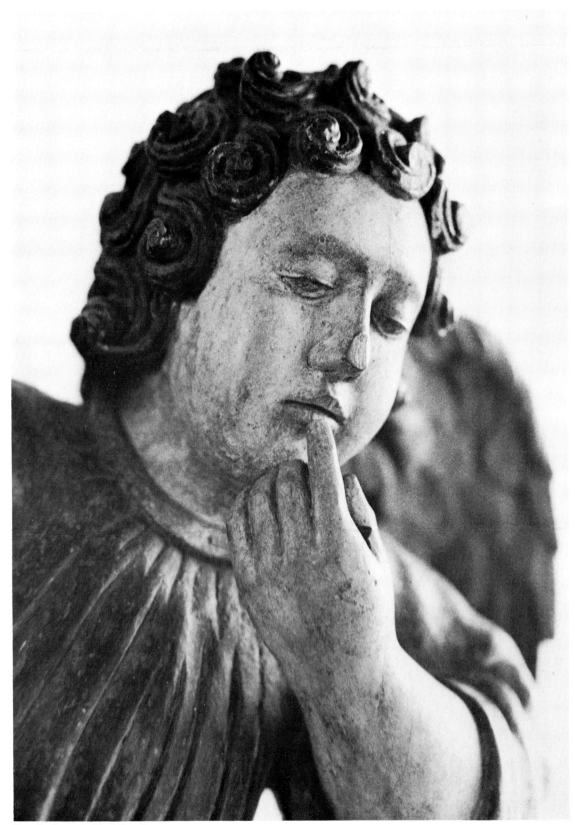

Detail of angel, São Miguel

Time and vandalism have dealt harshly with the remaining six Reductions in present-day Brazil. We are indebted to the historian Aurélio Porto whose study, published by the National Historic and Artistic Patrimony, includes just about everything that can be said on the subject. Accordingly, what follows is a brief summary of his work.

The first settlement of São Nicolás was established in 1626 by Roque González with his associate Miguel de Ampuero. São Nicolás had to move from its original location to the other side of the Uruguay River between Santa María and Concepción. Following Paulista raids, the community moved back across the river where it was refounded in 1687. Three years later it was destroyed by a hurricane, then again by fire. Thereupon tile factories were built to provide safer roofs for the buildings and houses. São Nicolás quickly became an important center of arts and crafts, carpentry, painting, woodwork, and gilding. But aside from a well-constructed stone arch, hardly anything remains today of this once important city.

Detail of bell tower, São Miguel

Mission bell with the inscription, "St. Michael, pray for us" São Miguel

São Francisco de Borja is actually the oldest of the Seven Cities founded on the Brazil side of the Uruguay River. It was an off-shoot of Santo Tomé on the Argentine side. Its population grew rapidly and the town soon needed a major church. In 1696 Brother Brasanelli arrived to serve as architect. This versatile brother, skilled also in military science, helped organize the city's defense against the Paulistas. He stayed on to supervise the construction of the church and to carve, in the words of a contemporary, "precious statues and magnificent altars."

Unfortunately we have neither plans nor documents to give us a clear idea of São Borja's church and hardly a trace of ruins remain. But the modern church possesses a fine statue of St. Francis Borgia.

São Luís Gonzaga, Aloysius Gonzaga as we say in English, is a modern town that stands on the site of the original Reduction. It was founded by the martyrs Alonso del Castillo and Miguel Fernández. The latter, like Roque González, was a native of Asunción; he was also the first pastor of São Luís. His contemporaries speak of him as having an exceptional mastery of the Guaraní language; he was also gifted with a warm manner of dealing with the Indians. Fernández was succeeded as pastor by another Asunceno, Francisco de Avedaño. The church was described as quite handsome, with stone walls, wooden vaulting, and a dome. It, too, was totally destroyed in the colonial wars.

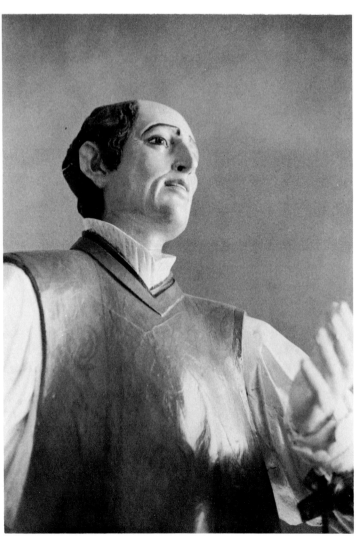

Saint Francis Borgia, São Borja

Candlestick, Museum of São Borja

São Lorenzo and Santo Angelo suffered the same fate; though, as we noted above, Santo Angelo is today the capital of the department appropriately called Missões ("missions").

There remains São João Batista. It has few archeological traces but is memorable as the creation of one of the truly outstanding missioners who labored in the Reductions, Father Anton Sepp, (1655-1733).

ANTON SEPP

Anton Sepp belonged to a noble Tirolese family from Kaltern. The full family name was Sepp von Seppenburg zu Salegg. The town of Kaltern, now known as Caldaro, lies in that part of the Tirol which today belongs to Italy. I am following the work of Artur Rabuske, the leading specialist on Sepp, who has discovered a great deal of information which corrects previous biographies.

Anton Sepp was born on November 22, the feast of St. Cecilia, patroness of musicians. Whether or not this circumstance stirred an early interest in music, we do not know. What we do know is that the young Sepp was musically gifted enough to be sent to Vienna where he became a member of the famed Vienna Boys Choir attached to the imperial court. (As a musician myself, I naturally noted the coincidence that Sepp was to die the year after the birth of Josef Haydn, another musical lad who would be sent to Vienna to learn to sing.)

Baptismal font, Museum of São Luis

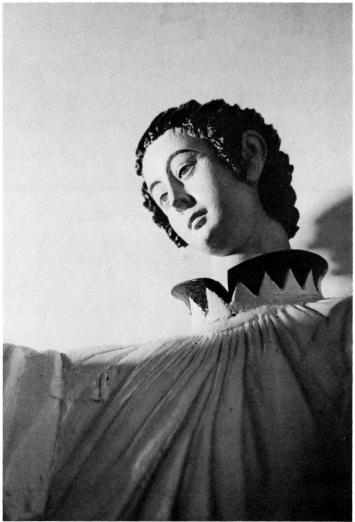

Saint Aloysius Gonzaga, Museum of São Luis

If this book were a survey of the music of the Reductions, the chapter on Anton Sepp would have to be substantial indeed. Before leaving Europe to work in the Reductions, Anton did serious music studies in Augsburg. It was there that he mastered the "figured bass" technique fundamental to the baroque style. His contemporaries refer to his "mastery" of some twenty instruments, among them the flute, fife, cornet, trumpet, clarinet, viola, other stringed instruments, and the sackbut, a sort of trombone.

Sepp's lost compositions, though probably not of enormous consequence in strictly musical terms, were geared to the needs of his charges. His music ranged from the more popular to the rather elaborately polyphonic. He was at least a versatile amateur, a musical factotum of the type that was incomparably valuable in the missions.

In any case, Anton Sepp provided a major impetus to artistic music in this region of America well before William Billings made his major contribution to music in North America. It was Sepp who founded the music school at Yapeyú where the more musically gifted Indians from other Reductions went for advanced study. Sepp was also a skilled maker of violins and other instruments. In fact, he made the very first pipe organ with pedals in the whole of Latin America. Paraguayans venerate Anton Sepp as the man who introduced their national instrument, the harp, which is played on every possible occasion.

Before becoming a Jesuit, Anton Sepp spent some time in London, presumably for advanced work in

Baptismal font in church, detail
São Borja

music, as Mozart would do in the following century. Some time later, while working in the missions, Sepp would write home: "My greatest recreation is practicing the harp half an hour every day. Today, however, I had to skip this, since I had promised to teach the Indians some dances I learned back in Innsbruck. These Guaranís have dancing in their blood!"

Sepp entered the Society of Jesus at the age of nineteen and went through the customary course of studies. This included three years of teaching before ordination. During this time of teaching he was director of music at the Jesuit school in Landsberg. He studied theology in Ingolstadt and was ordained a priest in Eichstaett on May 24, 1687. After his ordination, Sepp taught rhetoric and music. During this time he did further study under the well-known composer Johann Melchior Gletle, director of music in the cathedral. Later on, Sepp would frequently write home for more compositions by Gletle. At this time Sepp also wrote several plays which are still preserved in the archives of the Munich university library.

Sepp had volunteered for the missions as a young Jesuit, but he had to wait eight years before he was assigned to South America. He was finally able to embark from Cadiz on January 17, 1691 and reached Buenos Aires three and a half months later on April 6.

Sepp's diary makes for good reading. He writes in detail about his long wait in Cadiz and the harrowing transatlantic voyage. He vividly describes the ship's cabin: "I could hardly lie down, much less stand, but my poor companion, Anton Boehm,

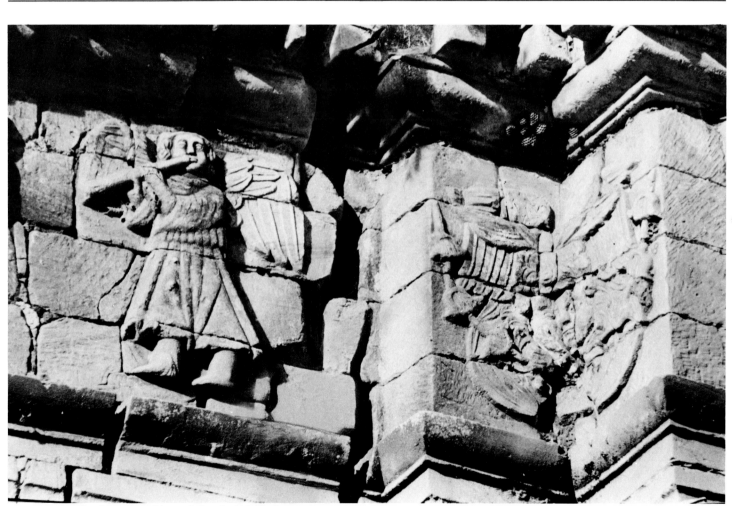

Angel playing the flute, from frieze of church, Trinidad

couldn't even stretch out to sleep." He describes the odors, the welcome rain, "water had become so foul on board that we drank the rain from our hats as though it were vintage wine," the flintlike bread, "yet somehow the worms managed to get in," the bedbugs, fleas and lice "that had embarked with us to go to America, too."

Sepp's diary became so popular in Europe that it was quickly published in several foreign languages. The English translation appeared, in fact, in 1697, just six years after the voyage,

at a time when Jesuits were thoroughly proscribed in England; this was less than twenty years after the Titus Oates Plot rocked that country with anti-Jesuit hatred. While I have not had the chance to read this translation, the title page is so flavorful that it is worth recording here: "An account of A Voyage from Spain to Paraguay, Perform'd by the Reverend Fathers Anthony Sepp and Anthony Behmes, Both German Jesuits, The first of Tyrol upon the River Eth, the other of Bavaria: Containing a Description of all the remarkable things, and the

Inhabitants, as well as of the Missioners residing in that Country. Taken from the Letters of the said Anthony Sepp, and published by his own brother Gabriel Sepp. Translated from the High Dutch Original, printed at Nuremberg, 1697. Printed for Henry Lintot, and John Osborn, at the Golden-Ball in Paternoster Row."

Artur Rabuske's new study of Sepp is titled *P. Antonio Sepp, S.J., O Gênio das Reduções Guaranis* ("The Genius of the Guaraní Reductions"). Rabuske grants that the term *genius* is commonly used all too loosely, in a sort

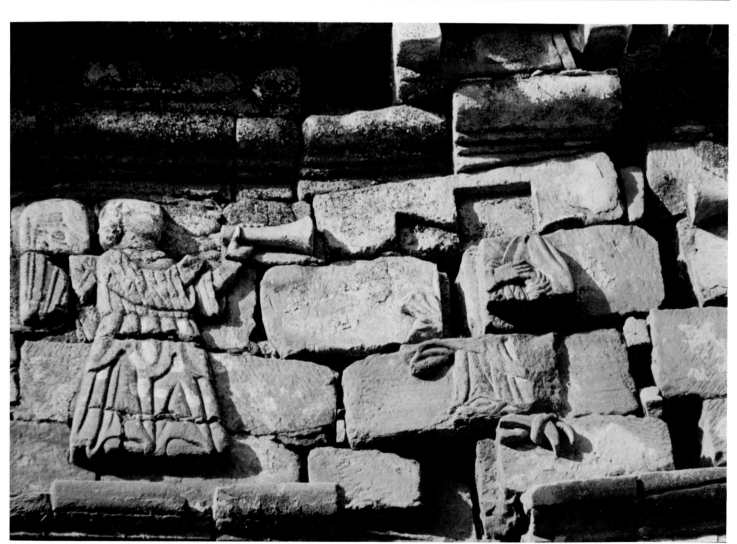

Angel musicians, frieze of church, Trinidad

of verbal inflation, for anyone at all extraordinary. While not attempting to define the word *genius,* Rabuske uses it in the sense of a "person possessing a high degree of creative or inventive ability above the common measure, one whose achievements elicit exceptional admiration, even a sense of awe or astonishment in normal people." All those who knew Sepp and worked with him certainly shared this opinion. The Indians even believed him to be some sort of demigod.

Rabuske lists some of Sepp's specific achievements: the founding of the São João Batista Reduction, with documents giving detailed descriptions of techniques used; the discovery and development of iron in this part of the world, as an impressive monument in Santo Angelo testifies; the organization of the economy that brought the Reductions to their greatest state of stability; the creation of the wine and cotton industries in this part of South America; the construction of the first pipe organ with pedal in all Latin America; many translations into German of the classic works of Antônio Vieira, S.J. (1609-97), recognized as the master of Brazilian prose; authorship of an invaluable book, *Gobernio Temporal,* a sort of "how-to" manual about growing corn, vines, maté, and tobacco, how to raise sheep and cattle, and how to construct buildings in adobe and other materials. In addition, Sepp was known as an exceptional master of the Guaraní language, despite the age at which he began studying it. Sepp also wrote original plays in Guaraní with his own musical accompaniment. He even admitted that he felt more at home preaching in Guaraní than in his native German.

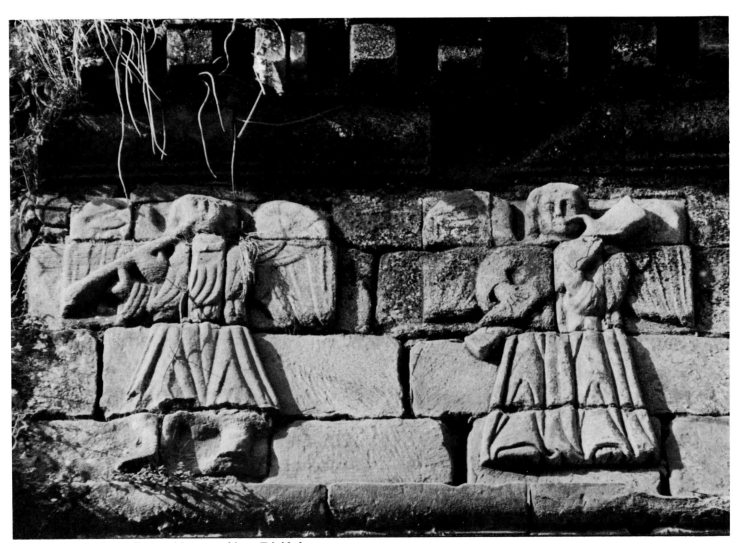

Angel musicians playing flute and bassoon, frieze, Trinidad

While poking around in archives, I ran across an interesting letter from the Swiss missioner Anton Betschon who arrived in Sepp's Sao Joao Batista Reduction in 1719 after a two month journey up the river. The reception, he says, was warm and polyglot. Indian youngsters greeted him in German, Latin, Spanish, and Guaraní. Sepp himself spoke German, but it was, as Betschon wryly reports, "without fluency" since "for 27 years he hadn't had much chance to speak German."

In his last words Anton Sepp gave thanks to God, for, as he said, "I believe that in all my work of whatever sort, I have had no other motive than the love of God." Perhaps Sepp was a saint as well as a multifaceted man of action.

In Reduction literature Anton Sepp is most often referred to as a musical missioner and, as mentioned, father of the Paraguayan national instrument, the harp. Music obviously played a major role in the evangelization of Latin America. As early as 1527 the Franciscan Pedro de Gante founded a school stressing music in Mexico. Some time before 1553 the Jesuit Leonard Nunes had founded a music school in São Vicente, Brazil.

Manuel de Nóbrega, founder of the Jesuit mission of Brazil, was often quoted as saying that "with music and harmony of voices" he could win all the "gentiles" to Christ. The first Paraguay missioners in the Guairá area, Fields, Ortega, and Saloni, already knew from their Brazilian experience how useful music was. They further reported that the Guaranís seemed to be more musically gifted than other Indians.

Rosette on church wall, Trinidad

Even before Sepp arrived, the music tradition of the Reductions had been well established and developed by Fathers Jean Vaisseau and Louis Berger. The latter had been professionally trained in France before he became a Jesuit. Music became very much a part of daily life, and it was especially prominent in the great liturgies described by European visitors as rivaling anything they had heard in the cathedrals of Spain, Italy, or France. Much of the music was sung by choirs of forty trained voices with as many as twenty instruments accompanying the vocal counterpoint.

Music was also quite naturally related to drama and dance. Again, both visitors and missioners like José Cardiel go into great detail describing choreography and costuming. And when the Jesuits were dispossessed, inventories of each mission showed an immense range of costumes and scenic properties. Both dances and plays had religious or moral themes, much like the *Autos Sacramentales* of the period. And they often went on for hours.

In her article "Jesuit Drama" in *The Oxford Companion to the Theatre*, Edna Purdie observes: "The desire to present abstract conceptions in visually attractive and therefore easily acceptable form was a powerful factor in the development of technical methods of production. And in this aspect of the art of the theatre the Jesuit drama was pre-eminent, its only contemporary rival being the opera. . . . At the least, the plays at the Jesuit colleges may be said to have constituted in the 17th and early 18th centuries a link between opera and drama, and to have furthered technical advances in the production of both." (p. 422) While Purdie is writing

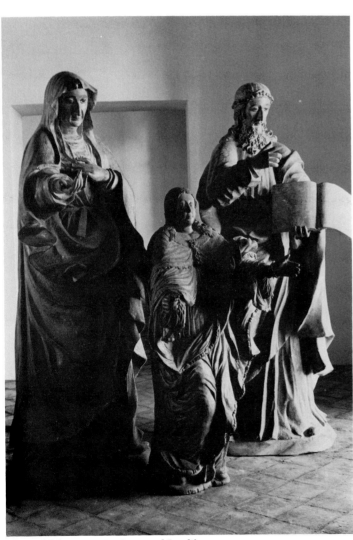

Mary with her parents, Anne and Joachim
Museum of Santa Maŕia

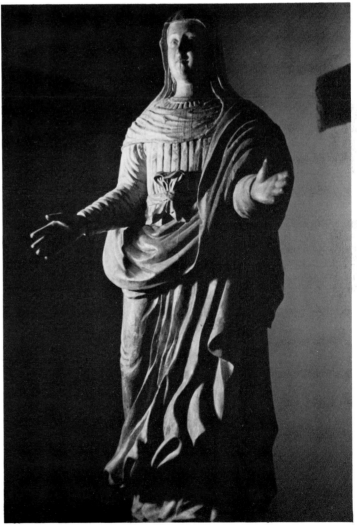

Virgin Mary meeting Christ
Museum of San Ignacio

especially about Jesuit drama in Europe, we know that the same tradition existed in Latin America, and not least in the Reductions.

Further, as Cardiel and others wrote, music played a major role in the more pedestrian aspects of Reduction life. Groups of workers setting out for the *estancias* were accompanied by instrumentalists clad in their special garb. Rodeos and processions and receptions for governors and other visitors were always enhanced by music. Even the election of officials was celebrated by an instrumental performance. In a very broad sense, while not as omnipresent or impersonal as Muzak, the sounds of music were very much a part of Reduction life and even offered something of what we call today "music therapy." When describing the tone of festivity, music, and costuming, Cardiel bursts into a rare subjective comment, "Really, it is a sight to see!"

DOMENICO ZIPOLI

Somewhat ironically, it seems to me, the best trained musician destined to work in the Reductions never actually arrived in present-day Paraguay. Domenico Zipoli, whose music is now well-known to musicologists, organists, and other keyboard artists in Europe and America, was born on October 17, 1688. He was thus a contemporary of Bach and Handel, and of the great Italian baroque master Domenico Scarlatti. Zipoli was born in Prato, a suburb of Florence. Since there had been some doubt about both the place and date of Zipoli's birth, I did some personal investigation several years ago, and thanks to the help of the parish priest of Prato, I found the document registering Domenico's birth there.

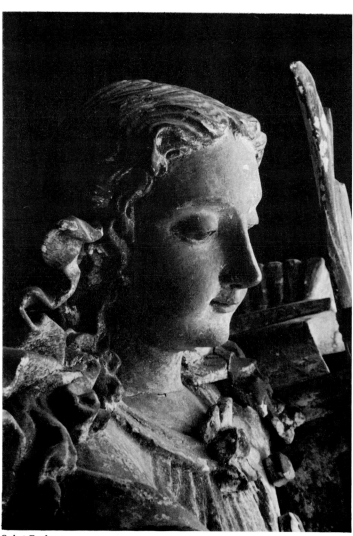

Saint Barbara
Museum of Santa María

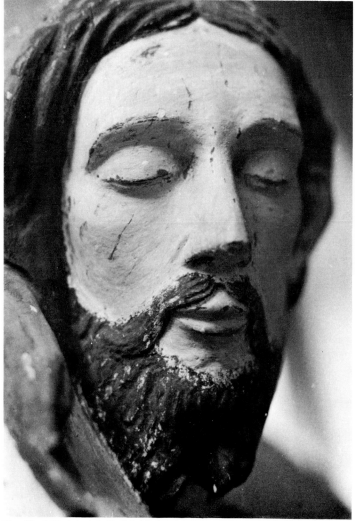

Crucified Christ, detail, Trinidad

Later, as a professional organist and composer, Zipoli served in what was then the important post of music master at the Gesú Church in Rome. There he published a classic study of organ performance, a number of keyboard compositions (recently republished by Luigi Ferdinando Tagliavini), composed two operas, and came into close contact with Jesuits. This led to his learning something of the romance of the Reductions and eventually to his applying to become a Jesuit. Like many other aspiring missioners, Domenico Zipoli had a long wait in Seville before he embarked for South America. During his three months in Seville, he performed frequently and was invited to remain there. But he was not diverted from his missionary goal.

As we mentioned earlier, Zipoli sailed for Buenos Aires on the same ship with Brother Primoli. From Buenos Aires he went on to do theological studies in Córdoba. There he found time to perform and to compose. He wrote music especially for use in the Reductions, but he also did some commissioned work for the Viceroy in Lima. Domenico Zipoli died on January 2, 1726, of consumption.

Zipoli's compositions quickly became the most popular in the Reductions. One missioner wrote that after hearing them he could not be satisfied with any other composer. Even long after his death, Zipoli's music continued to be immensely popular in the missions. His compositions were also widely performed in Bolivia and some of them have recently been found there in choir lofts or stored away in trunks.

Indeed, the lost compositions of Domenico Zipoli must rank high

Detail of closet door
Museum of Santa Marîa

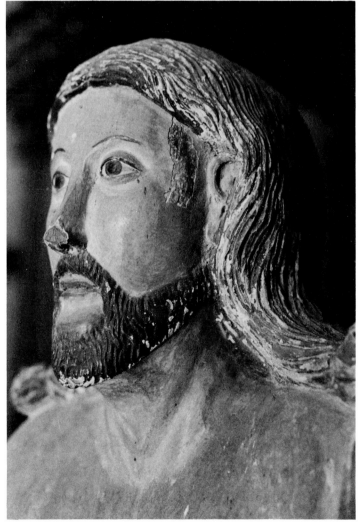

Risen Christ, Museum of Santa Marîa

among the serious cultural losses sustained when the Reduction libraries were destroyed or dismantled. We are fortunate, however, to have at least eight of them now easily accessible on records.

Of these recordings, the most remarkable known to me is a "Gloria" stylistically performed by the eminent American conductor Roger Wagner. The piece may be heard on "Festival of Early Latin American Music." The record comes with perceptive notes by the most esteemed student of this music, Robert Louis Stevenson. (Eldorado label, UCLA Latin American Center, Los Angeles, CA 90024).

In his notes Dr. Stevenson praises Zipoli for "timing his modulations exquisitely, never belaboring any imitative points, making of conciseness a cardinal virtue, and writing tunes instead of dry contrapuntal lines." At the same time I take very mild exception to Dr. Stevenson's referring to Zipoli's being "one of many excellent musicians recruited by the Society of Jesus for missionary work" in the Reductions. As we have already pointed out, these missioners were not "recruited" but chosen from among volunteers; and they were surely chosen for reasons far more compelling than artistic competence.

Given the pervasive place of music in the Reductions, it is no wonder that René Fülöp-Miller in his journalistic, uneven, but very readable *The Power and Secret of the Jesuits,* saw fit to title a section on Paraguay "The Musical State of the Jesuits." An exaggeration, to be sure, but perhaps a forgivable one.

Detail of retable in church
San Ignacio Guazú

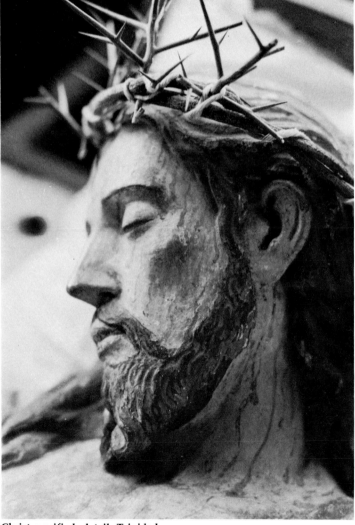

Christ crucified, detail, Trinidad

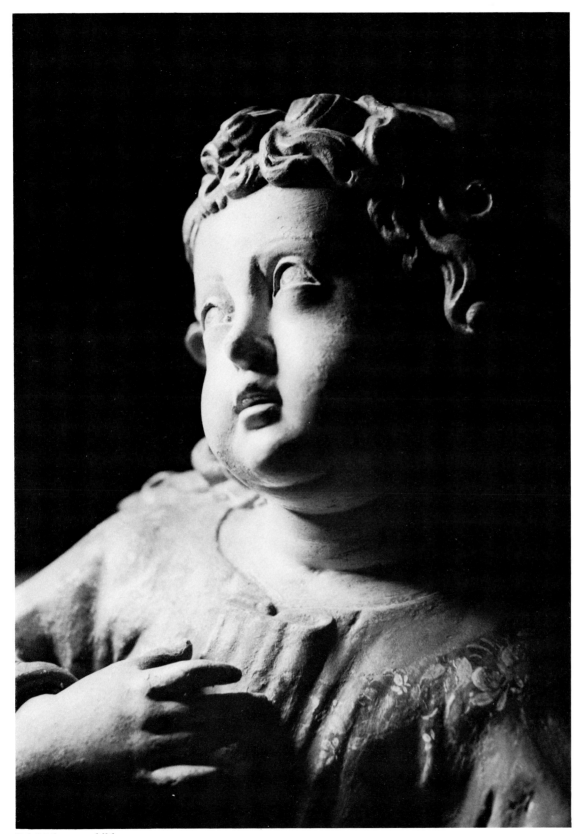

Saint John as a child
Museum of São Borja

GUARANÍ BAROQUE

Five years ago, during my first visit to the ruins of the Jesuit Reductions, I coined, as I thought, the phrase, "Guaraní Baroque." The very year before, however, Josefina Plá had used almost the same phrase as the title of her comprehensive work dealing with the arts of the Reductions, *El Bárroco Hispano-Guarani.*

Her title is surely more suggestive and generally more precise than mine. Yet one may cavil at the restriction implied in "Hispano," which would appear to exclude many, perhaps the very greatest, artists of the Reductions:

Italians like Primoli, Brasanelli, Zipoli; The Frenchman Berger; the Austrian-Tirolese Sepp; to mention only a few. None of these, one suspects, would relish being dubbed "hispanic."

My title, "Guaraní Baroque," is again somewhat too restrictive, since the prime artistic masters and teachers were Europeans by birth and training. But how does one cope with "Jesuit-European-Guaraní Baroque"? Further, it may be questioned whether all the art presented in this book is even baroque at all.

If we take the term to mean the period of art history in Europe and the European colonies from about 1580 to 1780 or so, as Germain Bazin does in his authoritative study *The Baroque,* then the problem is easily solved. For all the work mentioned here is clearly baroque in time—architecture, sculpture, painting, the minor arts, and even music.

Bazin finds many kinds of baroque existing simultaneously in Europe and the colonies. On a single page, 274 for example, he reproduces four statues contained in the museum of São

Paraguayan boy with angel from Reduction

Miguel Reduction illustrating, as he says, "all the great styles of Western art: Romanesque, Gothic, Renaissance, and Mannerism." I found it somewhat comforting to find that I had selected the same four statues to photograph when I visited São Miguel before I had studied Bazin in detail.

In another of his works, *Baroque and Rococo*, Bazin quotes Heinrich Wöllflin's now classic distinction between the two tendencies found alternately in the history of art: the classical and the baroque. In a word, classical art, of whatever period, goes beyond the disorder of appearances to seek the deeper underlying order of reality, while baroque art enters rather into the multiplicity of phenomena, the flux of things in their perpetual process of becoming. Whereas the classical tends to be simple, clear, and enclosed within limits, the baroque prefers fluid forms that seem to take flight, dynamic forms expanding beyond boundaries. In any case, all modern historians of the arts say something roughly equivalent to this. Scholars have long abandoned the derogatory use of the word "baroque" as meaning overdone or overornate, though it is still sometimes used in this sense by people who have not read a book on art in years.

Since the term "baroque" was not in common use during the era of the Reductions, it is unlikely that any of the Jesuits, much less any of the Guaraní Indians, thought of their work as baroque. Their concern was to create, for the glory of God and the good of His people, churches, colleges, statues, retables, and music, quite simply as well done and as beautiful as their gifts and means allowed. In this

Detail of retable in a church, San Ignacio Guazú

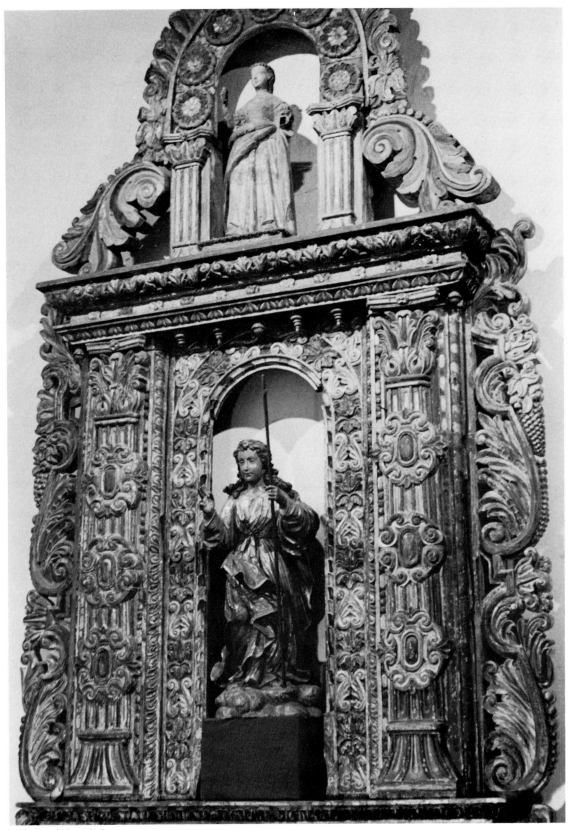

Retable of chapel altar
Museum of San Ignacio Guazú

they were following Vitruvius, perhaps even consciously, since his book was found in the Reduction libraries. His classic formulation of good construction held that a work must be well done, useful, and should delight the eye or ear; *firmitas, utilitas, venustas.*

The Jesuits who built and staffed the Reductions did not start from a cultural vacuum. Even those not professionally trained as artists had grown up in the baroque culture, exposed to its diversity and its glory. In Europe they had lived in an environment where Romanesque, Gothic, Renaissance, and Mannerist styles coexisted, often within the same building. They had observed and prayed before statues and paintings from a broad range of epochs. All this was part of the manifold cultural baggage they carried on their transatlantic journey.

Baroque culture is perhaps most perceptively described by Christopher Dawson in his Harvard lectures, "The Dividing of Christianity," as "an international movement which drew on all the different religious traditions that had already begun to make themselves felt in the earlier part of the 17th century, especially in Spain and Italy." Among these he lists Christian humanism, Italian mysticism and pietism, Spanish mysticism and "the moral dynamism of St. Ignatius and the Society of Jesus."

Dawson and his friend E. I. Watkin, as well as later cultural historians, find that "Baroque art is more akin to the art of the Middle Ages than to the rational idealism of the classical Renaissance; it expressed in fact the Gothic spirit through classical forms." They noted that Gothic architecture

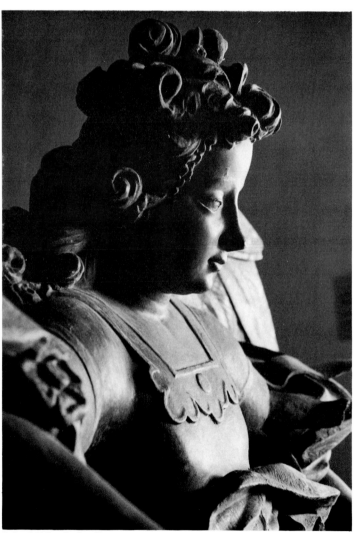

Saint Michael, detail
Museum of Santa María

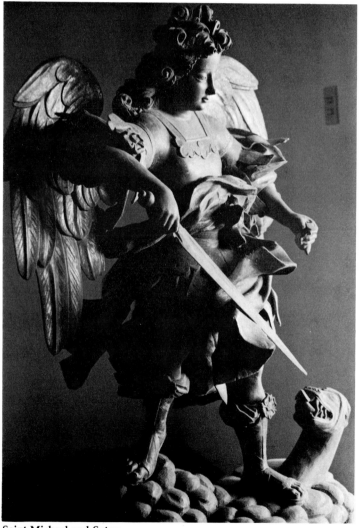

Saint Michael and Satan
Museum of Santa María

and baroque are alike in their attempt to transcend the limits of matter and space by mobility of line and a restless striving after infinity.

Thus baroque art often shows an extraordinary luxuriance of imagery and ornament, using every available space and making every church a "treasury of religious symbolism." Dawson shows that baroque is "a new religious art which represents a popularization of the more aristocratic Renaissance tradition and molded the popular taste of the Catholic world from Mexico and Peru to Hungary and Poland." This, of course, includes the Paraguay Reductions, for there as much as anywhere we find the "power of baroque culture to assimilate influences" plus a "rich flowering of regional types, some of which show considerable indigenous Indian influences." We have already observed this in some detail.

As there exists a baroque style of architecture, sculpture, painting, and music, so too scholars speak of the baroque city. Baroque Rome is almost the creation of Pope Sixtus V (pope from 1585-90), who worked with Domenico Fontana to bring order out of chaos. Great avenues were built to facilitate the flow of traffic and to provide perspective. The traffic, of course, was that of pilgrimages, long before the advent of the automobile. And though the supreme Roman baroque master Bernini later preferred surprise to perspective, the greatest surprise of all was his vast piazza of St. Peter's. This worked until Mussolini built the Via della Conciliazione, frustrating Bernini's purpose but paradoxically achieving an even more "baroque," if somewhat obvious, effect.

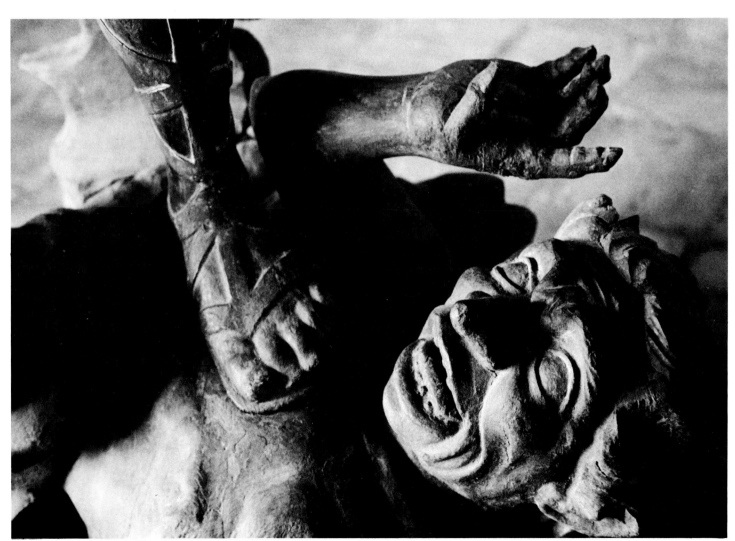

Demon, detail of statue with Saint Michael Museum of Santa María

Spanish baroque towns were centered on the *plaza mayor* which served as a sort of public theater for religious ceremonies, plays, processions, and even bullfights. French baroque cities stressed vistas on a grandiose scale. Washington, D.C., the creation of the French planner Pierre L'Enfant, is at least in design a baroque city. So was St. Petersburg, Russia's new capital under Peter the Great, again designed by a Frenchman, Francois LeBlond.

I find it interesting, too, that the great city planner, Lucio Costa, who designed the modern capital Brasilia, is a serious student of the Reductions. While it would be excessive to suggest that Brasilia is baroque in the same sense as the older capitals just mentioned, the vistaed focus on the Congress buildings reminds me of a secular equivalent of the Reductions' focus on the church.

The Reductions, centered around the *plaza de armas,* are obviously close to the Spanish concept, while suggesting a Roman-French interest in vistas. True, there are no large avenues. But all the streets connect with the plaza whose visual focus is the facade of the church. This highly ornamented facade may, in fact, be thought of as a sort of baroque outdoor reredos through which the faithful enter into the splendor of God's house.

In a major article, Ramón Gutiérrez points out that "this sense of urban elements possesses, like art and architecture, a didactic meaning regarding what is important and is a reflection of the concept of baroque persuasion." After all and before all, the Reductions were places of Christian instruction and accordingly of Christian living.

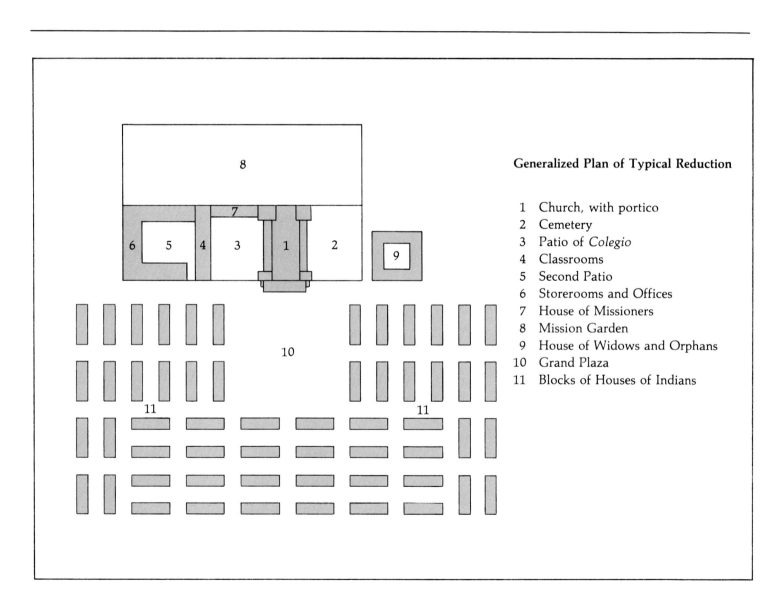

Generalized Plan of Typical Reduction

1 Church, with portico
2 Cemetery
3 Patio of *Colegio*
4 Classrooms
5 Second Patio
6 Storerooms and Offices
7 House of Missioners
8 Mission Garden
9 House of Widows and Orphans
10 Grand Plaza
11 Blocks of Houses of Indians

Gutiérrez also points out that the high development of music in the Reductions, in church services, in outdoor processions, and even in parades on the way to work on the *estancias*, was all part of the same catechetical pedagogy. The "cosmovision" of the Guaranís, their love of the outdoors and closeness to nature, were not only not diminished by the missioners, but enhanced and integrated into a rich Christian life and expression.

A noteworthy difference between the baroque city planning of the Reductions and that of more secular cities is that the center of interest in the Reductions is always on God, the King of the universe, and not on any earthly ruler. It is sacral, not merely secular space. Noticeably, almost sacramentally, the House of God and of God's people, not the house of the missioners, is the focal point of the Reduction. On one side, to be sure, is the *colegio,* for the use of priests and people; but correspondingly, on the other side, is the cemetery, the dedicated resting place of the people. It too is sacred space.

Hardly anyone brought up in the twentieth century can fail to feel a bit queasy when first encountering the splendors of baroque Rome. I recall feeling a twinge of discomfort when I first visited St. Peter's. Willy-nilly I had been trapped by what Kenneth Clark calls "conditioning by generations of liberal, Protestant historians who tell us that no society based on obedience, repression, and superstition can be really civilized." Lord Clark goes on: "But no one with an ounce of historical feeling or philosophic detachment can be blind

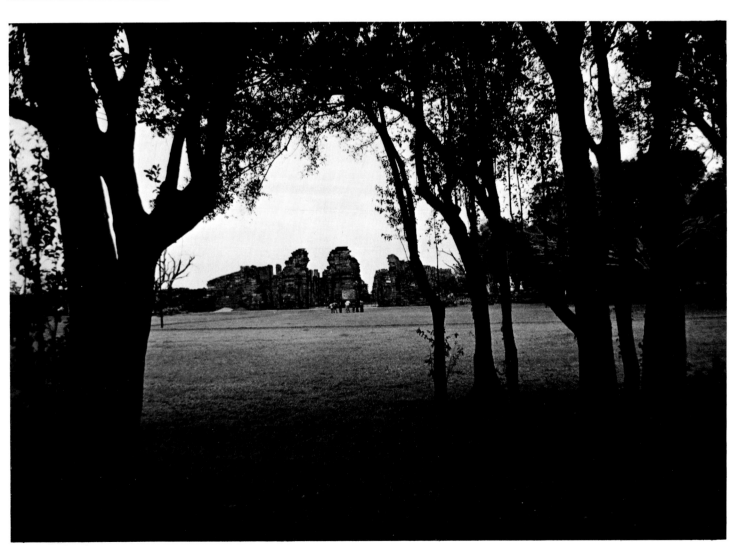

**Plaza and church
San Ignacio Mini**

to the great ideals, to the passionate belief in sanctity, to the expenditure of human genius in the service of God, which are made triumphantly visible to us with every step we take in Baroque Rome. Whatever it is, it isn't barbarian or provincial."

On a far less overpowering scale, the baroque art and architecture of the Reductions may evoke some such feelings. Modest as they are when compared to the glory of St. Peter's, the churches of the Reductions must have produced something like "awe and fear in the minds of the native people," to quote Nicholas Cushner, not to mention envy in the hearts of colonials who occasionally managed to see them or who heard them described.

A further observation of Kenneth Clark's regarding baroque Rome suggests something quite relevant about the Reduction churches as well. The baroque style, he says, was "a popular movement; it gave ordinary people a means of satisfying, through ritual, images, and symbols, their deepest impulses, so that their minds were at peace." Even the most confirmed secular humanist should recognize a real value here. And there is no spark of evidence that the Guaranís were other than delighted, not merely awed, by such splendor. This comes close to Otto's concept of the "holy" as something both *fascinans* and *tremendum*.

As was the case in medieval cathedral cities, the people of the Reductions were particularly proud of their churches. They engaged in a quite human if not altogether holy rivalry. We know this from documents. In any event, the churches were truly their own, built and adorned by them and

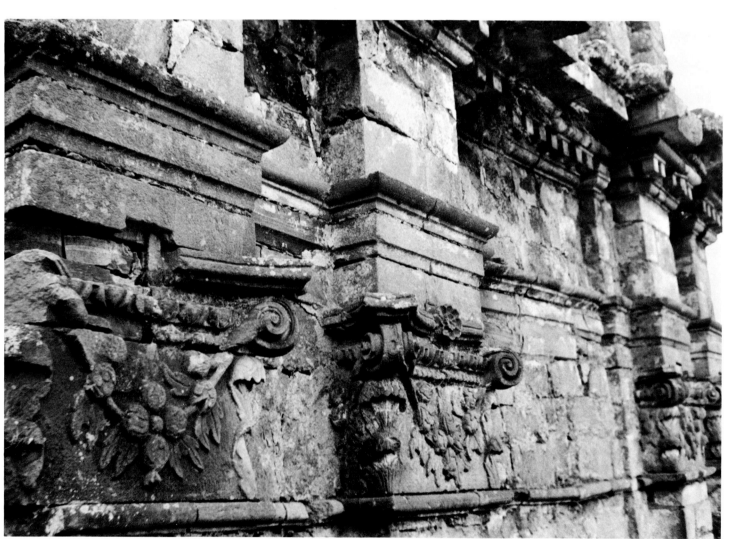

Capitals and cornices of bell tower
São Miguel

for them. To these people, the house of God was no less the house of the people of God. If any Guaraní ever heard of Jansenism or of its dour "saint" Mère Angélique Arnauld, I suspect he would have laughed at her assertion, "I love all that is ugly; art is nothing but lies and vanity; whatsoever gives to the senses takes away from God."

At the same time, the art of the Reductions, like religious art of whatever epoch, Byzantine, Romanesque, or Gothic, was anything but "art for art's sake." Missioners and Guaranís alike would have resonated far more to Bach's repeated formula: all music is for the glory of God and the good of souls. Such a transcendental purpose has never inhibited authentic artists in their quest for excellence. Rather the contrary. Creativity thrives on tension, and the tension between excessive self-glorification and selfless motivation in a great artist has been unforgettably interpreted by Dorothy Sayers in her play about the medieval architect William of Sens, *The Zeal of Thy House*.

MESTIZO ART

A word now about the problem of mestizo art and whether or not we may properly call the art of the Reductions by this name. There has been much discussion of this topic ever since the Argentine art historian Angel Guido first used or at least popularized the term *estilo mestizo* in 1925.

I readily grant that however mestizo the art of the Reductions may be, it cannot be equated with the colonial art found in Mexico, parts of Central America, or the Andes. At the time of the Conquest, we recall, the Guaranís

Relief from facade of church, Jesús

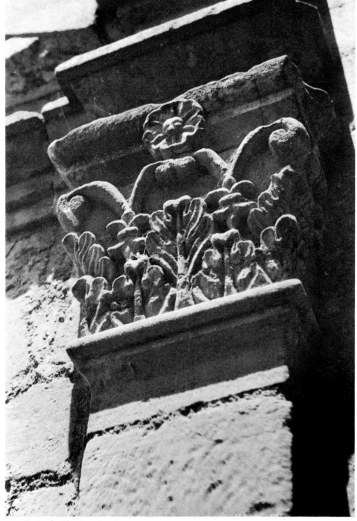

Capital of pilaster, Jesús

were not city-dwelling or "civilized" in the technical anthropological sense of the word. In this they were unlike the Mayas, the Incas, or certain other Middle-American groups. The Guaraní culture is described as being just at the beginning of the neolithic age.

These people had only elementary agricultural skills. They possessed only the rudiments of village life. Nothing, save fragments of ceramic work, remains of their art, which certainly included perishable clothing and basket weaving.

Colonial Mexican and Peruvian architecture, on the other hand, has a strong substratum of indigenous traditions and is obviously mestizo. This is apparent even to an amateur. No one, for example, would confuse the facade of Tepotzotlán with the famed Obradoiro of Santiago de Compostela, though they are roughly contemporary and both broadly Churrigueresque in style. Long before, during, and after the Conquest, Mexican artists enjoyed a lively tradition in the visual arts.

But east of the Andes, in the immensity of the South American continent, the Indians of Brazil, Paraguay, and the Southern Cone had little or nothing of traditions like these. They had never seen what we would call architecture in the sense of a fine art. Their culture expressed itself rather in the oral arts. Even today, Paraguayans have a high regard for eloquence either in Guaraní or in Spanish.

We are handicapped, too, in that we possess perhaps no more than one percent of the art of the Reductions. Does this really give us enough to work on? I obviously think so, or this book would not have been written. When we recall that we possess only

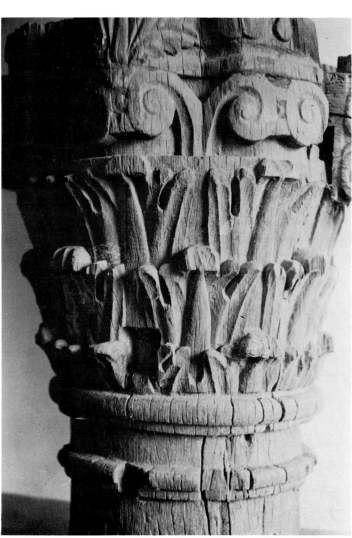

Wooden capital
Museum of San Ignacio Guazú

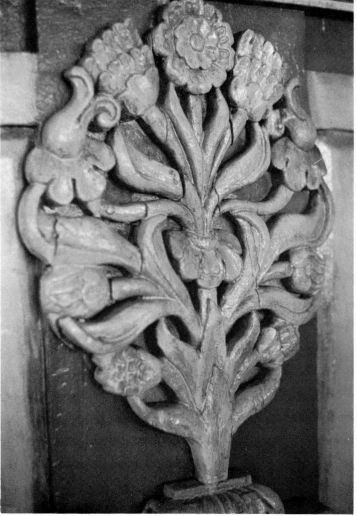

Detail of retable
Museum of São Borja

about one percent of classical Greek drama, to judge by the titles that have come down to us, the scarcity seems less shocking. No one would suggest that the Greek plays we possess are unrepresentative. There is too much evidence to the contrary. Nor, I believe, are the remnants of Reduction art unrepresentative. Again, we have too much evidence to the contrary.

Many of the missioners, notably Anton Sepp, repeatedly refer to the Guaranís as superlative imitators and copyists. We possess, in fact, whole pages which they have copied that are virtually indistinguishable from the printed originals. This has been taken as a sign of excessive paternalism. The system may indeed have been too protective and paternalistic, though I find it hard to believe that a person as intelligent as Anton Sepp, for example, could have missed so obvious a point. He loved and admired the Guaranís intensely but regretted their lack of originality. What seems more likely is that the quick leap from the early neolithic to the late baroque was a bit too much for the Guaranís to handle.

At the same time, one need not push Sepp's lament too far. I cannot imagine that the doors and facade of San Ignacio Miní and the surviving doors of Trinidad are mere servile imitations of European work. Whoever the craftsmen were, whether Guaraní or European, the execution and details and the very esthetic itself, are certainly not European. If not purely Guaraní, whatever that may mean in this context, the style seems quite genuinely mestizo. And while most of the statues preserved in the museums seem heavily European, with only nuances of mestizo, we do have these great doors to admire.

There appear in these doors a certain freedom and closeness to nature, the

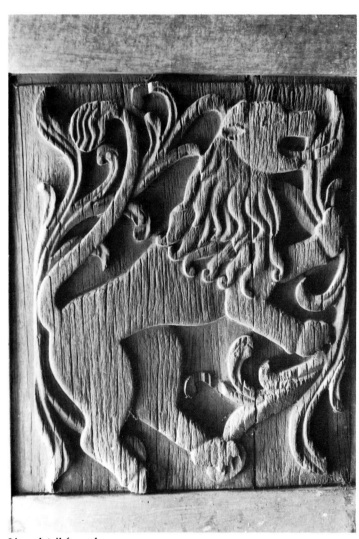

Lion, detail from door
Santiago

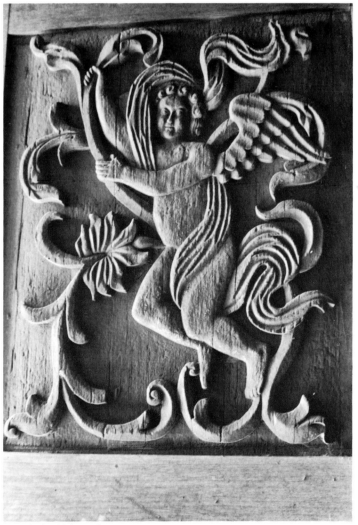

Angel, detail from door
Santiago

flora and fauna of Paraguay, not of Europe, which must have amazed and delighted the European missioners quite as much as they do us. In somewhat the same way, I find it hard to believe that the Guaranís were as docile, childlike, and subdued as some writers assert. We recall their independent resistance even to death against Portuguese and Spanish armies trying to dispossess them of their own Seven Cities.

What can be seen in the Blanch photographs and what I have personally observed from repeated visits reassures me that we are on fairly firm ground in calling Reduction art broadly mestizo and generically baroque. It is specifically Guaraní Baroque or Jesuit-Guaraní Baroque, or some other equivalent, whatever term one may prefer. Of the four thousand or so statues and virtually all of the original painting produced in this style, only a minute representation

remains. Most has been destroyed by vandals or pilfered by collectors. Only parts of four or five churches remain out of some sixty-five built. But despite the staggering loss, enough survives to ground a tentative judgment.

A rather far-fetched comparison might be enlightening. Imagine how we would evaluate French Gothic cathedrals if all we had left were the facade of Rheims after the bombing of

Mburucuya flower, from retable
Santa Rosa

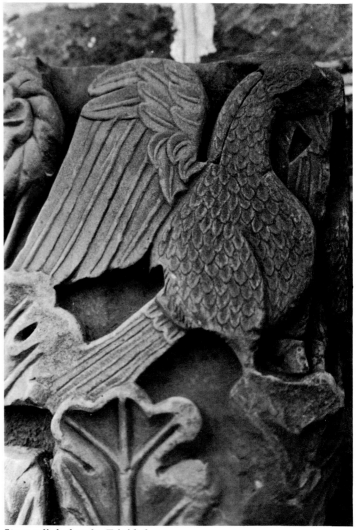

Stone relief of eagle, Trinidad

146

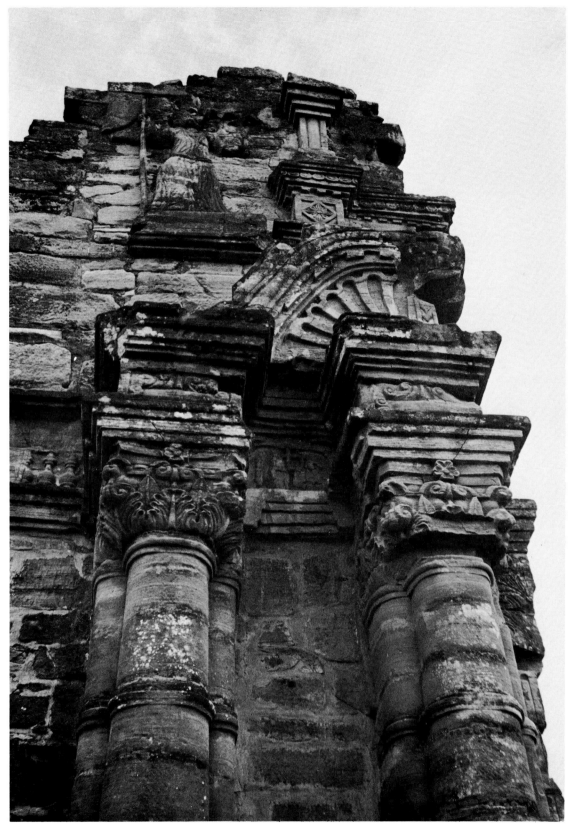

Church entrance, San Ignacio Mini

World War I, one gutted transept of Amiens, half of Senlis, and what remains of Beauvais without roof or nave. This, of course, would be comparing one of the supreme moments of art history with a relatively minor one. But proportionately the analogy might be helpful. Tourists and art historians would still come to admire and lament, and our grasp of Gothic would be much diminished. And yet we would still have some idea, and books like this would still be written.

Just over five years ago, while I was taking my first bus ride in Paraguay, I asked my neighbor what he was reading. He offered me the book but apologized, "I don't think you'll be able to understand. It's in Guaraní." I noticed that the author of the book was a Jesuit and I mentioned that I was one too. My neighbor smiled and said, "It was your predecessors who saved our language and our culture." I was elated and humbled, and I thanked him.

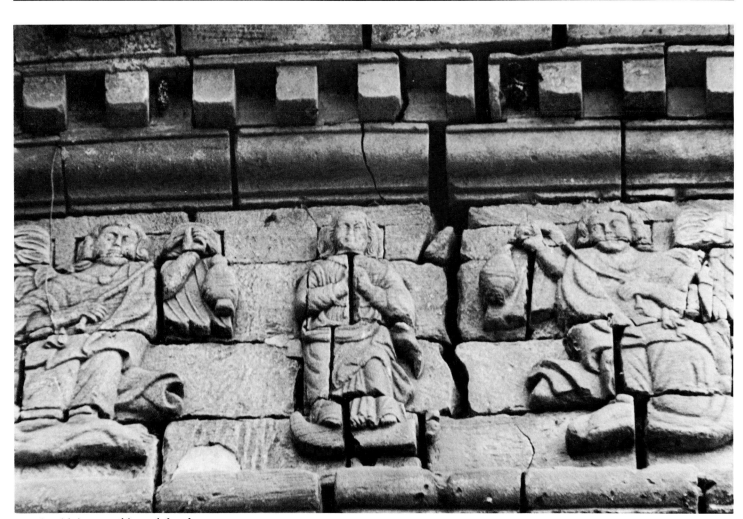

Angels with incense, frieze of church
Trinidad

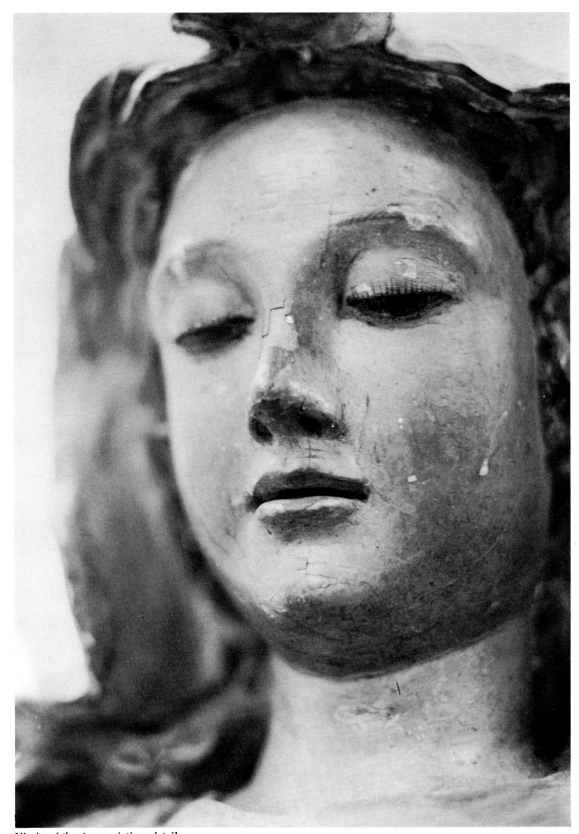

Virgin of the Annunciation, detail
Santa Rosa

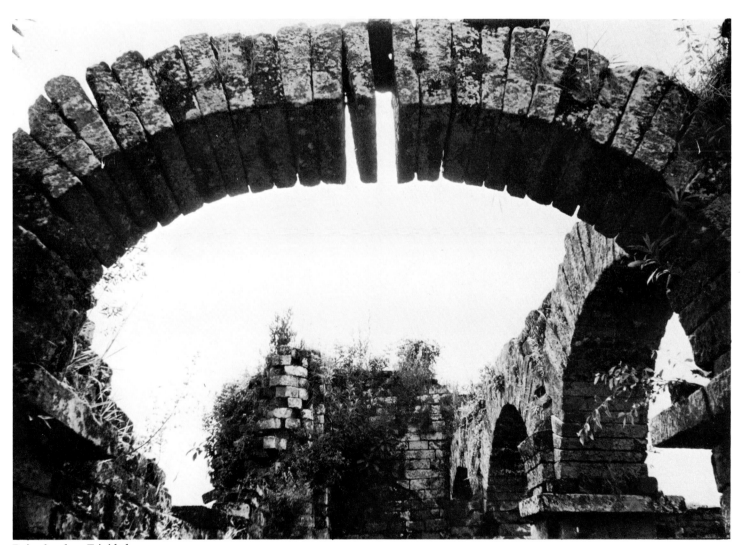

Ruined arches, Trinidad

Why did the Reduction "republic" collapse so quickly after the expulsion of the Jesuits? Anthropologist Alfred Métraux puts it as concisely and objectively as anyone: "The whole system was so well adapted to the missions founded by the Jesuits that after their expulsion the Spaniards were obliged to retain it in spite of several decisions made to destroy it. When the so-called communistic features of the mission villages were finally abolished, the situation of the Indians did not improve but rather deteriorated."

In point of fact, the Reductions themselves did not immediately collapse. They continued under new secular directors. The Guaranís were never given a chance to prove their ability to govern their own cities. Few if any of them returned to the forest. Many migrated to Buenos Aires and other cities and took up new lives as craftsmen and artists using the skills they had acquired in the Reductions. There was, however, a rapid decline in population in the Reductions, and we have detailed statistics to show this. The physical destruction of the towns was caused, as we have seen, by the armies of the Brazilian general Chagas and the Paraguayan dictator-president Francia. Furlong amasses a vast documentation in support of this opinion. It seems quite irrefutable.

But it was only in 1848 that the *coup de grâce* was finally delivered by Francia's successor Carlos Lopez. He forcibly abolished or destroyed the Guaraní's community property and appropriated what remained of their lands. It is not hard to imagine how the new rulers and established landowners were able to acquire property for their own profit. Even today the government has appropriated private land adjoining the two new hydroelectric plants at Itaipú and Yaciretá. Both the Indians themselves and the Paraguayan Church in their defense almost daily protest the alleged exploitation. This was exactly what the original missioners had feared when they set up the Reduction system.

The English anthropologist John Hemming, who is unabashedly hostile to what he calls "the hypocritical claptrap about the benefits of Christianity," points out that the Indians' situation was "even worse when lay directors were installed to replace the Fathers." For, as he shrewdly states, "no eighteenth-century settlers were going to endure the boredom and hardships of living in Indian villages solely to give disinterested instruction."

Hemming goes on: "The true purpose behind those who caused the Jesuits' expulsion was to ensure that there would be no interruption in the supply of Indian labour to state and settlers. It was obvious to the Governor and his contemporaries that the replacement of Jesuit missionaries—for all their faults—by laymen was the substitution of wolves for shepherds."

Somewhat lavishly, then, Hemming awards the following encomium to the Reduction system: "The Jesuits were the most determined and intelligent of the missionary orders. Their Paraguayan missions were the most successful attempt at conversion or acculturation of any South American Indians. Amid all the hypocritical claptrap about the benefits of Christianity, these missions demonstrated that in the right circumstances something could be done."

Another broad criticism of missionary work comes from those anthropologists and ethnologists who insist that all native groups remain isolated and uninfluenced by others. It goes without saying that they misunderstand or totally reject Christ's charge to "preach the Gospel to all nations and make disciples of them" (Matthew 28:18). At the same time, I am not unaware that the history of missiology has often been marred by naive ethnocentricity or the confusion of the Gospel of Christ with what is only Western culture.

In this regard I am happy to provide a concise response given in a personal letter from Ernest J. Burrus, a leading Latin American historian: "In demanding that all peoples should be left alone, some anthropologists and ethnologists overlook an

Monogram of the Society of Jesus
Detail, statue of Saint Ignatius
Museum of San Ignacio Guazú

obvious reality; except for a very few and small enclaves of humans, peoples from long before recorded history have acted on others and reacted to them. As mankind spread, such action and reaction also extended. This happened in every region on earth. The more we learn about any people, the more 'influenced' we find it to have been.

"After a long interval, Europe and the Orient again acted on and reacted to each other at the time of Marco Polo. With the discovery of the New World, action and reaction extended from a limited area to those between entire continents.

"It was into such a context that the missionaries entered whenever they strove to evangelize natives. The Jesuits in the Paraguay Reductions were but one of a group of agents affecting the acculturation of a comparatively small 'nation.' Although it was mainly the missionary who dealt directly with the native, the missionary had to operate under Spanish law. He brought in a foreign language which affected that of the native; he strove to have his charges conform to a new moral code, abolishing cannibalism, for example.

"The Jesuits in Paraguay and other mission fields had as their policy to effect a *gradual* change. In doing so, they had to violate specific Spanish laws. Thus, against the royal decrees demanding that they use only Spanish, the Jesuits, faced with the problem of instructing illiterate groups in complex moral and religious principles, opted for a middle course: communicate the essentials of the faith in Guaraní, readily understood by all; also teach the children to use Spanish. As a result, the native languages were usually preserved in Jesuit missions, since the people were allowed to speak them.

"This principle of gradual change or transformation was applied to every sphere. The Jesuits let the natives keep their social and political structures, and removed only such weaknesses which experience pointed out were detrimental. The missionary did not try to transform a stone or iron-age man into a 17th or 18th century Spaniard."

I have quoted this evaluation at some length because I have found nothing else so consise and at the same time so clear and so objective.

Burrus also takes up another complaint sometimes leveled against the Reductions: "A common charge brought against the Jesuits is that they kept their Indians isolated from the Spanish and mestizo colonists. There were two principal motives for doing so: to prevent the Spaniards from enslaving their charges (a constant threat), and to prevent the Spaniards from corrupting them through immoral conduct and inducement.

"Some opponents of the mission enterprise accuse the Jesuits of being too slow, others of being too fast. From countless documents it is evident that they tried to choose a pace dictated by common sense and long and extensive experience. The tragedy that later befell their charges is more eloquent than words."

Reductionism in popular historical writing is, of course, very much in vogue. When applied to the Reductions—the pun is unintended but inescapable—it can be a healthy corrective to the romanticism of writers like Chateaubriand who never came within a thousand miles of a Reduction but wrote rhapsodically about them as though every Reduction were an absolute paradise. No missioner ever did this.

I had to chuckle while reading Chateaubriand, but I could not resist a chuckle also while reading the dissertation abstract of a young sociologist at a celebrated American university. The author, perhaps to please her mentors, speaks of "mystification" as a technique used by the missioners to "manipulate" and "dominate" the Guaranís. Her proof? "The Jesuits did not eat in public, nor did they ever personally give physical punishment; this arrangement was designed to make the Guaraní respect the Jesuits and to consider them more Godlike."

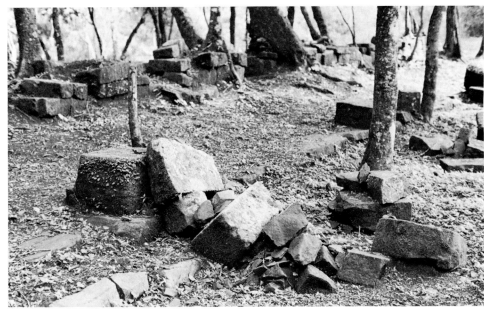

Left: **Ruins of Indian houses Santa Ana**

Below: **Ruins of church Trinidad**

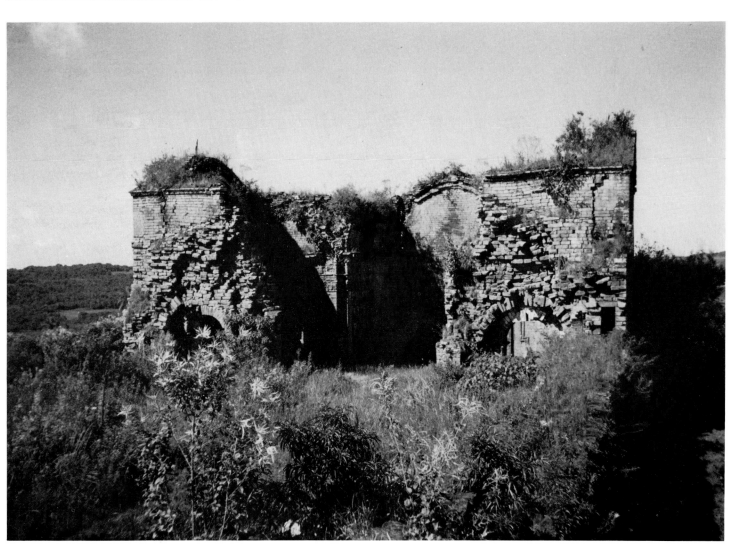

153

The author clearly knows nothing about the strict prohibitions in Canon Law against clerics administering physical punishment. Nor does she mention the far more significant fact that the Reductions were the first occidental society that we know to have excluded capital punishment. The first European country to do so was the grandduchy of Tuscany (Florence) and that not until 1786, long after the Reductions had set the example.

Nor does she apparently know the tradition of religious communities, now generally abandoned, of eating together in silence, save for simultaneous spiritual reading. The Indians who did the reading, in any case, knew that the Jesuits did eat. They would also have known that the Jesuits used such bizarre, exotic implements as knives and forks. This would hardly have been kept a secret.

Nor did our dissertation author reflect on the day-to-day proximity of missioners and Guaranís, not only during daily visits to the sick but through all the strenuous physical work which they did side by side, quarrying stone, hewing, carving, and the like. The odors of Europeans working in the tropics while wearing black soutanes, at a time when Europeans did not bathe very often, must have quickly "de-mystified" any alleged superiority. The Guaranís, on the other hand, bathed at least once a day, as they do now, and they never seem to accumulate body odor. Furthermore, the great churches were not ready-made, mystically descended from the empyrean. They were constructed and adorned over a matter of years, with the sweaty, bodily labor of Jesuits and Guaranís working together.

The dissertation abstract is admittedly based on "a model borrowed in part from Marxist sociology." This, however scientific and useful in part, inevitably tends to reduce values to prices and to other simplistic categories like "mechanisms" and crude "power." I was comforted, however, to find the author occasionally lapse from high jargon into plain human language: "It is interesting to point out the amazing success of the Jesuit venture. For over 150 years, a group of only 50 to 60 priests dominated up to 140,000 Indians with no serious attempt at rebellion. The Jesuits did not reap huge material advantages from this project. Life for them in the Reductions was emotionally and physically very hard. Only men with great strength of character were selected for this job."

I would add, even more simply and I hope more to the point: "only men with deep spiritual lives, a personal love of Christ and his people, and a strong apostolic and missionary motivation." While mine are hardly neat Marxist or reductionist categories, they may help the reader to see the forest, not just certain selected shrubs. Anyone familiar with the Spiritual Exercises of St. Ignatius Loyola, their key meditations and "rules for the discernment of spirits," that is, how to probe hidden motivations, can come closer to understanding why the Reductions came into being and how they flourished until they were destroyed by physical power.

A parallel occurs to me, suggested by the philosopher Isaiah Berlin at Oxford. One day as he was coming out of the Sheldonian Theatre after hearing a performance of Bach's B-Minor Mass, he met a celebrated logical positivist who quipped, 'Hello there, Isaiah. Been listening to some pretty tunes?' In response Berlin could only laugh. To anyone who enters into the profound symbolism of Bach, the reduction of a transcendent masterpiece to decibel counts or "pretty tunes" makes no more sense than reducing human love to adrenalin or other chemical flows. But then, specialists are entitled to have their fun.

More revelant is the explanation given me in a letter from Bartolomeu Meliá, an anthropologist who has spent decades working among the Guaranís and other indigenous groups: "The Reductions offered a real alternative within the colonial world. Of course colonialism is a great evil. But within the colonial world, the Reductions gave a utopian option, namely the belief that it was possible to struggle and actually create the geographic and economic space that for a time made possible a *colony without encomenderos*. Something else quite important

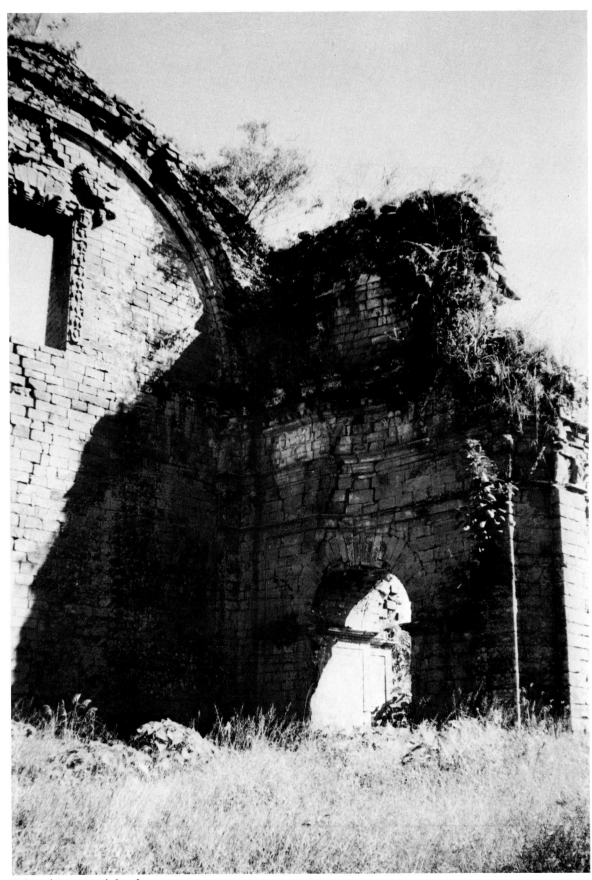

Ruins of transept of church
Trinidad

was further achieved: the realization that it was not necessary to be Spanish in order to be Christian. In my view the Jesuits had a theology and a pastoral technique adequate to resist those who wanted to enslave the Indians."

Indeed, no one will ever properly understand the Reductions, their successes and downfall, their arts and other human achievements, unless they view them as a huge missionary effort, an evangelistic and catechetical enterprise, a brave attempt to produce, not a "brave new world," but the beginnings of the kingdom of God on earth, or at least something resembling this. The leading lay church historian of Latin America, Enrique Dussel, concludes in his Mainz lectures that the Reductions, by insisting that mission work came within the competence of the Pope and not the kings of Spain, "consistently demonstrated the authentic way."

The abrupt termination of the Reductions and their eventual disappearance came about through the collusion of several factors: European absolutism which brooked no rivals, nascent dogmatic secularism, and the sort of economic "liberalism" that was to dominate nineteenth century thinking but which seems quite outdated today. The Reductions may have ended, too, partly because of too much success and an understandable human envy.

The phrase "barracks style" is occasionally used, as we have noted, to belittle life in the Reductions. When one recalls the fact that the Reductions existed almost constantly in a state of siege, with Paulistas poised for yet another slave raid, the analogy is not altogether far-fetched. Truce rather than comfortable peace was almost the best that could be hoped for in a land that was far from official centers of government.

The term "monastic" has also been captiously leveled against the lifestyle of the Reductions. Again, the analogy, while loose, is not entirely groundless. While reading Ursmer Berlière's account of the Benedictine abbeys during the darkest period of the early Middle Ages, I was reminded of the Reductions: "The Benedictine abbey was a little state which could serve as model to the new Christian society which was arising from the fusion of conquered and conquering races, a state which had religion for its foundation, work restored to honor as its support, and a new intellectual and artistic culture as its crown."

As during the Dark Ages there existed a distant emperor to whom one might appeal but on whom one could not depend; so in the dark age of the colonies, the laws emanating from distant Madrid may have been excellent, but day-to-day security depended on local organization and personal self-discipline. The Guaranís obviously recognized this. Otherwise it would have been easy enough for them to abandon the Reductions and dispose of the missioners if necessary. Yet, seldom did any Indians leave the Reductions, and in no instance did they ever kill a single Jesuit. This has to be rare, if not unique, in the history of human institutions.

And it must be constantly remembered that the entire Reduction enterprise was achieved and maintained in a state of enormous tension. The Jesuits did their work between two pressures, not to mention the threat from the Paulistas, which could simply be resisted. One pressure arose from the nomadic traditions and tendencies of the Indians who had never in this part of America settled down to city life. The other pressure was quite real, too, that which came from the colonists who naturally felt deprived of cheap labor or slaves while other colonists in both North and South America had slaves and indentured servants and continued to have them long after the Reductions were disestablished.

The immense difference between the monasteries and the Reductions need not be pointed out. While both were "rescue operations," the European monasteries numbered in the thousands and frequently lasted for centuries. The Paraguay Reductions at the time of their destruction numbered only thirty and in most instances they could not form the seed of future cities. And while in the Reductions life was rather structured, even Spartan by modern standards, individual Guaranís enjoyed private family lives and personal property.

And yet every time I visit the piteous ruins here in South America, despite their modest scale, I recall what I sensed when visiting the more awesome ruins of Tintern, Fountains, Rivaulx, or a dozen other medieval abbeys. For these, too, were ravaged for similar "reasons of state," if not more simply out of human envy or greed. Still, both monasteries and Reductions had been oases of Christian peace in a chaotic, brutal world.

The most recent criticism I have read concerning the Reductions is also the most original. Apparently convinced that they were the right thing at the right time, the respected Jesuit theologian Karl Rahner puts the question imaginatively in the mouth of St. Ignatius Loyola: "Why did you Jesuits in the eighteenth century, together with your Indians, not defend by force the holy experiment of the Reductions against the hideous colonialism of Europe? Did you really have to allow yourselves to be forced out of Latin America in the name of devout obedience?" I cannot presume to answer Rahner. Nor am I sure that he puts the question quite realistically.

In any case, whatever the flaws and limits of those who built and staffed the Reductions, enough of their artistic creations remain to point to authentic life enhancement and at least something of transcendence, all meant for the good of the Guaraní people.

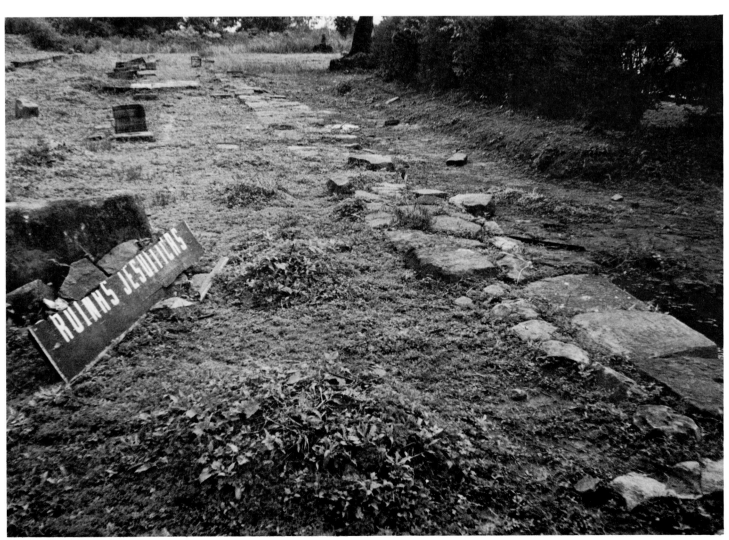

Marker "Jesuit Ruins" in plaza
Yapeyú, Argentina

GLOSSARY

Bandeirantes armed Brazilian pioneer explorers, frequently slave raiders who originally came from the São Paulo area and hence were called Paulistas. They are idealized in Brazilian mythology and are glorified with a giant monument in São Paulo. To Paraguayans and students of the Reductions they are considered to be villains.

Baroque a period in history, roughly 1580 to 1780, and an artistic style which is characterized by movement, luxuriance, striving after infinity, and "dynamic forms expanding outside their boundaries."

Beatification a declaration by the Catholic Church that a person has lived a life of extraordinary holiness and heroism; it is a step towards canonization (q.v.).

Brother member of a religious order or congregation who is not ordained to the priesthood. In the Reductions most of the leading architects, sculptors, and craftsmen were Jesuit brothers.

Canonization the solemn declaration by the Catholic Church that a person is a saint and is in heaven after leading a life of heroic holiness in imitation of Christ.

Churrigueresque a very ornate variant of Baroque, particularly developed in the Hispanic world.

Colegio a building complex in the Reductions which was located near the church and included the school, workshops, storage rooms, and living quarters for the missioners and guests.

Composite the most elaborate of classical columns; it combines a Corinthian capital with an Ionic volute (q.v.).

Dentil one of several stone or wood blocks, usually square, above a column.

Fluting grooves carved vertically in a column or pilaster (q.v.).

Frieze an architectural band high in a room or outside a building, usually adorned with sculpture in relief (q.v.).

Galería a porch, balcony, or veranda; as used in this book it refers to a covered walk which connects buildings or houses.

Mestizo of mixed parentage, usually Spanish and Amerindian.

Pilaster a projection from a wall with the appearance of a pillar or column, but relatively flat.

Polychrome coloring on statues. The majority of world sculpture seems to have originally been polychrome, though much of the color has been the victim of time or poor restoration.

Provincial in certain religious orders or congregations, the presiding official of a determined geographical area or province.

Relief sculptured figures projecting from a surface but not fully rounded in three dimensions.

Retable an ornamental screen or frame enclosing painted or carved panels which serves as a decoration or backdrop to an altar.

Sanctuary the area in a church which includes the altar and the space in which most of the liturgy takes place; also called "presbytery."

Volutes spirals or scroll-like ornaments on the capitals of Ionic columns or pilasters.

Voussoir a wedge-shaped block of stone used in arches; the central voussoir is called the keystone.

BIBLIOGRAPHY

For the English-speaking reader:

Caraman, Philip. *The Lost Paradise.* 1975. This is by far the most useful introduction to the Paraguay Reductions in English. It covers every aspect of the subject in a readable, reliable way.

Cunninghame Graham, R. B. *A Vanished Arcadia.* 1901, reprinted 1978. The English classic on the subject; very personal, exciting, somewhat romantic reading.

Cushner, Nicholas P. *Lords of the Land.* 1980. A scholarly study of the economics of the colonial period by a distinguished American Jesuit historian.

Mörner, Magnus. *The Expulsion of the Jesuits from Latin America.* 1965. This work by the Swedish economist treats the economics of the Reductions.

O'Neill, George. *Golden Years on the Paraguay.* 1934. A readable popularization of the general subject of the Reductions.

Some basic works in other languages that were much used in the preparation of this work but are less accessible to the general reader:

Armani, Alberto. *Città di Dio e Città del Sole.* 1977. The most recent over-all view of the Reductions. It is scholarly and readable; for Italian readers, of course.

Bruxel, Arnaldo. *Os Trinta Povos Guaranis.* 1978. This is the best brief account of the Thirty Cities, written by the leading Brazilian historian of the subject.

Busaniche, Hernán. *La Arquitectura en las Misones Jesuiticas Guaranies.* 1955. An invaluable study of all the architectural remains of the Reductions by a leading Argentine architectural historian.

Cardiff, Guillermo Furlong. *Misiones y Sus Pueblos de Guaraníes.* Second edition, 1978. A monumental treatment of the Reductions and their arts by an Argentine historian who dedicated a lifetime to research on the subject.

Culley, Thomas D. and McNaspy, Clement J. "Music and Early Jesuits (1540-1565)" in *Archivum Historicum Societatis Jesu.* (1971, pp. 213-45) The section titled "Music in the Missions until 1565," for which I was responsible, discusses music in the Brazil area and is somewhat relevant to the subject of this book. Furlong's article in the same journal, "Domenico Zipoli, Músico Eximio en Europa y America" (1955, pp. 418-28) is, of course, in Spanish and is the best published summary of Zipoli's work, though several dissertations have subsequently appeared.

Dussel, Enrique. *Historia de las Iglesia en América Latina.* 1972. See especially chapter 2.

Gutiérrez, Ramon. *Evolucion Urbanistica y Arquitectónica del Paraguay.* 1975. While treating more than our subject, this book dedicates several chapters to the Reductions. It was written by a leading Argentine historian of architecture and city planning.

Meliá, Bartolomeu. *Guaranies y Jesuitas.* 1976. A brief, perceptive guide to the Reductions in Paraguay by an eminent anthropolgist.

Plá, Josefina. *El Barroco Hispano Guarani.* 1975. A critical study of sculpture, painting, and minor arts of the Reductions. This is easily the best work on the subject by Paraguay's leading art historian and critic.

Plattner, F. A. *Deutsche Meister des Barock in Südamerika.* 1960. This is a splendidly illustrated volume by a leading Jesuit historian.

Popescu, Oreste. *El Sistema Economico en las Misiones Jesuiticas.* 1970.

Rabuske, Artur. *P. Antonio Sepp, S.J., O Genio das Reducoes Guaranis.* Second edition, 1980. Documents on Sepp and the Reductions by an outstanding Brazilian historian.

About this book

Lost Cities of Paraguay was edited by George A. Lane and designed by Mary Golon. It was set by Lakeshore Typographers, Inc. The text is 10 on 11 Palatino. The captions are 8 on 9 Palatino Bold. It was printed by Photopress, Inc., on Warren's 80-pound Lustro Offset Enamel paper and bound by the Engdahl Company.